What Is Paleolithic Art?

What Is Paleolithic Art?

Cave Paintings and the Dawn of Human Creativity

Jean Clottes

Translated by Oliver Y. Martin
and Robert D. Martin

The University of Chicago Press | Chicago and London

Jean Clottes is a prominent French archaeologist and former general inspector for archaeology and scientific advisor for prehistoric art at the French Ministry of Culture. He is the author of *Cave Art*, among other books. **Oliver Y. Martin** is a lecturer in the Department of Environmental Systems Science at ETH Zurich, Switzerland. **Robert D. Martin** is curator emeritus in the Integrative Research Center at the Field Museum, Chicago.

The University of Chicago Press, Chicago 60637
The University of Chicago Press, Ltd., London
© 2016 by The University of Chicago
All rights reserved. Published 2016.
Printed in the United States of America

25 24 23 22 21 20 19 18 17 16 1 2 3 4 5

ISBN-13: 978-0-226-26663-3 (paper)
ISBN-13: 978-0-226-18806-5 (e-book)

DOI: 10.7208/chicago/9780226188065.001.0001

Originally appeared in French as *Pourquoi l'art préhistorique?*
© Editions Gallimard, 2011.

Library of Congress Cataloging-in-Publication Data

Names: Clottes, Jean, author. | Martin, Oliver Y., 1973– translator. | Martin, R. D. (Robert D.), 1942– translator.
Title: What is paleolithic art? : cave paintings and the dawn of human creativity / Jean Clottes ; translated by Oliver Y. Martin and Robert D. Martin.
Other titles: Pourquoi l'art préhistorique? English
Description: Chicago : The University of Chicago Press, 2016 | Includes bibliographical references and index.
Identifiers: LCCN 2015029149 | ISBN 9780226266633 (pbk. : alk. paper) | ISBN 9780226188065 (e-book)
Subjects: LCSH: Art, Prehistoric.
Classification: LCC N5310 .C58513 2016 | DDC 709/.012—dc23
LC record available at http://lccn.loc.gov/2015029149

♾ This paper meets the requirements of ANSI/NISO Z39.48-1992 (Permanence of Paper).

Contents

Introduction

Ice Age people penetrated deep into vast caves to create images and engage in mysterious ceremonies, occasionally leaving traces on the walls and floors. They also adorned the walls of certain shelters where they lived with engravings, paintings, and sculptures that predominantly portrayed animals. In exceptional cases, engravings have been preserved on isolated rocks in the open (Fornols Haut, Pyrénées-Orientales) or along the banks of rivers (Foz Côa in Portugal; Siega Verde in Spain). It may seem something of a gamble to try to get close to the thought processes that guided these people. They are so remote from us, and they appear so alien because of this immense distance, that it is a seemingly futile exercise to investigate their motivations and, even more so, the significance of their images.

For quite some time, I also yielded to such skepticism, which is shared by most of my colleagues. The embarrassing question "Why?" is seemingly insoluble.

But surely all problems remain insoluble as long as nobody tackles them? Many specialists, undoubtedly the majority, are inclined to dodge the issue. Either they thrust it aside and never address it, or they focus on investigating the "What?" (describing and studying the themes represented, aiming to do so as thoroughly and as "objectively" as possible), the "When?" (addressing problems of dating and chronology), and the "How?" (meticulously studying the techniques employed). They may content themselves with rather brief explanations that admittedly always contain an element of truth: "They represented and perpetuated their myths." But in extreme cases certain

authors have resorted to heaping derision and sarcasm on those who propose hypothetical interpretations.[1]

For some fifteen years now, I have been particularly interested in the challenging problems of interpretation. There are three main reasons for this interest:

During a long research career essentially founded on archaeological excavations, predominantly in caves and shelters, I took a down-to-earth approach to Paleolithic lifestyles, if not to the underlying thought processes. I reached a point where I wished to know more about their beliefs and their worldviews as expressed in cave art, doubtless more informative in this respect than their tools and the evidence of their daily activities revealed by excavations. In the cave of Enlène (Montesquieu-Avantès, Ariège), I had encountered an extremely rich assemblage of Magdalenien portable art, consisting of engraved flat stones and engraved or sculptured bones or reindeer antlers, along with all kinds of body ornaments. Why did these objects accumulate to such an extent at this site? What thought processes drove their conception and production? The decorated caves in the Pyrenees, on which I worked for some considerable time (Réseau Clastres, Niaux), along with the Placard cave in Charente, the Cosquer cave in Marseille, and a number of others, had also aroused my unabated curiosity.

During those years, the vicissitudes of my career led me to travel a great deal, on every continent. In the course of my travels, guided and informed by my colleagues, I was able to visit a huge number of sites with rock art. These were and remain useful and even indispensable elements of comparison. Above all, I was able to engage in long discussions with research workers in the diverse countries that I visited and to read their publications in languages in which I am fluent (notably English and Spanish). Traditions connected with these artworks of the Holocene (that is to say, subsequent to the last Ice Age and hence relatively recent) have sometimes persisted. As far as the local populations are concerned, for example, Australian Aborigines or American Indians, they have occasionally preserved precious an-

cient knowledge; but, above all, they have perpetuated a state of mind, an attitude toward nature and the world in general, which differs from our own and extends back through the mists of time. In the course of my contacts and conversations with them, I have learned an enormous amount—and unceasingly continue to do so. I have also gleaned valuable information from bibliographical research into their activities as recorded by missionaries, explorers, and ethnologists. Thanks to these influences, my reflections slowly matured.

The third element, and a decisive one, was my encounter with David Lewis-Williams and with his research. For many years, this South African prehistorian has studied the art, religion, and customs of the San people of southern Africa. He conceived the idea that Paleolithic art, like that of San artists, might have been created in the context of a shamanic form of religion. Together with his colleague Thomas Dowson, he published a seminal article that attracted a great deal of attention.[2] Like many others, the article aroused my interest because it took account of numerous facts concerning caves and their art that had long intrigued me. Thus it was that collaboration, and friendship, between us were born. Our work together gave rise to a series of publications, books, and articles.[3] Ever since, I have never ceased to reflect upon these questions and to probe them in depth in my own way, as far as I possibly can.[4]

My reflections were fed by various inextricably connected sources. In the course of my travels, encounters with the descendants of those who had engraved or painted rock surfaces were incontestably the most rewarding moments of all. Nonetheless, regional specialists, my colleagues, who have engaged with them—sometimes for many years—revealed to me unanticipated aspects of their modes of thought and of their art. They also provided me with precise information regarding ancient testimonies, often published in obscure treatises or articles. Every now and then, certain comments unexpectedly clarified a mystery regarding cave art that had intrigued me, remaining constantly at the back of my mind. I occasionally reported such insights in specialist articles. Above all, I drew upon them for my courses[5] and lectures, and

I was able to witness the great interest shown by the public for such accounts and for their contribution to an improved understanding of Paleolithic parietal art.

Thus it was that the idea developed[6] to record these findings in print in order to expand beyond the narrow circle of specialists and reach out to a broader readership interested in Ice Age art and in parietal art in general. My goal was to show them, to show *you*, how it is possible to approach the modes of thought and the worldviews of civilizations that disappeared long ago, while doing so prudently and respecting the constraints of scientific procedure (see chapter 1). With respect and attention, I took pains to listen, observe, and analyze distant echoes in practices and beliefs of people closer to us, but whose lifestyles, until relatively recently, resembled those of their remote ancestors far more closely than they do our own.[7]

One

What Is the Correct Way to Approach
Art in Caves and Shelters?

All art is a message. It can address a more-or-less cohesive community whose knowledge varies according to membership of one group or another. Age, sex, degree of initiation, social status, and many other individual factors may also play a part. Art may serve as warning or a prohibition directed at all members of a group or just some of them, and it may also be directed at people outside the group, possibly even at potential enemies ("No entry"). It may also tell a story, either profane or sacred, or eternalize real or mythical facts of special importance. Alternatively, art may have no role other than that of manifesting or affirming individual or collective presence ("Here am I" or "Here we are"). This is the motivation for graffiti. Sometimes, art is intended not for other humans but for one or more divine beings, aimed at establishing a bond of one kind or another with the netherworld. It may serve to recruit the power of spirits or gods believed to reside in the rock or in the mysterious world beyond the permeable boundary that the rock wall forms between the universe of the living and that of fearsome supernatural powers.

All of these kinds of significance, and doubtless many others, can be envisaged when dealing with art that is prehistoric—"fossilized art"—whose nuances and complexities cannot be explained by those who created it, by their contemporaries, or by their successors. One

can surely appreciate the challenges facing any attempt to approach these questions of significance millennia after the disappearance of the societies that created the art.

Deceptive Empiricism and Its Lack of Ambition

There is hence a strong temptation to abandon any attempt to provide explanations or to shun this risky enterprise altogether. Viewpoints with varying degrees of pessimism have been expressed, notably over the past twenty-five years. "Precise understanding of significance lies beyond the domain of archaeological investigation of prehistoric art, which must confine itself to the modest satisfaction of recording its *structures* rather than literally seeking the sense of the depictions studied."[1] Some authors go even further, proclaiming that any research in this direction should be abandoned: "An increasing number of investigators have decided to abandon the fruitless search for meaning."[2] "Interpretation of the art lies outside of science's capabilities, and will presumably always remain there," because "empirical knowledge is the only form available to us about the physical world."[3]

The alternative proposed by the pessimists would therefore be to limit oneself to an objective description of the facts, or even of the structures, and to compose immediate explanations that are as simple as possible. But this position is unsatisfactory not only because of its lack of ambition but above all because its deceptive empiricism is actually dangerous. In effect, empiricists claim to be objective and celebrate their freedom from any preexisting hypotheses. But they are clearly deluding themselves, albeit unwittingly, as philosophers of sciences have abundantly demonstrated: "Utterly unbiased observation must rank as a primary myth and shibboleth of science, for we can only see what fits into our mental space, and all description includes interpretation."[4] Confronted with the infinite scope of material reality, we are manifestly quite unable to choose among the countless alternatives that present themselves without previously accepting or deciding that one parameter will be important and another not. In other words, we favor one hypothesis over another. Bronislaw Mali-

novski clearly stated this in 1944: "There is no description untouched by theory." "To observe is to choose, to classify; it is to select in accordance with theory."[5]

Empiricism hence presents a double danger: On one hand, the apparent objectivity that is claimed is in fact nothing more than the implicit application of hypotheses and theories that are generally accepted in the contemporary context, often without debate or even formulation, as if they were self-evident. On the other hand, it carries in its wake a kind of sterilization of research, which is reduced to description while ignoring the context in which the art was created.

Yet, despite all the dangers and difficulties, the ultimate goal of archaeology is, or should be, an understanding of the phenomena examined, in other words a search for significance. In fact, ever since the first discoveries of Paleolithic art during the nineteenth century and ensuing decades, there has been no lack of attempts to provide explanations. After all, it is evident that the question "Why?" is one of the first to be posed by an investigator or even by a simple spectator confronted by these images, whose antiquity renders their mystery even more disquieting.

Suppositions regarding the Significance of Paleolithic Art

When engraved objects were first discovered in Paleolithic levels some 150 years ago, they evoked considerable surprise, because "these works of art did not fit well with the uncultured barbarous state that we had imagined for these aboriginal populations."[6]

Initial hypotheses[7] were simple, framed to fit the image of a life thought to be idyllic, uniquely devoted to hunting and leisure. Engravings and sculptures accordingly had no purpose other than ornamentation of weapons and tools, just for pleasure, fulfilling an innate need for aesthetic expression. This is the theory known as "art for art's sake": Art is gratuitous and self-sufficing. This interpretation was particularly championed, at the end the nineteenth century, by Gabriel de Mortillet, a militant atheist who opposed any idea of religion. It went

hand in hand with the established notion of "noble savages," who had sufficient free time to devote themselves to artistic pursuits, to the extent that they were able and with the means at their disposal. Faced with the contradictions that it generated, this notion fell by the wayside.

Two major opposing arguments contributed to abandonment of the notion of "art for art's sake," particularly following the discovery and description of art deep in caves. The initial discovery at Altamira (Spain) in 1879 eventually became widely accepted in 1902, after discoveries in 1901 at Combarelles and Font-de-Gaume in Dordogne (France) led Émile Cartailhac to retract his doubts regarding the authenticity of Altamira and to publish his famous "Mea Culpa of a Skeptic."[8] On the one hand, why should people descend deep into uninhabited caves to create such images? If the purpose of art is to serve communication, this was at the very least improbable at the sites selected, unless their role was something other than providing simple receptacles for images destined to be seen and admired by the artists' contemporaries, in which case "art for art's sake" is an inadequate explanation. On the other hand, ethnological reports that began to arrive from other continents (particularly Africa and Australia) bore witness to more complex patterns of thought than had been envisaged for populations regarded as "primitive." Among these remote people, art often played a prominent part in their cultural practices.

This hypothesis does occasionally resurface either from members of the general public, unaware of the arguments presented above (sometimes taking the form of a question posed during lectures: "Why not just say quite simply that they created images in caves because they liked doing it?") or, more rarely, in an academic environment. Its latest manifestation was in a controversial publication by the American university professor John Halverson in 1987. In a prominent American journal, *Current Anthropology*, he criticized the various intervening interpretations of cave art and, being wary of loaded connotations of the word "art," vainly attempted to resuscitate what he preferred to call "representation for representation's sake." His arguments were essentially based on the absence of formal proof for the

magical character of the representations and even, joining the company of Gabriel de Mortillet, for the existence of any kind of religion in the Paleolithic.[9]

However, numerous authors, faced with the unquestionable visual qualities of cave art, have emphasized the fact that its realization implied precise knowledge and a mastery of sophisticated techniques, along with a quest for, and indeed enjoyment of, aesthetic properties on the part of the artists concerned. So, without being "art for art's sake," the activity entails artistic sentiment and its application. This is not inconsequential, and we will return to it with respect to shamans and their apprenticeship.

At the beginning of the twentieth century, *totemism* briefly appealed to certain prehistorians, one example being Salomon Reinach, who influenced quite a number of others. He set out from the close association that a human group establishes between itself or some of its members and one or more specific animal or plant species. The individual or group characterized by a particular totem attributes to it certain powers, respecting and venerating it, for example, abstaining from hunting it.

Three more-or-less well-founded principal criticisms were directed at this hypothesis. Representations of animals wounded by arrows or other projectiles, for which examples are known from caves (Niaux, Les Trois-Frères, and, more recently, Cosquer), would be incompatible with the veneration granted to an animal totem. Above all, however, no major ornamented cave is dedicated exclusively to a single species as would be expected. If that were the case, there would be "lion caves," "bear caves," "ibex caves," and so forth. Nevertheless, some caves are dominated by images of a particular animal, either numerically (mammoths at Rouffignac; bison at Niaux) or by the proportions accorded to them (aurochs at Lascaux). Conversely, the bestiaries of cave art, that is to say the collections of animal representations found at any given site, show relatively little variability. Yet the range of available choices, without even considering plant species, was immense. As André Leroi-Gourhan noted, if they represented totems, we would be obliged to "conclude that all Paleolithic societies were

subdivided in the same fashion, with each possessing a bison clan, a horse clan and an ibex clan. Such an interpretation is not beyond the bounds of possibility, but it is not convincingly indicated by the facts themselves."[10]

Last, as the twentieth century progressed, the inference of totemism was scarcely crowned with success, doubtless because—without being clearly excluded in certain cases—it was unable to provide the unique explanation that was sought for the complex phenomena observed.

So-called *sympathetic magic* implies a fundamental, indeed literally vital, relationship between the image and its subject. By taking action on the image, action was exerted on the subject represented, whether human or animal. This was the theory that had the greatest success following the revelation of cave art. Here, too, the first to formulate it was Salomon Reinach, in an article published in 1903 bearing the eloquent title: "Art and Magic in Relation to the Paintings and Engravings of the Age of the Reindeer."[11] Adopted, elaborated, and promulgated by abbé Henri Breuil and Count Henri Bégouën,[12] this theory, under the rubric of hunting magic, enjoyed astonishing success for decades.

Count Bégouën precisely defined the foundations and procedures, although nowadays we reject use of the term "primitive," which Bégouën applied repeatedly to traditional societies or to prehistoric cultures: "A notion widely held among all primitive populations is that representation of any living being is, in some way, an emanation of that being itself and that a human being in possession of the image of the being already has a certain power over it . . . Accordingly, one can infer that primitive people similarly believed that the fact of representing an animal somehow subjected it to their domination. As masters of its image, of its replica, they were more easily able to master the animal itself."[13]

Art was hence magical and utilitarian. Objects decorated with images of animals could serve as amulets or talismans. And as for depictions in the depths of caves, they were not intended to be seen; they were created to influence reality through its representation. Creation

of the artwork therefore took precedence over the result and over its visibility to the mortal community. This explained multiple super-positions of images on a given cave wall, where each magical cere-mony added representations that ended up in an inextricable tangle, rendering the panels concerned virtually unreadable. "Once this act had been accomplished . . . the image was no longer important."[14]

The magic concerned had three major components. The first of these, accounting for its familiar name "hunting magic," was to facili-tate hunting of large herbivores constituting the customary prey and to enhance their fecundity. These animals were spellbound through their images and by the marks of projectiles and wounds that were depicted on them. Some animals were incompletely represented in order to diminish their capacities for defense. Within this conceptual framework, what are now called "geometric signs" were interpreted as weapons or as traps. Humans represented were sorcerers. Those that we refer to as "composite creatures," which present a combination of human and animal characteristics (Les Trois-Frères; fig. 1), were clothed in animal skins or endowed with animal attributes (horns, tails, claws) in order to capture more effectively their qualities and their power. They might also have represented gods reigning over the animal world.

The second kind of magic, called "fertility magic," was aimed at promoting reproduction of the game animals. This explained images of pregnant females and of numerous animals lacking any traces of wounds.

"Destructive magic" served the goal of eliminating harmful ani-mals, such as lions or bears, which were represented in certain caves, such as Montespan or Les Trois-Frères. This hypothesis stood to some degree in contradiction to the preceding one, as in one case animals were represented in order to increase their numbers, whereas in the other this was done in order to eliminate them.

During the second half of the twentieth century, certain inconsis-tencies in this explanation, such as the one just mentioned, were dem-onstrated, while new research and discoveries contradicted some as-pects.

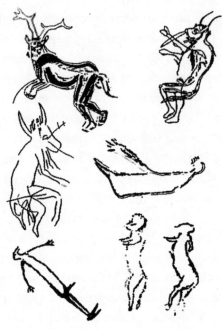

Figure 1. Composite creatures, partly human and partly animal.
Top: the two "sorcerers" of Les Trois-Frères (Ariège) (tracings by H. Breuil).
Center: on the left, the "sorcerer" of Gabillou (Dordogne) (tracing by J. Gaussen,
completed); on the right, the "slain man" of Cosquer (Bouches-du-Rhône), without
the harpoon traversing his body (after a photograph). Bottom: on the left, the man
with a bird's head in the Shaft scene at Lascaux (Dordogne); on the right, men
transfixed by lines (not shown here), one with a bird's head (Pech-Merle) and
both with peculiar arms (Cougnac). The latter is shown in an upright position
to facilitate direct comparison with that of Pech-Merle (after photos).

For example, animals marked with signs in the form of arrows
should logically predominate, but they are in fact relatively rare and
confined to particular caves, while being completely absent from
others. More seriously, excavations at the entrances of decorated caves
or in shelters or caverns associated with them revealed that, contrary
to expectation, the animals hunted and consumed did not closely cor-
respond to the painted or engraved bestiary. At Niaux (Ariège), for
instance, bison represent more than half of the animals portrayed.
So the expectation would be that the authors of the artwork, Magda-
lenian people of the nearby La Vache cave, were bison hunters and not

that their prey would be essentially ibex, as is actually the case.[15] This observed discordance between animals hunted and animals depicted is too consistent to be a chance outcome. This brings to mind an observation made by Claude Lévi-Strauss in a different context: "It is not sufficient that a food is good to eat; it also has to be good to think."

The proposed explanation, which was intended to be globally valid, failed to take account of a large number of elements present in caves. This was true, for example, of negative handprints called hand stencils, indeterminate human figures, or composite animals, essentially chimeras that do not exist in nature and therefore could not lead their authors to desire either multiplication or disappearance.

Nevertheless certain observations made by the champions of this hypothesis have been confirmed by discoveries made during the intervening half century and are not without interest. As will be seen in chapter 3, a double logic is notable in caves: One kind is spectacular, in chambers where ceremonies may have taken place with a variable number of participants or spectators (Chamber of the Bulls at Lascaux, Black Salon at Niaux). The other has an isolated character, where only one or two people could have access simultaneously and where visibility of the artwork is limited (Camarin at Portel, fig. 15; Chamber of the Felines at Lascaux). In the latter context, it is evidently the action of engraving or painting that is important, rather than the effect produced.

Sympathetic magic rests upon a fundamental idea that is found in all traditional societies and is hence part of the modes of thought that are universal to the human species. This is the belief that it is possible—through prayers, offerings, or in this case ceremonies—to exert a direct influence on the supernatural forces that govern our daily existence. The methods employed differ, naturally, from one culture to another, just as the beliefs differ. But, given the importance that is attached to images, the suggestion that art could be one of these privileged methods is entirely credible.

During the second half of the twentieth century, notably from the 1960s onward, attempts were made to provide an explanation from a *structuralist perspective*. Max Raphaël served as a pioneer in

this respect,[16] and he was particularly followed by Annette Laming-Emperaire and André Leroi-Gourhan,[17] who elaborated his structuralist approach and made it more widely known. Taking a variety of forms, such attempts continue to the present day. The basic principle was to reject any comparison with traditional societies, each one of which was regarded as irreducibly original, and to return to the caves themselves and their contents to investigate their organizational structures. Cave art became the object of classification, according to the animal species and the categories of signs represented. The goal was to identify them precisely, to enumerate them, and to study their spatial distribution, according to three major elements: the other depictions (for example, the distributions of horses and bison, or different types of signs in relation to one another); the topography of the cave (entrance, background, passages, side chambers, central panels, etc.); the morphology of the cave walls (fissures perceived as female, panels, reliefs). For the first time, research required statistics, indispensable in view of the sheer number of parameters and the proliferation of possibilities and combinations.

Considerable progress was made. It was realized that animals and signs were not distributed randomly. For instance, bovines (bison, aurochs) and horses appeared close to one another in proportions that excluded randomness, and they were preferentially located in a central position. Such constancy must surely reflect certain guiding ideas. Leroi-Gourhan, like Laming-Emperaire at the outset, inferred from this that the Paleolithic system of thought had a binary structure. They logically saw in this a pattern of sexual symbolism in which animals and signs had a male or female value, at once opposed and complementary. This system must have persisted for between twenty and twenty-five millennia, given the recognizable similarities from one cave to another throughout this extensive time span. It materialized a particular conception of the world. It was accordingly necessary to consider "the totality of Paleolithic art as the expression of natural and supernatural organizational concepts of the living world (which necessarily formed a single entity in Paleolithic thought)."[18]

But why did Paleolithic people penetrate deep into uninhabited

caves to portray their myths, which persisted essentially unchanged, at least with respect to their structure? This primordial question, which the adepts of hunting magic assiduously attempted to answer, received no response within the framework of structuralist theory.

Among other things, structuralist concepts were criticized because of the excessive subjectivity involved in determining associations. (Can two images located several yards apart, for example, at Niaux, be regarded as associated and complementary?) Questionable postulates were also challenged: If animals had a general symbolic value, how can we explain the fact that they were portrayed in full detail, permitting recognition of age, sex, or behavior? We will return to this major problem in due course. If bison represented a female principle, why were so many male bison depicted? In numerous caves, the galleries did not accord well with the proposed subdivisions, which were nevertheless included in statistics. Finally, and above all, recent discoveries (particularly that of Chauvet) failed to confirm the proposed schemes.

The methods on which the structuralist approach are based was [failed] nevertheless adopted by most researchers,[19] who continue to count bison, horses, and other categories, as well as taking account of the cave itself, when studying the art.

The hypothesis according to which Paleolithic people had a *shamanic type of religion*, and created their art within the framework of those beliefs, was proposed at the beginning of the 1950s by Mircea Eliade, a historian of religion.[20] It was then revived, without any great success, by various researchers during the second half of the twentieth century.[21] But eventually it was considerably developed and reinforced by numerous studies published by David Lewis-Williams over the course of almost a quarter century.[22] Since 1995, often in association with Lewis-Williams,[23] I have endeavored to reconcile this hypothesis with the realities of the subterranean world and its exploitation by Paleolithic people.[24]

Shamanism, documented from every continent and predominantly linked to hunting economies, is based on a belief system according to which, with certain individuals—particularly shamans but

sometimes others—the spirit can leave the body to travel between worlds and to gain direct access to the supernatural forces that govern life processes in our own world. The different worlds are habitually organized hierarchically or superimposed.[25] The netherworld can differ considerably from one population to another. It has a particular geography, presenting its own inherent dangers, inhabitants, and obstacles. Everything has to be learned. The world beyond may exist in the sky (the Tucanos of Colombia), in water (the Nuu-chah-nulth of Victoria Island in Canada), or inside rock and in the subterranean world (numerous examples in the Americas). In the netherworld, or in its distinct levels, the shaman will encounter spirits, often with an animal form, with which he or she will converse and negotiate. The shaman may seek to restore a stolen soul to its owner, foretell the future, or sometimes battle with other, "evil" shamans, endeavoring to resolve problems of everyday life and to reestablish a disrupted harmony. The functions of a shaman include healing the sick, summoning up beneficial rain, and seeking permission and favor for the hunt.

The process works in both directions, because visits by entities from the netherworld, generally described as auxiliary spirits, can be received in order to benefit from their help. An auxiliary spirit often takes the form of an animal, and the shaman serving as the recipient is literally transformed. Shamans are hence mediators for all aspects of existence between the world of everyday life and that inhabited by one or more spirits.

Accordingly, visions constitute one of the major aspects of shamanism. They may be evoked in multiple ways and not just with hallucinogenic substances, as many wrongly believe. Prolonged fasting, fatigue, lack of sleep, fever and illness, repeated monotonous sounds (drums, hand-clapping), frenzied dancing, and intense concentration can all induce trances, as can so-called sensory deprivation, that is to say the absence or drastic reduction of external stimuli. For example, individuals seeking visions may trek into a desert or to some particularly isolated place and remain there for a very long time until the apparition occurs. Certain sites where they have already had this experience, or the images that are found there, can subsequently serve

as catalysts, inducing a trance much more rapidly. There are "inducers and revivers of dreams," which are sometimes images that are "quite simple (cross, stars, spheres, patches of color)."[26]

The content of visions, which is very variable, depends on three principal factors: the personality and life of the person perceiving them; the cultural context, which can determine the hallucination when the trance is the outcome of a long apprenticeship, as is the case with shamanic societies; and finally neurophysiological constants. Among the latter one can include certain recurrent phenomena such as levitation and the sensation of flying, the permanence of entoptic signs, the frequency of composite entities, half-human and half-animal, or even the perception of a tunnel or a whirlwind that transports the soul into a different worlds.

The stance adopted by Lewis-Williams and Dowson in their pioneering article was determined first and foremost by findings from neurophysiology.[27] Ice Age people resembled us, with the same brain and nervous system. It was therefore logical to think that they must also have had visions responding to the same constants and that this could translate into the depictions that they left. Accordingly, many geometric signs, such as clouds of points, zigzags, and so forth present on the walls of caves could correspond to entoptic signs that often accompany trances.

Prudent use of the ethnographic analogy, especially with respect to practices of hunting societies, provides another major support for the shamanic hypothesis. For example, throughout the entire world, deep caves are considered to be supernatural places—the domain of spirits, the dead, or deities—and their dangers can only be braved if there is a well-defined and exceptional intent.[28]

Criticisms and polemics, which are customary whenever a new hypothesis is formulated, were unexpectedly virulent in this case.[29] Aside from unfounded accusations and false interpretations, which are not worth reiterating here, there are four main issues at stake. The first of these is the impossibility of understanding significance because the absence of formal proof for any kind of hypothetical interpretations renders them subjective and inherently unscientific.

The second point is rejection of ethnological comparisons, which have suffered from a bad press in response to past abuses, following the alarms sounded by eminent ethnologists such as Claude Lévi-Strauss and André Leroi-Gourhan.

The third criticism concerned our conception of shamanism, which was seen as invalid because it was all-embracing and attributed a disproportionate role to trance. In this context, I cite just one example of a criticism and its refutation. Roberte Hamayon[30] reproached us for envisaging shamanism only through trance (something which we in fact carefully avoided doing). This, it was stated, is "like analyzing marriage exclusively with regard to its biological function of reproduction."[31] As it happens, the comparison is an excellent one, because it singles out an aspect of shamanism that is, strictly speaking, fundamental. Shamanism is certainly not limited to trance, but the latter does play a leading role. In the same way, marriage is not restricted to sexual function, but the latter provides the basis for an institution that would not exist in its absence.

The fourth criticism concerns Paleolithic art itself. The hypotheses formulated are seen as contradictory or inadequate: Diversity of the art and its perpetuation for so many millennia are seen as incompatible with a theory that is perceived as too all-encompassing. Any art that persisted for more than twenty thousand years and presents so many diverse facets cannot possibly fit within a single framework of interpretation. The explanations provided are necessarily limited because they cannot account for the precise meaning of graphic representations, and they apply to too few specific images (for instance, composite beings). Last, certain characteristics of cave art, for example, portable art objects or art exposed to daylight in shelters or on rocks, lie outside the proposed scheme.

All of these points deserve attention. Responses were made at the time, and they will be revisited in light of the research, discoveries, and experiences that followed in the wake of our publications and constitute the framework of this book.

Despite the differences between them, the interpretations and hypotheses that have just been presented reside, by force of circum-

stances, on identical foundations, employed in diverse ways at different times. These foundations are constituted by analyses of the art itself, of the traces and vestiges at our disposal, the universality of certain forms of human behavior that nobody can deny, and ethnological comparisons rendered possible by that universality. They will now be examined in succession.

Studying Art: Choice of Methods and Choice of Perspective

Paleolithic parietal art (wall art) is commonly—but improperly—called "cave art," because in fact more paintings and engravings were doubtless produced in shelters and outdoors than in the depths of caverns. Investigations of this spectacular and mysterious art began at the very beginning of the twentieth century, essentially conducted by abbé Henri Breuil or under his influence. Breuil meticulously recorded the artworks, sometimes working freehand (as at Altamira), but predominantly by tracing on transparent paper directly applied to the wall (as in the Trois-Frères cave). Techniques have since progressed, and nowadays recording is conducted by working as closely as possible to the decorated surfaces without making contact with them and using tracings superimposed on photographs enlarged as desired. But such recordings continue to provide the basis for study in Europe.

This is not always the case in other parts of the world. In many countries and in vast regions such as the Sahara, studies are based on counting and producing inventories of images using sketches, descriptive record sheets, and photographs. The choice of such methods is explained by the challenging conditions in the areas concerned, the immense distances involved, and the prodigious number of sites. The extensive research involved yields huge quantities of information but does not match the precision permitted by individual tracings.

As has often been remarked, a tracing is in fact not just a simple facsimile of an image. It is a form of research entailing fine analysis, and as such it is irreplaceable. An investigator tracing an image reproduces the motions of the artist. Doing so permits recognition of the

order in which the images were created, their superimpositions, the techniques employed, the problems posed by using an uneven surface, and the way in which they were resolved. In so far as the conditions allow, the investigator also discovers and observes traces of all kinds left on the rock surface at the time when the images were created and over the course of the millennia that have since elapsed. Tracings provide the indispensable basis for detailed analysis.

While the tracing is being made, choices must be made, and it is necessary to interpret what is seen. How far, for example, should fissures and slight irregularities (microrelief), or perhaps even fine calcite deposits, be reproduced? The "hand" of the tracer also plays a role that is far from negligible. Spotting a tracing on a worktable, anyone in a research team will instantly recognize something produced by Gilles, easily distinguishing it from one done by Marc or Valérie, and vice versa. Subjectivity is surely involved, even if we make a special effort to reduce its influence by adopting shared methods. Tracings manifestly depend on an implicit theory regarding what is important, indeed even indispensable, and what is not.

Even when research is based increasingly on advanced methods of photographic recording and three-dimensional scanning—as is already beginning to happen—this will not eliminate subjectivity in the choice of criteria to apply at the moment of recording, and even less so at the stage of detailed analysis.

The process of analysis that takes place after the image has been recorded, that is to say its scientific exploitation, is decidedly more delicate. How should the raw results be studied in order to detect significant constants? What should be described, and what ignored? Which parameters should be selected and compared? The history of our discipline is very enlightening in this respect, clearly revealing how presuppositions, indeed hypothetical interpretations, have biased descriptions and even the database assembled. Let us consider a few examples.

For abbé Breuil and his successors, for whom cave art was motivated by magical practices, very little was said, beyond admiring comments regarding the precision of the wall images, about the details of

animal representation concerning sex, age, individual postures, or the scenes containing them. Because the purpose of each image, according to accepted theory, was to exert a specific action on a prey animal or its predators, sex or age was scarcely important, as was their depiction as immobile or actively moving. Each image was the result of an individual magic transaction, and their progressive accumulation generated the palimpsest that now confronts us, in which the images are unrelated to one another.

By contrast, André Leroi-Gourhan—far from neglecting the study of behavior[32]—in his courses at the Collège de France repeatedly addressed what he called "animation." This interest in the positioning of the animals depicted is a sign of considerable and decisive progress relative to previous research. With his customary clear-sightedness, he raised the question of its significance. As a result, he asked himself whether the details of animation might convey the real meaning of the assemblages of images. He asked whether they might ultimately constitute true symbolic ideograms, or whether, conversely, they might be "nothing more than picturesque variations and not pictograms bearing significance."[33] He favored the second interpretation because of the often marginal character of animated subjects, as he saw it, and their frequent coincidence with exploitation of natural surface forms to portray movement. According to Leroi-Gourhan, animation was therefore no more than "narrative license resting on a foundation of essential representations."[34] He particularly emphasized this conclusion: "It is evident that the subject (bison, deer, etc.) massively dominates any action (fleeing, attacking, falling, etc.) because most of the depictions encountered are completely immobile. . . . That may indicate that, in assemblages of parietal images, the association of subjects constituted the pertinent framework of the mythogram and that the imagery of action intervened only incidentally."[35] "Animation occupied second place."[36] This was understandable from Leroi-Gourhan's viewpoint, which was that of a binary symbolic system, in which animals possessed either a male value (horse, deer) or a female value (bison), such that the species was the dominant criterion.

His successors closely followed his approach and method, though

without adopting his sexual interpretation of the art. Denis Vialou, in the footsteps of Leroi-Gourhan, opined that "the Magdalenians primarily or principally aimed to depict an animal as such . . . and hence its thematic role within parietal systems,"[37] reinforcing or reducing the impact of the theme by varying the number of individuals. Studying the caves of Ariège from a structuralist perspective, he focused his analysis essentially on "thematic connections" and problems of composition in order to establish the "symbolic system." However, he did not go beyond identifying species (bison, ibex, etc.). Although he does characterize the animals and their positioning in his descriptions, which are actually precise and meticulous, he takes no account of this in his analyses and hence a fortiori in his enumerations.

Leroi-Gourhan was the first to set up a data bank, using perforated cards, and to apply simple statistical methods. Ever since, other research workers have followed suit. The tools have become much more efficient, but quantification of the animals is always conducted using the same criteria, that is to say according to species. This is not without certain formal contradictions, for example, when distinct categories are used for stags and does but not for bulls and cows or for stallions and mares.

Georges Sauvet and André Wlodarczyk continued and extended the structuralist methods introduced by Leroi-Gourhan and established a substantial data bank. From this they derived statistics and conclusions concerning the persistence of themes and rules in Upper Paleolithic art in its entirety and the existence of a kind of "grammar" for the images. They achieved this through impressive analyses and graphical presentations (factor analysis, algorithms, cluster analysis, etc.). In a recent study,[38] they distinguished fourteen types (twelve specific animals including the stag, the doe, and the reindeer, but not the giant elk; one human; one diverse or rare). The impression given, and doubtless that which was intended, is one of total objectivity, achieved through enumeration, statistics, diagrams, and tables. Yet it is already evident that, rightly or wrongly, drastic a priori choices have been made. It will be seen later on, in light of ethnographic experiences, that sex, positioning, age, and indications of seasons can

have considerable importance in the characterization of images and in the meaning attributed to them. All of these notions are excluded from current statistics, which, for convenience, favor certain themes (the species) and exclude others.

Moreover, Sauvet and Wlodarczyk, in order (as they state) to "facilitate comparisons" between image panels, employ a peculiar method,[39] while recognizing that it "entails considerable loss of information," which they refer to as "thematic reduction." In any given panel, "a group of ten complete images of bison will be treated as a single bison equivalent to one small finely engraved bison head."[40] Yet this deliberately and arbitrarily chosen method influences the results, eliminating the quantitative aspect of the representations and the thematic changes that they may reveal, which is at the very least strange for a purportedly objective statistical method.

By the same token, one might ask oneself whether the criterion of size, which is never taken into account in the statistics, is involved in the significance of the images. With respect to Lascaux, but also for other decorated caves, Norbert Aujoulat[41] raised the problem of visibility of the images: At Lascaux, is it legitimate to give equal weight to those spectacular huge bulls and tiny representations of horses tucked away in a corner? It is doubtful whether the images possessed the same value for those who created them or for those who saw them.

These few examples at once reveal the pretension of claiming impeccable "scientific" objectivity, even when based upon modern statistical methods, and the complexity of the problems that are concealed beneath the apparent simplicity of elementary descriptions.

In fact, a further parameter is involved, namely, that of the localization of images in a cave. In this case, too, Leroi-Gourhan was a forerunner and a guiding light because he distinguished, in addition to the central panels "images at the cave entrance, those preceding each great composition, those occupying the periphery of compositions, those marking the end of each chamber or segment of the cave, and those at the rear."[42] He believed that one could find a consistent structure in the composition of a sanctuary, the product of a unique conception whose constituent elements, as we have seen, were the

relationships among animals/themes, with symbolic signs and their subterranean spatial distribution. In fact, an "ideal" sanctuary does not exist. Each cave is by nature different from every other, such that more often than not it is difficult to apply precise and objective distinctions that can provide the basis for statistical study in this domain.

Nevertheless, the problem exists and certain examples yield some illumination and raise further questions. The Great Sorcerer of Les Trois-Frères, which abbé Breuil called the Horned God, is located in a dominant position on the cave wall, several meters higher than hundreds of other engravings in the Sanctuary. Its preeminent position contrasts with that of the "Sorcerer" of Gabillou, which is just as extraordinary but very different. It is also a half-human, half-animal composite, but relegated to the far end of the long, narrow, and low-slung decorated passageway that constitutes the Gabillou cave. In the Chauvet cave, the two most complex and spectacularly decorated assemblages are the Recess of Horses and the Great Panel in the End Chamber. In both cases, the decorated panels are situated on either side of a central niche. Does the modest image of a horse in the center of the Great Panel have a greater symbolic value than that of the large rhinoceroses to the left or the bison-hunting lions on the right? Any response to this question is necessarily subjective and must start out from presuppositions.

In these cases, as in many others, enumeration of species is evidently far removed from the realities at stake. Different methods of study are needed for any interpretation.

Which Hypotheses for Which Meanings?

Archaeology is not a "hard" science in the sense understood for mathematics or physics. We can neither replicate an experiment under identical conditions nor demonstrate a theorem. As far as "proof" is concerned, which is often mentioned and often demanded of us, it never exists above a relatively low level of understanding. In fact, whether they are aware of this or not, archaeologists must content themselves

with more-or-less plausible hypotheses to explain the majority of the facts at their disposal.

To take a concrete example: If excavation of a Magdalenian habitat reveals the presence of a large fire, analysis of wood charcoal (anthracology) will permit identification of the fuel (Scots pine, for instance). With suitable equipment the temperature reached (say 932°F) can be determined. Radiocarbon dates providing a chronological age might be obtained from charcoal or bones. Study of pieces of flint strewn across the ground will reveal their geological origin and might indicate any spatial transfer, the method and stages of their processing (operational sequence), the nature of the resulting object, and sometimes even its mode of use (study of microwear indicating slicing of meat or scraping of skins). Paleontological specialists can attribute fragmented and burned bone to a given animal species, such as bison, reindeer, horse, or ibex. Such facts, which are far from negligible, can be firmly established. They are "evidence."

On the other hand, experiments and ethnological comparisons will permit formulation of more-or-less plausible hypotheses regarding the function of most of those objects. For instance, did a finished Magdalenian harpoon really serve to impale aquatic prey, as is presumed, or was it a hook to suspend objects, or perhaps even a symbol of power and prestige? Although the first hypothesis—rather than the others—is sufficiently plausible to gain immediate general approval, this does not at all mean that it is ipso facto transformed into proof in a rigorous scientific sense.

In the same way, keeping to the illustration presented, if the fauna identified at the site is constituted 80 percent by reindeer and 20 percent by bison, this will be interpreted to mean that the Magdalenians consumed more of one than of the other. It will not be seen as evidence that they burned the bones as a tribute to their gods and ate something else entirely or even that they were vegetarians. The first hypothesis, which is unprovable because nobody saw them eating and no testimony exists, is empirically perceived—without doubt rightly so—as far more plausible than the second. So it is adopted by all as self-evident without any discussion. This assessment is im-

plicitly based on our understanding of human nature and its needs, as well as on countless ethnological examples. So what we have is not a proof but the best-fit hypothesis, the one that best takes account of perceived reality in the context of acquired knowledge.

The conditions for a best-fit hypothesis in the human sciences, to which archaeology belongs, were established long ago by philosophers of science.[43] It must meet five major requirements that can be briefly summarized as follows:

- it must explain a larger number of facts than other hypotheses;
- it must explain a greater diversity of facts, which is not the same thing;
- it must not contradict firmly established facts;
- its foundations must be verifiable and refutable;
- finally, it must have a potential for prediction, although this does not mean that it must necessarily predict specific discoveries, but that any discoveries that are made will provide reinforcement.

There is another notion that is important in the implementation of a hypothesis. It entails something that has been called the method of the rope and its strands.[44] It is based on two closely connected observations. However robust it may be, a rope with a single strand will be less resilient than a rope consisting of several interwoven strands. Each one, regardless of its inherent qualities, reinforces the cohesion and robustness of the whole, which greatly exceeds the simple addition of each strand. In the same way, different lines of research recruited in the development of a hypothesis provide reciprocal reinforcement. The corollary is that, to test the robustness of the rope, that is to say a hypothesis, it is not sufficient to tackle an isolated strand. Instead, it must be put to the test as a whole, above all by proposing an alternative hypothesis that turns out to be more reliable by better meeting the conditions listed above. If that is the case, this will ipso facto become the best possible hypothesis[45] and its predecessor will be eliminated. It is in this way that the main elements of Paleolithic art will

be associated with ethnological observations and with the universal nature of certain human phenomena.

The Human Species, Art, and Spirituality

We know that humanity is a single entity and that races do not exist. All of us can interbreed, and our brains, nervous system, and basic needs are identical, even if adaptation to different environments has led to divergence in pigmentation or certain physical characteristics according to location. Besides, the modern human beings that we all are, conventionally called *Homo sapiens*, universally possess common ancestors, probably on a particular continent (Africa), where they became distinct from preceding hominids at least two hundred thousand years ago, before spreading across the entire planet. It is this reality and the associated evidence that permit us to extrapolate certain familiar forms of human behavior back into a past that is far less well known.

Are art and the spirituality that underlies its appearance essential features of humanity? If that is the case, we should find traces of them in the very distant past. That is where the difficulties begin. Was there a long period of evolution culminating in the artistic explosion of the Upper Paleolithic in Europe, or was that triggered by some event or process?

To keep things clear, an initial problem is to define the concepts of spirituality and art. Rather than compiling the countless attempts that have been made to do this, it seems preferable to take their lowest common denominator. Spirituality can be regarded as the awakening of a thought that goes beyond the circumstances of everyday life, the mere adjustment to material necessities demanded by foraging, reproduction, and survival. Humans begin to pose questions about the world around them, and that is the essential point. They will often seek a reality other than that perceived by their senses, to which — like the animals from which they are descended — they have always responded instinctively. Here, we are not very far removed from art.

Another stage is reached with religion. Strictly speaking, this is

the organization, or an organization, of spirituality. The world, interpreted and transcended through the human spirit, now possesses a precise sense, often revealed by a prophet or god. This leads on to codes of conduct to avoid provoking catastrophes, to facilitate everyday life and social relationships, to procure the aid of mysterious powers or to help them conserve the indispensable harmony of the world, always threatened, never guaranteed, sometimes disrupted and therefore in need of restoration. Under these circumstances, human beings are conscious of taking action to influence their fate. This is different from confronting material dangers of the environment, but not very different because the aims—that is to say all of the problems connected with survival—remain the same.

Seen from this perspective, spirituality and religion are closely connected, because the emergence of consciousness that detaches itself, even to the slightest degree, from material contingencies and attempts, however rudimentarily, to organize its new contributions cannot remain separate for very long. However, even if there is no religion without spirituality, spirituality can evidently do without organized religion.

As far as art is concerned, its definition is just as challenging.[46] Art, too, can be founded on detachment from the real world. Multiple forms and modes of application can doubtless occur, but the foundation will remain the same, namely *projection onto the world surrounding humans of a strong mental image that colors reality before taking shape and transfiguring or recreating it.*[47] In this sense, art is incontestably an indicator of spirituality. As André Leroi-Gourhan wrote, "if perception of the extraordinary by Paleolithic people is an essential stage, symbolic representation is the decisive sign of attainment of abstract values."[48]

What were the elements that triggered spirituality? Although there is an abundant literature dealing with this subject, the uncertainties persist. It seems difficult to contest the notion that developing and perfecting the brain played a leading role. Wherever the threshold is placed for the first faltering steps of spirituality, it is also certain that, for millions of years, the beings that preceded this crucial evo-

lutionary transition were adapted to their environments and hence survived, were able to have relatively sophisticated social organization (like certain primates), invented and perfected tools, experienced emotions, and that they were on the path toward humanity. The criteria used to define humankind have progressed considerably over the course of fifty years. Instead of *Homo faber*, which is now of historical interest only, and *Homo sapiens*, a label that is really too optimistic, I would propose the substitution of *Homo spiritualis*, the being for whom the world reveals itself to be more complex than it seems and who attempts to understand and to adapt as well as possible to this novel complexity by calling upon nonmaterial forces.[49]

It would be difficult to avoid thinking that two particular phenomena would have played a decisive role in this awareness.

The first of these is death.[50] Faced with the disappearance of somebody close to us, we often feel disbelief, particularly when death is brutal: He or she was there, with his or her uniquely distinctive personality and he or she has "left us." To go where? In order to leave, there has to be an "elsewhere." Even if animals such as chimpanzees or elephants display strong emotions following the death of one of their fellows, humans go far beyond that by rationalizing the phenomenon.

As far as dreams[51] are concerned, mammals other than humans are capable of dreaming, as is evident to anyone who owns a cat or a dog. Human beings, on the other hand, have the unique capacity to recall their dreams and to refer to them because they possess language. It seems logical that this would have spawned the idea that there is an "other" world through which a person travels while asleep and encounters individuals who have departed but are very much alive.

These two realities of life, seemingly simple, have several consequences. The first is recognition of the spirit as an entity distinct from the body, as it does not move around during dreams and can freeze and disappear forever at the time of death. This awareness, in the proper sense of the term, lies right at the root of spirituality. The second consequence follows from the survival instinct and is hence particularly powerful. It is the attempt to take advantage of this other world, to profit from its existence and from its particularities. The third con-

sequence is linked to the previous one: given that this universe, to which one gains access through dreams, exists with rules and characteristics that are so different from those of the customary world, will it not influence, or even determine, everyday events? These ideas themselves have a cascade of consequences which are inextricably bound up together. They stem directly from awareness of death and dreams and could well lie at the source of spirituality and religions.

Where and How Did Art Emerge?

The question that presents itself here for archaeology is not so much that of chronology (What is the date of this threshold?), but more one of the means available to ascertain the consequences of crossing it for a human perspective on the universe. From this viewpoint, the emergence of art is crucial.

Mastery of fire by *Homo erectus* may have exerted a considerable influence on the development of exchange among humans and on their sociability,[52] but in itself it is just an additional instrument, albeit one of major importance. As for the natural curios that very ancient humans brought back to their living area, such as the Acheulian rock crystals of Singi Talat in India mentioned by Leroi-Gourhan (see above), they are now seen to be less important. There are numerous examples of animals displaying a similar kind of curiosity, apparently devoid of any utilitarian function. For the same reasons, harmony and symmetry in the form of certain hand axes, which appear to our eyes to be works of art, cannot be accepted as decisive evidence of artistic creation and the existence of spirituality and of art or proto-art, or at least they do not in themselves suffice to establish that. After all, what should we then say about the complexity and beauty of the nests built by certain birds?

There is no indication of the existence of art for the most ancient humans such as *Homo habilis*. An unworked pebble that, for us, is vaguely reminiscent of a human head when it is turned the right way, was found at Makapansgat in South Africa in a level assigned a date of three million years. It should be placed with the other natural curios

already mentioned, whose unusual color or form may have attracted attention, thus leading to their collection.

By contrast, with *Homo erectus* in the broad sense (particularly *Homo heidelbergensis* in Europe), accompanied by the major Acheulian culture, multiple lines of evidence can be seen that are mutually reinforcing as discoveries accumulate. One of the earliest known instances is the use of iron ores (notably hematite and limonite) as coloring agents. Examples have been found in Africa, in India, and in Europe, sometimes in contexts dating back several hundred thousand years.[53] Of course, we do not know the uses to which these coloring agents were put: For body decoration and various rites as is the case in so many cultures around the world? The fact that their coloring property is evident does not constitute proof that they were used to materialize symbols or to express spirituality. Lines engraved on bones discovered in Acheulian contexts have also attracted attention. As usual, controversies have raged regarding their intentional or fortuitous nature. However, it is possible that certain engraved sequences, for example, at Bilzingsleben (Germany), were made deliberately.[54]

The strangest object discovered is a small stone of volcanic origin brought to light in an Acheulian layer at Berekhat Ram in Israel, dated at 250,000 to 280,000 years ago. It was purported to be a figurine or "proto-figurine" representing a woman. But this object is not sufficiently persuasive in its own right for this interpretation to be accepted unreservedly. In fact, it should never be forgotten that, if we automatically project our own mental images onto the material reality that surrounds us and interpret it accordingly, what we see and the process of interpretation are the result of prior development and education of which we are no longer aware. We cannot conclude from this that archaic humans saw things in the same way. Nevertheless, detailed examination[55] did show that this stone had been slightly reworked. Another Acheulian "proto-figurine," discovered at Tan-Tan in southern Morocco,[56] is not particularly convincing.

Cupules, small hollows made in rock surfaces, have also been reported from Bhimbetka (Madhya Pradesh) in central India, underlying an Acheulian level. In many more recent contexts, cupules have

generally been considered to be part of rock art, although this opinion deserves discussion and refinement, as we will see with ethnological examples. Because they are particularly durable, cupules are conserved better than any other form of art, and this leads to the logical conclusion that they represent just the tip of the iceberg and are the only symbolic expression that has survived until the present day, whereas all the others (paintings, engravings) have disappeared.[57]

It is therefore likely that, starting from the Acheulian, the humans that preceded *Homo sapiens* (or rather *Homo spiritualis*) had already crossed a certain threshold. If we cannot affirm that art really existed, at least according to the definition proposed above, the conditions are present to detect an elementary form of symbolic thought and a certain detachment from a purely material reality.

That is confirmed by the thirty-two skeletons of *Homo heidelbergensis*, dated at 400,000 to 460,000 years ago, discovered at the single site of Sima de los Huesos at Atapuerca, close to Burgos (Spain), at the bottom of a natural shaft. The accumulation itself might be (and has been) interpreted as a collective burial. In addition, however, the discovery of a spectacular hand axe in pink quartzite rose, of exceptional quality and entirely unused, could represent a funerary offering and hence provide evidence of belief in a world beyond.

The use of coloring agents is widespread, also including our cousins the Neanderthals. They are known from several dozen Mousterian sites, such as that at Pech-de l'Azé II in the Dordogne region of France. It is likely that their use was not uniquely restricted to material tasks such as tanning of skins. Bones engraved with regular lines have also been reported, for example, from La Ferrassie, from Montgaudier (Charente) and Arcy-sur-Cure (Yonne) in France, but also from Bacho Kiro in Bulgaria. It must be noted that these intentional engravings are not naturalistic. It is quite possible that they had a symbolic function. It is debatable whether this is art in the strict sense of the term.

As is usually the case, specialists argue about the details, which are admittedly important, but nevertheless subscribe to a fair number of shared concepts that are not so widely mentioned. There are two main schools of thought that can be characterized as follows: One

aims to "rehabilitate" the Neanderthals to the extent that, without any influence from modern humans and sometimes before them, they invented everything themselves (art, jewelry, burials, grave goods). The other school reckons that the relatively tardy "inventions" of the Neanderthals in fact resulted from influences, perhaps even a certain degree of acculturation, exerted by the Cro-Magnons, as European modern humans are familiarly known. That would seem to be quite logical because it was only after these two forms of humanity became contemporaries in western Europe that the appearance of most of these novelties became evident. They were not noticeable during the tens of thousand years prior to that, before the Neanderthals experienced the arrival of their strange and inconvenient neighbors. Recent investigations, however, seem to indicate that some groups of Neanderthals made use of perforated shells (jewelry) before modern humans arrived in Europe.[58] Whatever the case may be, this is not of capital importance, because the prevalent fact is that everyone agrees about the mental capacities of the Neanderthals, which were certainly distinct from those of modern humans but surely included spirituality. Accordingly, one could call them *Homo spiritualis neanderthalensis*. As far as art is concerned, if they possessed it, it was certainly quite different from that of our direct ancestors. Thus far, at least, no form of representative art has been attributable to Neanderthals.

One of the most widely cited examples is the grave of a three-year-old child discovered at La Ferrassie (Dordogne), surmounted by a block of limestone with a score of small cupules on its lower surface. In this case, evidence of complex thought is substantiated at three levels: the wish to preserve the body of the deceased through burial, the installation of a worked block of stone, and the nature of the work itself, given that the cupules were organized in four or five small clusters and probably had symbolic significance. That is sufficient to establish the spiritual conditions of these people, but should the cupules be considered to be works of art? To take another example: In Indre-et-Loire at La Roche-Cotard, in a Mousterian level with Acheulian tradition, a block of flint was discovered in which a long bone splinter was found wedged into two interconnecting natural holes. Inappropri-

ately called a "mask," which it could not have been, this object, which does somewhat resemble a face given a little imagination, is reminiscent of the natural curios already cited.[59] Without being able to assert that it is a naturalistic representation, it is nevertheless more than a simple freak of nature because it seems that it was quickly refashioned and the splinter was deliberately inserted into the hole.

With modern humans, originally called *Homo sapiens sapiens* and then just *Homo sapiens*—although *Homo spiritualis artifex* might be more appropriate—the problem is posed in quite a different way. In fact, it is no longer a question of wondering about the possible existence of spirituality and art, which is accepted by all, but of studying it and establishing its nature, modalities, chronology, and evolution.

The most ancient symbolic object attributable to modern humans (so far) was discovered in Blombos cave, on the Southern Cape coastline of South Africa. It is a modified, polished block of hematite bearing a complex engraved lattice composed of three parallel lines and a series of crossing lines,[60] found in a layer dated at 70,000 to 80,000 BP. Recently, also in South Africa, a large number of ostrich eggshells have been discovered, used as containers and engraved with geometric patterns (bands of incisions), dating back sixty thousand years.[61] There is no doubt that discoveries will increase in the future on various continents that were inhabited by modern humans, primarily Africa but also Asia and Australia, well before their arrival in Europe.

After modern humans reached Europe, at least fifty millennia ago, concrete evidence of spiritual and magico-religious activities became abundant, including both wall art and portable art objects. And such evidence persists in comparable form for some twenty-five thousand years. However, one problem that has yet to be resolved is the absence of certified wall art during the very first millennia during which modern humans became established in Europe. Is this a gap that will be closed with new discoveries, or does it reflect selective use of deep caves that began only after some delay, while any art that may have existed out in the open was not preserved?

Among the themes used in art in its diverse forms, either on walls or as portable objects, human-animal depictions deserve spe-

cial mention. Such representation of composite beings persisted from the Aurignacian ivory statuettes of Hohlenstein-Stadel (mammoth) and Hohle Fels (humans with lion heads) in Germany,[62] or the man-bison of Chauvet cave (fig. 28), doubtless also Aurignacian, right up to the middle Magdalenian parietal depictions ("sorcerers" of Les Trois-Frères). At intermediate ages, probably mainly Solutrean, they extended through the man with a bird's head and wings at Pech-Merle to the seal-headed man of Cosquer, the bird-headed man in the Shaft at Lascaux, and the "sorcerer" of Gabillou (fig. 1).

Now it is known that belief in the existence of composite beings — that is to say gods, spirits, or heroes — simultaneously possessing human and animal characteristics is common to many religions, in numerous cultures, in all ages, and on every continent. One only needs to think of various divinities in Egypt, such as the woman with a lion's head (Sekhmet) or men with the head of a jackal (Anubis), a ram (Amon-Ra), or a crocodile (Sobek). Other examples are the monkey-headed Hanuman of India or the devil and angels of Christian religion. Such ubiquitous beliefs, whatever infinitely variable culturally dependent specific forms and concrete details they may have, bear witness to certain universal characteristics of the human spirit. We will return to this later.

Contributions and Risks of Ethnological Comparison

This naturally leads on to ethnological comparisons, which will be expounded in the next chapter with extant examples.

Such comparisons were called into play as soon as the first discoveries were made. It was tempting to merge the "savages" of distant lands with "primitive" people in prehistory, but this was based on representations that were uniformly false despite their apparent relevance. Australian Aborigines, Native American tribes, or South African Bushmen, just like Magdalenians or Solutreans, are all modern humans, which implies affinities in behavior, beliefs, and modes of thought for groups at the same economic and social stage, that of hunting and gathering. Moreover, these contemporary traditional

cultures also practiced rock art, so it was acceptable to make refer-
ence to them.

This approach led to excesses and errors during the first half of the
twentieth century. For example, in the famous treatise that crowned
his works, abbé Henri Breuil[63] placed side by side a photograph of a
"black sorcerer of French Guinea clad from head to toe in a costume
made of interwoven fibers"[64] and a photograph of a set of engrav-
ings from Lascaux[65] in order to interpret the latter: "It probably rep-
resents a Paleolithic sorcerer wearing a costume made of grass." But
human beliefs and concepts are so variable that this kind of superfi-
cial ethnographic analogy, which depends on a convergence of form,
is inevitably doomed to failure. The salutary rejoinder of André Leroi-
Gourhan—himself a distinguished ethnologist—to this type of abuse
put an end to it in the 1960s.[66]

However, Leroi-Gourhan took things very far, too far, by aggres-
sively rejecting any recruitment of ethnological comparisons, while at
the same time employing them—without explicit acknowledgment—
in his analyses of prehistoric art, as Catherine Perlès has shown. In
discussing the rejection that he championed, she cited an anecdote
that she herself describes as revealing: "During a seminar in 1970 or
1972, he rebuffed my hypothesis that bones were used as fuel in re-
gions where trees were rare, claiming that bone does not burn. When
I pointed out that Thucydides had described in detail how the Scythi-
ans used the bones of animals they had just slaughtered to cook their
meat, he replied: 'That means nothing, it is just ethnographic com-
parison!'"[67] In this connection, during the excavations that I con-
ducted with Robert Bégouën in the Enlène cave in Ariège, we found
indisputable evidence of Magdalenians using bones as fuel.

Following Leroi-Gourhan, however, comparisons between rela-
tively recent or contemporary cultures and the Paleolithic finds gen-
erally suffered from a bad press, often without the slightest justifica-
tion, as if this were self-evident by virtue of the principle of authority:
"Leroi-Gourhan said it, therefore . . ."[68] In fact, things are not that
simple. One must be clearly aware of what one is comparing and the
manner in which it is done. It is clearly inappropriate to superimpose

the behavior of Eskimos or Aboriginals on that of Magdalenians or Aurignacians and to project a modern reality onto the past, as is the case with the example cited in the book by abbé Breuil. On the other hand, reasoning can very well be based on the behavior of analogous societies without resorting to a one-on-one comparison.[69]

This type of ethnological comparison differs from simple analogy in the sense that it indicates possible similarities in concepts and social and mental structures, or perhaps the frequent recurrence of forms of behavior and dispositions in certain contexts. Far from seeking a "so-called primitive mentality," the attempt is made to detect convergences in ways of thinking or conceiving of particular aspects of reality, and to proceed accordingly.

Leroi-Gourhan himself, although he forbade it, did not act any differently. For example, in addressing the subject of human-animal associations, after remarking that "modern iconographic principles cannot account for the organizational system of cave images," encourages the reader to "turn instead toward religious art of the Middle Ages" and the ways in which Christian themes are represented and associated in a church or cathedral. He concludes: "One would perhaps find oneself very close to Magdalenian thought and inclined to accept what is preserved of its flexibility in the works created."[70] This is surely an ethnological comparison at the level of certain modes of thought.

"Universals" can provide us with possible keys to the interpretation of Paleolithic facts, as Michel Lorblanchet quite rightly wrote in 1989: "The search for universals in artistic creations throughout the world and the eventual recognition of different groups or types is one of the fascinating orientations of research into rock art, which of course implies the development of a new comparative approach . . . Extant traditional societies will not provide ready-made answers, but they can teach the prehistorian of art to think more appropriately and to achieve a better orientation of his 'internal analysis.'"[71] What I have aimed to report in this book is the contribution of the experiences that I have had that have nourished my reflection and my analysis.

This approach is more logical than that consisting of "letting the facts speak for themselves," which they clearly will never do, or to in-

terpret them in a "literal" or "objective" fashion. In this case, as we
have seen, interpretation is necessarily the fruit of concepts or hy-
potheses, be they formulated or not, that prevail in the society or en-
vironment, scientific or not, in which we live.

Here are three examples (and many others will follow in the next
chapter): Throughout the world (except in our own culture as a rela-
tively recent development), the subterranean realm is regarded as
"otherworldly," a place inhabited by gods, spirits, or the dead (think
of the Styx of the ancient Greeks), a place endowed with power and
supernatural dangers.[72] Another universal phenomenon: the power
attributed to images, the foundation of sympathetic magic, which is
based on the idea that the image and reality are closely connected and
that reality can be directly influenced through an image.[73] That ex-
plains all kinds of magic rites, for example, in voodoo, as well as the
instinctive reticence of many people to allow themselves to be photo-
graphed by strangers. Here, too, there are countless ethnological ex-
amples in all kinds of cultures.

All human beings are familiar with nighttime dreams, and some
experience "waking dreams,"[74] that is to say hallucinations or visions.
Visions can be extremely precise and detailed, affecting various senses.
They disrupt order in the world, with certain repetitions or constant
features: the presence of geometric (entoptic) signs, the sensation
of a whirlwind or a tunnel, that of flying or instantaneous transport
from one place to another, encounters with animals that speak or with
transformed beings, and so forth. In many human populations, most
especially in shamanic societies, these visions are recruited and ex-
ploited by the group, in contrast to our contemporary Western society
where they are frowned upon and considered as residing in the prov-
ince of psychiatry.

Accordingly, without fear of error, we can propose that the modes
of thought of the Magdalenians and other Paleolithic peoples were
closer to those of traditional cultures, and particularly to those of
hunter-gatherers living on other continents, than they are to Western
materialists living in a complex industrial society at the beginning of
the twenty-first century.

Two

Encountering Multiple Realities
on Other Continents

Throughout the entire world, at all times and for all kinds of reasons, people have engraved and painted rocks. Wall art is found on all five continents, in the bush or in deserts, on mountain flanks, on cliffs alongside major waterways or at the bottom of canyons in the wilderness. Despite convergent features resulting from the use of identical techniques, each assemblage of paintings or engravings proves to be profoundly original. With just a glance at a photograph, a specialist is able to distinguish the paintings of the Kimberley from those of Utah or Patagonia, even when the subjects represented (men and women, for example) are similar.

Nothing is more exciting or more rewarding than to travel through one of these regions for the first time. Although I have had the privilege of traveling at every latitude, I never tire of doing so, and I am keenly aware of the countless cultural treasures that I have not yet seen. I would, for instance, like to return to Australia, that inexhaustible continent, to immerse myself once again in the Kimberley and Arnhem Land and to discover the engravings, numbering in their tens of thousands, in the Pilbara. In China, I have only seen, far too briefly, a small part of the Helan Mountains in Inner Mongolia. But I know that there are thousands of sites in this region, like that of Hua Shan, with paintings up to 130 feet high on the flank of a gigantic cliff.[1] Only

through articles, conversations, and books[2] do I know about the extraordinary caves buried deep in the jungles of Kalimantan on Borneo, with their strange hand stencils decorated with geometric patterns. In Africa, I have visited a fair number of sites in Niger, Kenya, Morocco, Namibia, and South Africa, but it is still far from enough. I would very much like to discover the marvelous engravings of the Acacus Mountains, of Wadi Mathendous and of Mesak Settafet in Libya, the paintings of the Tassili n'Ajjer and Hoggar mountains in Algeria, the rock art of Mauritania, Mali, Chad, and the Matobo Hills in Zimbabwe, and the decorated shelters of Lesotho, Tanzania, Zambia, and Botswana. As far as South America is concerned, I am familiar only with certain decorated rock shelters in Argentina, Bolivia, and Brazil. I need to return to visit Peru to see Toro Muerto, where there are thousands of outdoor engravings, and the geoglyphs of Nazca, those immense motifs on the bare ground, so impressive in scale and proportions that some misinformed authors have foolishly interpreted them as the work of aliens from outer space. Human ingenuity and artistic sensibility have no limits, whatever the period or place, and there is no need at all to seek the origin of the Nazca geoglyphs in distant worlds!

In the introduction I said that, whenever possible during my travels, I sought engagement with people that I encountered, colleagues who guided me at sites that they knew better than anyone else, or members of traditional populations—American Indians, Australian Aboriginals, or Siberian shamans. Even though I have learned from all of these interactions, and never cease to do so, it goes without saying that these multiple experiences have nothing to do with genuine ethnological research, which takes years spent within a particular group, studying in depth their ways of life, their beliefs, and their social organization. I really want to emphasize this point: My modest experiences, which are predominantly impressionistic and personal, simply opened up new horizons and allowed me to appreciate, in a concrete fashion and not just through books, certain ways of perceiving the world, sometimes very different from our own. They allowed me to go further in my investigations and my perception of Paleolithic

art, illuminating and invigorating the academic accounts that provide the customary framework of the research enterprise.

In this chapter, I will recount some of my principal encounters, just as I experienced them, in the belief that they are likely to interest the reader. It is thanks to them that I was able to get closer to the Magdalenians and Aurignacians.[3] Research is not conducted uniquely through lectures and learned references. Sensitivity to personal experiences also intervenes to play a part, whether it be through impressions or in the ideas and hypotheses that we devise and develop. To take account of this and, where necessary, to bring these processes to light, is surely more "scientific" than claiming absolute objectivity, which is always a futile undertaking.

The Americas

I have had the opportunity to meet with Indians of various tribes in North America—Cheyenne, Hopi, Navajo, Nez Percé, Ute, Yakoma, Zuni, Huron—and to engage them in conversation. But this is generally limited to a relatively superficial level. It takes a long time to establish confidence, and I was just passing through. Nonetheless, I have had several memorable and rewarding experiences.

In 1991, David Whitley, a specialist in Californian rock art, spent several days taking me to visit sites. We became friends and continue to meet up from time to time, either in the field or at conferences. That year, he took me to Rocky Hill in central California. Our small group was met by a Yokut Indian, Hector, who was to serve as our guide. He was the spiritual guardian of the site, following in the footsteps of his father and grandfather. This man in the prime of life, sturdy and well built, was accompanied by his young son. He received us rather coldly, explaining that he was guiding the tour because he had been asked to do so, but was short of time. A ceremony was due to take place in his village at four o'clock in the afternoon, and he was obliged to be there. He told us that we were strangers to the spirits that haunted the area and that those residing in the rocks where we stood were powerful and

dangerous. If we went to see the decorated shelters immediately, misfortune could befall us: we might fall from a rock and break a limb, or perhaps be bitten by a rattlesnake. To avoid that happening, the spirits had to get to know us. So a ceremony was indispensable.

Our guide took us a little further, near to a rock face decorated with quite ancient red images. There, he delivered a sermon on the harm that white men had inflicted on the Indians, the Native Americans. This took quite a while. We listened in respectful silence. At that point he began to intone a sacred chant while his son produced a musical accompaniment by shaking instruments resembling maracas. He then asked us to make an offering to the spirits. From a leather pouch that he carried on his belt, he took pinches of local tobacco and gave them to us. Afterward, we went one by one to place strands of tobacco in the fissures of the rock face, beneath the painted images. Accomplishing this ancient gesture in my turn, I was deeply affected. This reminded me of the caves in the Pyrenees, where Magdalaniens had placed bone splinters in natural crevices, perhaps also in order to contact the powers hidden behind the rock or to appease them. I had studied this behavior and written articles about it, and here I was not just seeing it but actually replicating it!

We then set off to visit the site. In front of a rock wall covered in cupules, Hector cursed. Two or three beer cans had been discarded there. "People do not respect anything any more! This place is sacred. It is here that puberty ceremonies for young girls are performed," he exclaimed in his anger. Almost everywhere in the world, cupules are used as a feminine symbol. Here we were confronted, explicitly, with yet another example.

In front of a small cavity, between two enormous stone blocks, I noticed some vertical red bars and I asked Hector about their meaning. "That indicates that this place is accessible to those who have been initiated to the second level." It then struck me that, without this direct explanation, it would have been absolutely impossible to guess the purpose of these marks. This is the case for all rock art that has become fossilized, given that those who created and used them disappeared a very long time ago.

We spent hours examining one decorated rock face after another. I suddenly realized that it was after four o'clock and, remembering his initial admonition, I pointed this out to Hector. He shrugged his shoulders and replied that he had time and that the ceremony could wait. Confidence had been established. David questioned him about the significance of the paintings. One of them represented what seemed to me to be a somewhat stylized human being holding an oval object in one hand. I thought that it might be a shaman with his drum. "It's a bear," said Hector. Surprised, I responded: "Really? I would have thought that it was a man."—"It's the same thing." He said nothing more. Afterward, David explained to me that, during hallucinatory visions sought out in isolated places, it often happens that a spirit in animal form—called a spirit-helper—appears to the person who has prepared for the vision through fasting and meditation. In a way, that person becomes the spirit. Our guide's response was perfectly consistent with a logical framework that we needed to understand, reflecting a conception of the world that is very different from our own.

Near the end of our visit to Rocky Hill, after I had shown my keen interest and my profound respect for this art and for the beliefs of those who had created it, Hector explained to me that the inclined stone slab on which I was sitting, just beneath a low vault decorated with images, was the place where sick people would be made to lie during healing ceremonies. We were alone in this small cave. In order to attract to me the good will of the occult powers that permeated it, he began to chant beneath the rock paintings. I had the shivers. It was a magical moment, in every sense of the term.

Later on, on June 1, 1999, I happened to be in the extreme northwest of the United States, in the state of Washington, not far from Canada. My colleague and friend Jim Keyser had invited David Whitley and me, along with another colleague specializing in preservation, Jannie Loubser, to visit a large island on the Columbia River, where he wanted to show us a program for study and monitoring of conditions required for preservation of the rock art. A Yakoma Indian, Gregg, accompanied us. He said very little and only—very briefly— when spoken to.

Figure 2. On this rock on Miller Island (state of Washington),
many natural red spots can be seen, with superimposition
of a red figure, intended to counter their evil power.

The art was dispersed in small panels, primarily with red and white
paintings and a few engravings. One of the decorated sites showed a
red-painted motif about eight inches high, depicting a kind of hoop
(a head?), open at its lower end and bristling with short parallel lines
on its outer perimeter. The interior was painted in white (fig. 2). This
depiction was superimposed on a cloud of red dots. At first, I thought
that these red marks had been made with a finger, before realizing
that there were many of them all over the area concerned and that the
effect was due to natural oxidation of the rock face.

 Gregg was close to me. I showed him what had interested me and
said to him, thinking aloud, that I was wondering whether the motif

had been painted in connection with these small red spots, which could not fail to attract attention. "Yes, undoubtedly," he said, "these red spots must have reminded them of measles or smallpox."

Initially taken aback, I then recalled the recent history of this stretch of the Columbia River, whose tribes were decimated in the eighteenth century by epidemics of contagious diseases introduced by white men. As a rule, these diseases, spread by peddlers or travelers who had been in contact with the invaders in more-or-less distant regions, preceded their arrival there. The Indians did not understand what was happening to them. The spirits were angry with them. Their customary religious practices were ineffective. Part of the original rock art in that locality was then transformed and new motifs were created, with the aim of appeasement, to combat these new evil influences. In this context, Gregg's remark was completely understandable. The memory of these events and of their consequences had endured among the tribes to the present day, thanks to the persistence of oral traditions. A moment like this, when a casual comment explains a piece of rock art and allows us to penetrate to the very heart of beliefs that we thought had disappeared forever, is a rare privilege and an instant of pure joy. Abruptly, we understand what happened. What more could an investigator ask for?

That same day, Gregg provided us with another item of information of the same kind, again in an unexpected fashion. We were alongside a very small decorated panel, located several feet up on the flank of a large basaltic boulder. By climbing up one side, we had reached the panel, which included a half dozen engraved and painted images of bighorn sheep. Right in front of the representations and a bit below them, a ledge a couple of feet wide allowed me to lie down to take some photographs, although not without difficulty. While I was doing this, Jim and David were chatting. Jim commented: "They must have reclined there in their quest for visions." Gregg spontaneously intervened: "No, no. They did not lie down. They remained sitting while they chanted. They could stay there for several days—up to seven—without eating, waiting for the vision to appear." We looked at each other, amazed by this confirmation and by the unsolicited details.

"But were they facing the rock during that entire time?"—"No, they kept looking east, toward the rising sun and Mount Hood [the highest mountain in the region, at 7,706 feet, with a snow-capped summit]."— "Do you think that a single individual made these images of bighorn sheep, or were several people involved?"—"Oh, just one of course. It was not possible to leave a vision unfinished. It had to be materialized on the rock." At this point, we all had the same thought, because we had just attended an international congress at Ripon in Wisconsin, where one of our colleagues had publicly launched a violent assault on this kind of interpretation, claiming that there was no reliable ethnological account concerning them, that rock art had become fossilized everywhere, and that it was impossible to say anything about its meaning(s) without succumbing to lunacy. What a stinging and surprising rebuttal less than a week later!

My third memorable encounter with an American Indian took place in Zuni, northern Arizona. Our small party, led by David Whitley, traveled to Canyon de Chelly. Somebody had recommended that we should visit the church in Zuni if we were in the neighborhood, and we had time to do so. It was a small Catholic church of adobe construction, in the Mexican style. It had been reconstructed just a short while previously. Inside, two men were working on some murals from scaffolding. One of them came to meet us; the other briefly glanced at us and then continued with his work. The one who came to speak to us explained that he and his brother were completing an undertaking started several years previously by members of their family. Their grandfather had reconstructed the derelict church and their father had begun to decorate it with traditional paintings. They were continuing his work to bring it to a proper conclusion.

The murals on which they were working took up the two walls along the length of the church. They occupied the area between six and twelve feet high, above panels showing utterly ordinary classical portrayals of the Stations of the Cross, just like those seen in countless European churches. By contrast, the multicolored paintings above them were quite remarkable, not only in the quality of their accomplishment but also with respect to the subjects depicted. These veri-

table artworks—detailed, lively, and eloquent—portrayed charac-
ters in Zuni mythology. On the right, the two men in the lead wore
the same lavish and complex ceremonial garments. The headdress of
the first was crowned with two bison horns, whereas the second had
only one horn. I asked what the reason for this was, if we were able
to know. Seeing that we were actively interested, our interpreter was
more than happy to oblige, and we spent more than two hours asking
him questions and listening to his explanations. The first character,
the one with two horns, knew the entire history of the tribe and was
able to recite it, word for word, with the requisite inflections. Nothing
should be changed. The performance lasted six and a half hours. The
second character was his substitute, who would be able to replace him
in case of mishap. He also knew the sacred history, whose loss could
not be put at risk; yet, because he was not the incumbent storyteller,
he was only allowed to have a single horn. This is how oral traditions
are perpetuated.

In this connection, he drew our attention to another figure, that of
a smaller man, whose features and clothing were less distinct and less
detailed than for the others. This was the Echo Man. Nobody knew
any longer exactly what his role and functions were, because he died
prematurely in a car accident before he was able to train his successor.
This was a great loss for the tribe. They tried to track down informa-
tion about him at the Universities of New Mexico (Albuquerque) and
California (Los Angeles), hoping that ethnologists might have noted
the details of his role at some time in the past, thus permitting them
to recover a character in their mythology.

We asked him how the traditional beliefs of the Zuni could be
combined with Catholicism. "There is no problem with coexistence.
My brother and I are also good Christians. The important thing is to
believe in the supernatural world and to lead harmonious lives. Every-
thing else is just details that are in no way contradictory." This good-
natured syncretism both touched and amused me, even more so when
he revealed to us that the last figure that they aimed to paint, above
the chancel, would be that of Christ wearing a necklace with tur-
quoise beads, the precious stone common to all American Indians in

the Southwest. The work of art is doubtless finished by now. I hope to return one day to Zuni to see Christ with his Indian necklace and to ask whether the Echo Man has been rediscovered.

Also under David's guidance, I spent a few days in the region of Chalfont in California. Our first impression was that the rock engravings were not distributed haphazardly but were confined to really large boulders. This was confirmed the next day when we visited a very remote site, after spending more than half an hour following a wildly meandering narrow path in the middle of a desert with scattered thorny plants and cactuses. In fact, the area was spectacular, with shambles of crumbling cliffs and large numbers of scattered large blocks on the slopes. This explained why it had been chosen for depictions and ceremonies. However, the rock—a kind of volcanic tuff with an extremely corroded and granular texture—was not at all suitable for engravings. As a result, the figures were difficult to see and rudimentary in appearance. The spectacular appearance of the area and the resonance that it inspired in visitors had evidently won out over technical considerations for creating the artwork and over their final manifestation. It was the choice of the site and the gesture that were important, not the quality of the rock and the outcome.

Years later, I encountered another example of this in Utah. Accompanied by one of my colleagues from Moab, Craig Barney, I had set out to see some engravings in one of the canyons close to that small city. We found ourselves at a superb site, at the foot of impressive cliffs, with magnificent smooth rock faces that were ideally suited for engraving. But the engravings were located not in the favorable places where we would have expected to find them, but on panels that, at first sight, seemed to be less suitable and unpromising. I mentioned this to Barney, citing the example of European caves where the same phenomenon is noticeable. Was it possible that the rock itself had rejected the images? Laughing, he told me that I had hit the nail on the head. For many years, he had spent time with the Hopi and knew them well enough to discuss these problems with them. It was indeed the case that the rock face must accept being engraved or painted. That called for lengthy meditation and communion with the rock before

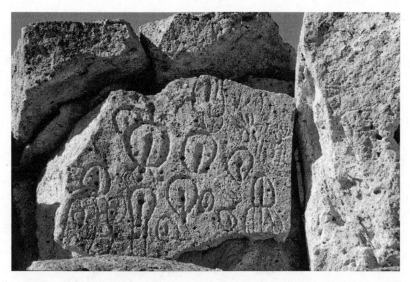

Figure 3. Panel with engraved vulvas at Chalfont (California).

it could be known whether it accepted or refused. When Barney expressed surprise about this in conversation with a Hopi acquaintance, the sharp retort was "Would you paint your mother's face if she did not want you to?"

But let us return to Chalfont, where engraved vulvas were particularly frequent (fig. 3). David thought that sorcery practices were involved as female genitalia were reputedly regarded as malevolent by certain tribes. I imagined Paiute Indians in this locality, a few centuries previously, arriving there, in front of the sacred cliffs, seeking visions after fasting for several days. In the solitude of the desert, beneath the sun, they concentrated while intoning traditional chants. Eventually, they succeeded in receiving an image, or several images, of the supernatural powers that they had come to request. When their own spirits returned and reunited with their bodies, they materialized the visions on the rock so as not to forget them, to preserve and use their power, just like many other tribes right up to the Northwest region close to the Pacific coast. At the foot of those cliffs, I felt that they were quite close, despite the time that had elapsed.

At the beginning of the month of June in 2008, following on from lectures in Colorado, I went to visit a site with rock art that had re-

Figure 4. Female bighorn sheep that, according to the medicine man
who accompanied us, was the spirit of the site that welcomed us and allowed
a photograph to be taken during a visit to a decorated site in Utah.

cently been discovered by Quentin and Pamela Baker not far from
Moab, in Utah. We were accompanied by another colleague special-
izing in rock art, Carol Patterson, and by a Ute Indian, Clifford, an
elderly and venerated medicine man, with whom Carol had been
working for some considerable time and who had confidence in her.
It was very hot, and access to the site was steep. Breathless after the
long climb, we sat down to recover. I then saw, just a hundred feet
away, an animal that, at first sight, reminded me of an ibex. It was an
adult female bighorn sheep. She gazed at us placidly without moving
(fig. 4). I cautiously reached for my camera and began to take photo-
graphs, after wordlessly signaling my intent to my companions so that
they would not frighten the animal. After a while, she slowly moved
away across the long rocky expanse, stopping from time to time to
look at us again. I was delighted by that unexpected encounter in this
remote area. At this point, Clifford began to chant, or rather intone,
a wordless Indian air. Afterward, he took a pouch of native tobacco

from his pocket and threw pinches to the four points of the compass, reminding me of my first adventure in California. We then set off to visit the site with its large red-painted human figures.

Our visit concluded, we returned to Moab. In the car, Clifford abruptly began to chant the same tune, this time accompanying it with a small drum. Nobody uttered the slightest question. We were staying with Quent and Pam. That evening, after dinner, Quent posed a deliberately neutral question to Clifford: "Cliff, what did you think of the site?" The response was at first matter of fact, but then became less so: "Oh, it is a very good site." Then, using words that I recorded exactly immediately afterward, he added: "But you know, that animal, it was not an animal, it was the spirit of the site, come to welcome us. She accepted us. That is why a song came to me, a song with no words. She also came to me in the car, so I had to sing. That is why I made an offering of tobacco." He also added during the conversation, without anyone asking him, that this would be "a very good vision-questing site."

This spontaneous testimony from a venerated elder provides illumination for a number of aspects. The quest for visions remains very much alive as a practice, often connected to sites with rock art, as we know from many ancient or recent accounts. Above all, identification of an animal present as the spirit of the site illustrates the difference in attitude between our own materialist culture and a traditional one in which every event is a sign and where there is no boundary between the natural domain and that of the powers and creatures that we would call supernatural.

〰
〰

In most countries of Latin America, the ancient traditions have disappeared. However, there are thousands of decorated sites in shelters, on rock faces, and, far more rarely, in deep caves.[4] I have been able to view some of those sites, learning new things with every visit. I will provide a few examples.

Among the regions and sites that I had wanted to get to know for some time, those of Baja California in Mexico occupied a special place.

I was finally able to visit them, on four different occasions, and I spent several weeks in the Sierra de San Francisco at Baja California Sur, where most of the large decorated shelters are located in canyons that can be reached only by riding on muleback for hours. At Pintada, a huge shelter decorated with hundreds of paintings, I noticed certain similarities to the art of Paleolithic caves in France and Spain. Superimpositions of figures, which were frequent, showed how the initial images had rendered the rock wall sacred. The successors of the first artists had not erased them. They added their own creations, benefiting from the power bestowed on these initial images and reinforcing them with their own contributions. Another similarity to the art in European caves: repeated exploitation of natural contours. In some cases, bulges in the rock wall served to materialize the swollen bellies of pregnant women, in others the contours of the rock permitted portrayal of the heads and limbs of animals.

I have noticed the same phenomenon elsewhere, for instance, at Boca de San Julio, on the left wall of a canyon adjacent to that of Pintada. There were little more than a dozen animal images, but they were very big (about eight feet across) and well conserved. In the center a large left-facing stag, with a black belly and a red back, had limbs that had been drawn in extended form to follow the rock contours. Just above the stag and to his right, the convexity of the rock wall had allowed plastic depiction of the rear end of another deer painted in red. In this same shelter, one ten-foot line with ten red spots, accompanied by another with black spots and a horizontal sequence of white dashes, transected by a long slash, was similarly reminiscent of geometric signs from the Paleolithic. By contrast, a man killing a condor with a white arrow, another man, and some birds (undoubtedly vultures) were themes not found in Europe but peculiar to Baja California. At Brinco, a doe's eye was represented by a stone in the rock face.

Despite differences in the treatment of subjects from one shelter to another, this art shows great uniformity throughout the region, just like cave art in Europe. Like the latter, it is a response to identical preoccupations and portrays themes that are common to the human groups that produced them.

The shelter at San Gregorio was of the utmost importance. Its front surface, decorated in a very spectacular manner with very tall humans and animal figures, was visible from the opposite slope of the valley. One morning at sunrise, I went to stand directly in front of the shelter and patiently waited for the sun's rays to reach it and light it up, not without thinking that perhaps many others had done the same thing before me. The arched ceiling was packed with figures including, among others, a big white snake and various birds. This shelter displayed the double logic typical of Paleolithic caves: the monumental aspect of the front face contrasting with the ceiling covered with a tangle of much smaller figures that could be clearly seen only by lying on one's back in a very specific place. Art at this site was made to be seen, but part of it was seemingly created for its own sake.

In 1997, together with two colleagues and friends, George Chaloupka (Australia) and Antonio Beltrán (Spain), and invited by André Prous, professor at the university at Belo Horizonte in Brazil, we went to see some spectacular decorated shelters in the valley of Peruaçu in the north of the state of Minas Gerais. (At the time, this site was under consideration for inclusion on the World Heritage List by UNESCO.) It turned out to be a well-organized adventure. The state governor loaned us his plane and his pilot. Nestled in the luxury of this official aircraft, we flew over immense Brazilian expanses and the muddy torrents of the great Saô Francisco River before landing on a makeshift airstrip, where four-wheel-drive vehicles were awaiting us. After a night spent in the only hotel in a small isolated town, we set out for the jungle. Having driven several miles on tracks, we had to leave the vehicles behind and continue on foot. Two local guides led the way. In view of his advanced age, our friend Antonio was entitled to a horse for part of the journey. It was the first time in his life that he had been on horseback. When we arrived at a large pond, our guides made us skirt around it because a twenty-five-foot anaconda lived there and it was advisable not to approach. That day and on following days, we visited several very large painted shelters. The multicolored motifs (red, black, yellow) were predominantly geometric patterns showing considerable diversity. Images of humans and animals (snakes, etc.)

were present but uncommon. In some cases the paintings covered a substantial part of the cliff, up to a height of thirty feet, which meant that some form of assisted access would have been needed.

Apart from the predominance of "signs" over naturalistic figures, I was struck by two thoughts. All of the paintings were on illuminated surfaces or, at worst, in half-light. This was confirmed at Ballet, a decorated site thirty miles from Belo Horizonte, where paintings ceased as soon as the dark zone was reached. Clearly they had to be created in illuminated areas, and this bore witness to a mistrust or taboo with respect to deep caves. It occurred to me that it was exactly the opposite in the Chauvet cave (Ardèche), where paintings began in the dark zone, whereas they were completely lacking in the first big chamber, located in half-light.

Before arriving at a large shelter, we passed through dense jungle, with our two guides opening up a narrow passage with machetes. Eventually, they stopped and warned us that a puma had taken up residence at one end of the shelter. If he were there, we would not be able to see the paintings nearby, and we would have to make do with looking at those located at the other end. I was scarcely convinced by this and asked whether we would not risk being attacked anyway. I was reassured with the comment that the puma is a territorial animal and only attacks if a certain virtual boundary is crossed. I waited for our guides to examine the traces to determine whether the puma was present or not. In fact, they began to sniff the air all around and jointly decided that the animal was not there and that we could approach without fear. In our own civilization, we have somewhat forgotten to use our sense of smell as a source of information and of defense. I said to myself that those who made use of the Chauvet cave thirty-five thousand years ago surely did not behave any differently from our guides in order to be sure that one or two cave bears were not lurking in the depths.

In Argentina, the Cueva de las Manos at the very extremity of Patagonia, not far from the renowned glacier of Perito Moreno, is a very special place, famous for its eight hundred hand stencils, which earned it inclusion in the World Heritage List in 1999. According to re-

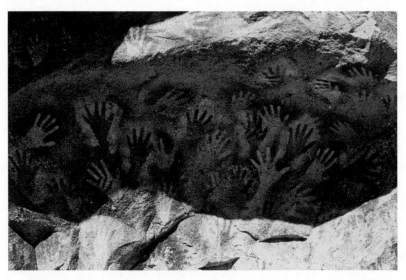

Figure 5. Hand stencils in the Cueva de las Manos in Patagonia (Argentina).

search conducted by our Argentinean colleagues, especially the late, lamented Carlos Gradín and his team, the most ancient stencils date back more than nine thousand years, and the site was used for several millennia (fig. 5).

It is obvious why this site was chosen as a place for worship and ceremonies. The cave entrance is located exactly in the center of a rock massif on the aptly named Rio Pinturas, right at the foot of a cliff that is some two hundred feet high. It overshadows an embankment of about the same height. The cavern is about eighty feet deep, with a wide entrance measuring fifty meters across and thirty feet high. It is a clearly visible feature of the landscape. With its impressive and spectacular immediate surroundings, this dark, gaping shadow in the middle of the cliff could not fail to evoke the notion that it was a door opening into another world, a sacred place marked by the powers that govern life.

The major problem with the accumulation of those hand stencils is the deep meaning of their creation. Placing one's hand on a rock face and surrounding it with pigment can have various motivations. It is sometimes a gesture of no importance, an elementary affirmation of the individual, a little like graffiti ("I was here"). We will see

evidence of this kind of activity in Australia. On the other hand, in a context of magico-religious art, as at La Cueva de las Manos, the likelihood of such behavior is virtually zero. There, the hand stencils are associated with other complex representations—animals, humans, and signs—at a site chosen because it is an open cave right in the middle of a gigantic cliff.

The most plausible interpretation is clearly the desire to take advantage of a place imbued with power in the course of ceremonies about which we will never know anything. The hand and the paint that covered it established a bond between occult powers and the man, woman, or child who performed the gesture. Particular circumstances such as illness may have called for this rite.

This hypothesis does not explain everything; far from it. Why use the same technique to represent feet of the rhea, a large flightless bird native to Patagonia? Did the different colors have their own part to play? Were they associated with individuals of different sex or status? What was the relationship between the hands and the other motifs often associated with them? A great deal of work—analysis, reflection, and interpretation—remains to be done. Perhaps comparisons with other neighboring sites will contribute to a solution.

We returned to the locality for a last look at the Cueva, this time from the other side of the canyon, where we overlooked the valley at the edge of a vertiginous sheer cliff. In front of us, the surrounding rocky massif was lit by the sun, and the black shadow of the cave entrance contrasted starkly with the brightness of the illuminated rock walls. We descended into the canyon down an extremely steep slope, over a surface of fallen rocks, thanks to a wide opening between two sections of the cliff, a kind of monstrous door opening onto the site just in front of the cave. How could one fail to daydream and imagine that access to the sacred cavern was granted by this impressive passage?

Australia

In 1992, while attending a congress on rock art at Cairns in northeast-ern Australia, I took part in an excursion through the region of Laura (Cape York Peninsula), organized by one of our colleagues, Percy Tre-zise, then sixty-seven or sixty-eight years old, together with his sons. They had set up a sort of agency specializing in this kind of safari in the heart of the Australian bush. I knew Percy by name and reputa-tion because he had discovered and described most of the rock art sites in the Laura region. Through good fortune, I had the occasion to talk with him at length and to become better acquainted with this ex-traordinary individual. For years, he had been a bush-pilot, landing wherever needed in response to an emergency. He carried out many medical evacuations and saved many lives, often at the risk of his own. The Aborigines were duly grateful. He forged friendships with some of them and was even adopted and initiated into a tribe.

From his plane, Percy had spotted countless shelters in the red cliffs scattered through the bush. In some cases, he believed that he had noticed paintings. Over the years, he returned with his local guides. He spent months systematically exploring the bush, discover-ing one decorated site after another. When he retired, he purchased huge tracts of this wild and barren bushland and constructed a base camp, subsequently spending several months a year there during the dry season. He called this base Jowalbinna Bush Camp, taking the Ab-original name of a tall red cliff nearby.

With Percy's guidance, our group saw many decorated shelters in the few days at our disposal. Every time, Percy announced his pres-ence, calling: "Hoo, Hoo! Anybody there?" When I asked him why, he replied that he did this as a gesture of politeness toward the spirits that haunted the site. "Do you really believe, Percy, that there are spirits present?"—"Of course not, old man, not at all, but it can't do any harm." Prudence and wisdom from an old hand in the bush, but also a traditional attitude dating back thousands of years! He told us that one day, before entering a shelter with particularly formidable powers, his Aboriginal mentor, who was sweating profusely, thrust his

hands under his armpits to cover them with his sweat, which he then rubbed over Percy's face and body, so that the spirits would recognize a familiar odor and would not be hostile. Luckily, we were not compelled to take such extreme precautions.

In contrast with the motifs present in the European caves, human depictions were abundant. Some of the human figures, with their heads pointing downward or others lying prone, having been bitten by snakes, portrayed scenes of bewitchment or evil. For the most part, they dated from the time of contact. The Aborigines, unable to fight on equal terms against white men armed with rifles, had resorted to magic. We know how things turned out. The most peculiar representations were those of Quinkans, a type of evil spirit, male or female, formidable for any traveler. The male Quinkan was endowed with an enormous penis that, it was said, enabled him to leap from place to place, covering several miles with a single bound (fig. 6). The persistence of traditions and stories constitutes one of the original features of aboriginal art, rendering it particularly interesting. Percy delighted in telling us about them, just as they had been communicated to him by his Aboriginal informants.

For example, in order to reach a site that they called Yam Dreaming, Percy and his son Steve made us pass through a steep upward passage. According to them, it symbolized initiation, that is to say rebirth in the spirit world. After passing through, the inductee was reborn in the world of Yams (which are edible roots). The Yams were the mythical ancestors of certain groups. On the walls, well-preserved red paintings portrayed the Yams, either in their real form or partially transformed into humans—or vice versa. The paintings also included numerous "flying foxes," huge bats thus named because of their distinctive odor. The artists had portrayed the flying foxes suspended with their heads pointing down. They were indicators of other stories.

One hundred and twenty miles to the south of the northern capital of Australia, Darwin, Kakadu National Park, which is also included in the World Heritage List, is to a large extent open to the public. I spent more than a week there in 2000, thanks to the hospitality of my colleague and friend the late George Chaloupka, who knew its archaeo-

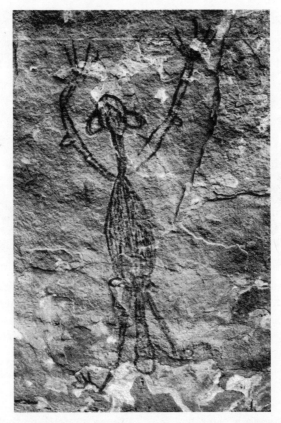

Figure 6. Male Quinkan at the site of Yam Dreaming on Cape York
Peninsula in northeastern Australia. His enormous penis allows him
to make gigantic leaps when moving around in the bush.

logical treasures better than anyone and who enabled me to visit nu-
merous decorated shelters, several of them very remote and lost in
the bush.

In stark contrast, the best-known site, Nourlangie Rock[5] is con-
tinually invaded by hordes of tourists. In spite of the crowd, I was
impressed by the expansive compositions of one of the last great Ab-
original rock artists, Nayombolmi, nicknamed Barramundi Charlie by
Europeans. In 1964, a year before his death, he came to visit this site,
whose true Aboriginal name is Burrunguy. He was saddened, regret-
tably for good reason, by the changes that he saw in his region and by
the loss of traditions among his people. With traditional pigments, he

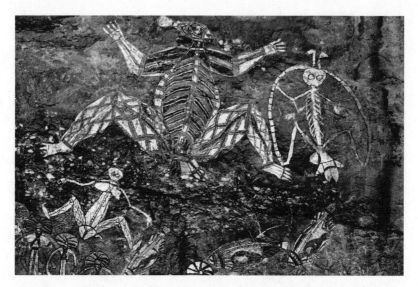

Figure 7. Among these paintings in Anbangang Shelter, at Nourlangie Rock (Kakadu
National Park, Australia), produced in 1964 by Nayombolmi, the Lightning Man
Namargon can be seen on the right. The band surrounding his body represents
lightning, while the axes protruding from his head, like those attached to his elbows
and knees, were used during the Wet (rainy season) to strike the clouds and produce
bolts of lightning. To his left is his wife Barginj (Chaloupka 1992).

immortalized those who had lived in these shelters and their power-
ful spirits, restoring them to life and eternalizing them on the rock
walls. One can see two family groups, men and women, some with
milk flowing from their breasts. One of the most notable spirits is
Namargon, the Lightning Man. A large semicircle around his body
represents lightning. Stone axes protrude from his head, his elbows,
and his knees. He used the axes during the rainy season to strike the
clouds and produce bolts of lightning (fig. 7).

Another shelter called Nanguluwur, also of great importance, is
visited far less, because a hike of a mile and a half completely exposed
to the sun is needed to get there. Algaigho, the Fire-Woman, one of
the First People who created the world, associated with Namargon,
is represented there (fig. 8). She planted yellow banksia in the woods
and used its burning flowers to carry fire. She hunted rock-haunting
possums with the aid of dingoes (wild dogs). People were afraid of her

because she could burn them and even kill them. Further to the right, another woman was lying down, and other human figures were standing. These were Nayuhyunggi, creative spirits who bestowed fundamental laws upon future generations. Some of them took human form, others changed into animals. All were endowed with special powers. They are also called Namandi. Invisible to ordinary people, they live in caves or in hollow trees, and they only emerge at night. They can lure humans into their lairs by summoning them to approach. The Namandi eat human flesh. Their toes and nipples are elongated, each hand has six fingers, and they carry with them dilly bags in which they keep the liver, lungs, heart, and kidneys of their victims.

Figure 8. The woman on the left, depicted with four arms and the antlers of a deer, is Algaigho, an associate of Namargon, painted in the Nanguluwur shelter (Kakadu National Park, Australia).

Ubirr is another oft-visited large shelter at Kakadu. The walls and vaults are covered with a multitude of paintings, often superimposed one upon another. It is understood to have been an important center for the settlement and for cultural practices. This was revealed and confirmed to me during a brief flight over this part of Arnhem Land up to the coast in a small plane. Ubirr is located very close to the Wet Lands, a swampy territory with specific resources. It was therefore a zone of contact between two worlds, and food must have been abundant at this place of transition blessed by spirits.

During the course of the same visit to Australia, in the summer of 2000, I traveled to other regions and to other sites, in the center of the country and in the Kimberley, to the northwest.

The town of Katherine, between Arnhem Land and the Kimberley, is something of a must, in one sense or another. I spent a day climbing through the gorges, and I remember seeing high up on cliffs paintings representing, among other things, an upside-down person and a big snake that appeared to be emerging from a hole in the rock, an eternal and universal myth. The snake, like the bird and the lizard, is a spiritually powerful animal because it moves between two worlds, the one in which we live and subterranean spirit worlds.

In the center of the continent, during a congress at Alice Springs, I had the opportunity to visit several sites with rock art. At the site of Emily Gap I was guided by a colleague, June. In order to get there, we had to cross a large water pocket, holding our cameras at arm's length because the (cold) water was up to our waists. On the other side of the water pocket, the rocks were painted in black and red with large vertical stripes, like coats of arms, on every available surface. One of the motifs was topped off with a stripe perpendicular to the others. June explained to me that this referred to some women who had seen the site when they were not supposed to, because it was reserved for men, most particularly for the initiation of young boys. Some time back, a century or more ago, policemen on horseback, who had arrested some Aboriginal women for some misdemeanor, real or supposed, went through this passage with their detainees. The women protested and refused to go that way, but they were forced to do so. They hid their

eyes and tried their best to see nothing. Despite these precautions, once they were freed they were executed with spear thrusts because they had infringed, albeit involuntarily, a powerful taboo. Nowadays, the taboo has been lifted, such that the site is accessible to women.

At this same site, my guide pointed out a tree whose branches were whipped about by the wind that is always blowing through this gap, scraping against some of the paintings and slowly destroying them. She had reported this to the traditional old Aboriginal caretakers of the site and had suggested that they should trim the branches to protect the images. They were horrified because for them the trees had a spiritual value at least as great as that of the paintings. For some groups, the trees represented the souls of the dead. Cutting those trees would have been a veritable crime in the eyes of the ancestors.

These few examples of relatively recent art show just how complex the meaning of the images may be and how deprived and impoverished we are when it is lost and we are confronted—as is commonly the case around the world and always for the decorated caves of Europe—with images that have become fossils. They open the way to a better understanding of ways of thinking in the populations that created or used that art and, by analogy and extension, among people that are no longer with us; but they also prompt us to be prudent in our interpretations.

In the distant Kimberley, which is reached after hundreds of miles of road followed by dirt tracks, the site of Merrele is a veritable paradise, with a small lake accompanied by a waterfall and surrounded by tall trees. On the left there is a series of Wandjinas, painted on a white background, that are seemingly very recent. Unrefined and poorly executed, they plainly lack the sophistication of traditional paintings. I asked our Aboriginal guide, Paul Chapman, an elder of the tribe, what he thought of these modern paintings, taking care to hide my disappointment. With a desolate gesture, he replied: "It's awful!" I then asked him: "Were there any ceremonies?" His reply: "No ceremonies. They were done by the youngsters." "Why?" "For money."

After returning to Darwin, I sought information about this sad business,[6] after seeing five sites disfigured in the same way during

my journey. This enterprise was officially launched and financed in 1986 under a Commonwealth Employment Grant of 110,000 Australian dollars (just over a hundred thousand US dollars). This was done with the best intentions in the world, to provide work for nine unemployed young Aborigines of both sexes, from the Wanang Ngari Association of Derby, whose then president was the renowned media darling David Mowaljarlai of the Ngariniin tribe. The idea was to induce these young people to return to their origins and renew acquaintance with their roots, given that most young Aborigines have become estranged from them. They could have created images on any of the countless rocks in the country that are devoid of ancient paintings. But no; they chose to repaint eight shelters that had been decorated long ago and in the process destroyed admirable artwork. Those who knew those shelters as they were before these subsidized acts of cultural vandalism were still very upset about what had happened. Paul Chapman, that respected Aboriginal elder, confirmed that the work was carried out with no supervision at all, entirely divorced from ancestral tradition. At the time, several people, including Lorin Bishop, owner of the station at Mount Barnett, had the courage to protest vigorously, although to do so was not politically correct. In the face of scandal, the project, which was slated to continue, was abandoned, but a great deal of damage had already been done.

This story was echoed by the newspaper *West Australian* in its edition of August 8, 1987. It was reported that "Tribal elders have been upset by the work because it broke ancient traditions. Only elderly men, who were trained as boys, are supposed to retouch the Wandjina. Women should not have been used to carry out the work, they say."

Several responsible officials wrongly came out in opposition to the indignant testimony of Lorin Bishop and other admirers of rock art, rejecting the arguments given. "However, the Director of Aboriginal sites, Mr. Mike Robinson said the report [of the Western Australian Museum] showed there was little substance to protestations of Mr. Bishop's claim. The paintings had been enhanced in the traditional manner and were not wantonly desecrated. Elders and custodians were consulted and generally approved the renovations." A

week later, the same newspaper returned to the issue and showed a photograph of Crocodile Shelter, which I would visit and photograph on the return leg of my voyage to the Kimberley. It cited David Mowaljarlai, who said: "We did not use materials at Mount Barnett . . . , but if we had used modern materials it would have been our concern." M. Colbung, a member of the Western Australia Cultural Materials Committee, said: "complaints about the so-called garish effects in restorations reflected a lack of familiarity of Aboriginal traditions." This claim stemmed from the fact that the Aborigines have always renovated the paintings and that, way back in the past, they were seemingly brighter and much more vivid than they are nowadays.

These arguments are as specious as they are unfounded. Ancient paintings were neither "enhanced" nor "renovated." These inappropriate terms were employed to ascribe de facto legitimacy to the undertaking. As I was able to see with my own eyes, and as is evident from photographs taken, the ancient images had been covered with a layer of white paint on which new figures had been drawn. The shocking thing is not that the colors of the ancient paintings had been refreshed, as stated in press reports at the time, because that had not happened. What is unacceptable is that the modern additions did not respect the originals, that they are so coarse and clumsy, that they contrast with the ancient art that they are supposed to replace to such a degree, and that they were executed outside the traditional frameworks and procedures.

As for the argument "It belongs to us, therefore we can do what we like with it," it is doubly perverse. This collective art does not belong to an individual but to a community, and one of its present leaders has expressed directly to me his deep distress regarding the damage and its causes. The art also belongs to humanity as a whole. Just imagine the worldwide outcry that would ensue if the pope had the Sistine Chapel covered with the modern daubings of subsidized unemployed youngsters in order to provide them with work and to reacquaint them with Christian practices. Why consider Aborigines any differently from other people? Does their art have less universal value than European art? If anyone were to decide once again to vandalize the art of their

ancestors, what would be the most respectful attitude to adopt toward them? Should the enterprise be encouraged and financed, as if they were irresponsible children who should be indulged at all costs, or should they instead be treated as equals and told that, by acting in that way, they would be surrendering an exceptional patrimony and that their own descendants would unfailingly hold it against them one day?

This problem is real and it is acute. Two days later, an example floored me. We were at King Edward River Crossing, at the passage across that great river, with a group of Aborigines from the Wunambal tribe. Two very elderly members of the group, Wilfred Goonack and William Bunjuk, were respected initiates covered with ritual scars. They were accompanied by the then current chief, John Kandival, a younger man in the prime of life. These proud and respectable individuals were aware of the value of their knowledge, of their art, and of our keen interest. They were accompanied by one middle-aged white woman and another, younger, who recorded our encounter on video-tape and explained to me that she was doing this as part of a project to record the narratives and customs of the Wunambal, having been engaged to do so by the tribe itself. This struck me as an excellent project. In fact, in their youth these elderly men lived like their ancestors had for tens of thousands of years. They were hunter-gatherers, like the Magdalenians. In the near future, if it has not already happened, the elders will all be gone, and these last witnesses of a way of life led by humanity for so many thousands of years will have disappeared, along with their traditions and their stories. I felt honored and privileged to have met some of them and to have listened to them for a considerable time.

The elders did indeed open themselves up to our questions for hours. They told us about their "previous" life, when they were young and lived on bush tucker: yams, water lilies, wallabies, and many other natural treasures that are at hand in Australia. To shave themselves, men coated their faces with plant gum that pulled out the hairs when it was removed. David Welsh, our Australian guide—a physician by profession—got them to answer questions about their ancestral remedies: a tea made with green ants, beneficial for the stomach;

Figure 9. Wandjinas in a shelter near King Edward River Crossing in the Kimberley (Australia). Wandjinas are linked to the rainy season.

the red gum that was applied to wounds; the hole dug in the ground to accommodate water lilies and burned bark before being covered with soil so that those who had backache could stretch out over it and obtain relief.

We later made an extended visit to a superb site, covered with heads of Wandjinas that seemed to be looking at us (fig. 9). Before we gained access, John made a small aromatic fire to present us to the resident spirits. That reminded me of our introduction to the spirits at the site of Rocky Hill in California, or Percy Trezise's remarks before entering decorated shelters.

Wilfred, the oldest member of the group, told us that the Wandjinas, in fact called Munnury, are spirits linked to rain and storms. When a Wandjina blinks its eyes, lightning is discharged. Its voice is the thunder. The white surfaces inside the head represent clouds. The black dots around the head are feathers of cockatoos in the headdress and symbolize lightning. Many mythical tales relate to Wandjinas, those characters with large round heads and outsize eyes staring at us from the rock. None of them has a mouth because, according to some, a deluge of rain would pour out, flooding the region. My friend

George Chaloupka told me that the cult of the Wandjinas is probably linked to the Wet, the season for rain, storms, and cyclones that is so dramatic in this tropical zone.

I commented that the paint of certain figures was flaking away and that it was possible to distinguish quite clearly underlying layers of more ancient repaintings. These Wandjinas had been restored numerous times, appropriately following tradition, and had nothing in common with the desolate caricatures that we had seen some days previously. Still reflecting on this, I asked Wilfred Goonack: "Do you aim to repaint them?" I expected either a negative response such as "No, they don't need it," or a positive one of the kind "Yes, they are beginning to lose their power and it will soon be necessary." Regrettably, it was neither one nor the other. To my profound dismay, Wilfred replied, and I am citing him word for word: "Sure, if we get the funding for it." Can one still speak of living tradition when sacred activities depend on funding? It is rather like asking a priest whether he will celebrate Mass on Sunday and receiving the reply "Sure, if we get the funding for it." So there is reason to fear that there will be sequels to the dark history of 1986 in one form or another.

Before leaving, I asked Wilfred about the meaning of certain images near to the Wandjinas. He identified a small duck, a water lily, and bull-roarers, whose name he refused to pronounce because women were present and it is a masculine musical instrument. He mimed the action "You know . . ." and laughed while he twirled an imaginary object.

The distinction between Man's Business and Woman's Business is in fact fundamental in Australia, as it is elsewhere. I encountered a striking example during a different journey on that continent. On that occasion, in 2006, I had traveled to the southeastern part of the country, north of Sydney.

My Australian colleagues Paul Taçon and John Clegg had organized numerous visits to decorated sites for me. Several of those visits were accompanied by local Aborigines. For example, in their company we saw several decorated shelters in or near the Blue Mountains. Once again, I was struck by the extent to which everything had mean-

ing, both in the art and in its context. For instance, a sandstone block some twenty feet high, riddled with shelters (Bora cave), was dedicated to ceremonies, while dwellings stood opposite, several hundred feet away. Because this site served for gatherings of diverse groups, the rites and their precise meanings varied. One of the powerful spirits of this region was the lyrebird, represented on rock walls at certain sites. Now, when we arrived, an Aborigine noticed the tracks of this bird on the floor of the main shelter. Everyone agreed that this was an excellent omen, as the bird "had come to welcome us." This was the same attitude on the part of the Aborigines as that of Cliff, the Ute medicine man, when he saw the female bighorn sheep near the decorated site that we were visiting. I was also told that the landscape is important: "When the trees are leaning, this is good spirit country. When they are straight it's no good." Everything makes sense.

I spent almost a week with the family of Dave Pross, a prominent member of the Darkinjung. He and his wife lead a modern existence in a small town about sixty miles from Sydney. They put me up in a caravan at the bottom of their garden. We became friends.

Every day, we went into the bush to look at rock engravings, mostly representing animals on a large scale (several feet across), especially kangaroos, on the surface of flat or mildly convex rocks at ground level and not on walls. His grandson, six or seven years old, and his daughter, a teacher, accompanied us along with a few friends.

On one occasion, Dave drew my attention to a large isolated rock that formed a kind of tiny shelter, the lower part more-or-less flat and the upper part inclined. It was called Tiddalik Shelter, after the name of a mythical frog that one day began to drink all the water in the region, from ponds and streams, until not a drop was left. The inhabitants, who were dying of thirst, begged the frog to give them back the water, but in vain. The council of elders decided that they needed to make Tiddalik laugh, hoping that this would make him regurgitate the water. The people writhed about and acted crazily, but the frog remained unmoved. They ended up calling upon the creator god Baiame. The latter responded by creating the platypus, an animal of bizarre appearance with a duck's beak and a beaver's tail. On see-

Figure 10. Baiame, represented in the shelter close to Milbrodale in southeastern
Australia that bears his name, is a creator god whose large eyes reflect the fact that
he sees everything. His seven wives are represented by white stripes across his chest,
and he has immense widespread arms because he gathers people together.
Width: eighteen feet.

ing the platypus, Tiddalik burst out laughing and spat out all of the
water. To punish him, Baiame transformed him into a rock with his
mouth open. The platypus became a sacred animal that nobody was
permitted to kill. In this case, it is the form of the rock itself, without
any decoration, that gave rise to the myth.

A large shelter, sixty feet long and fifteen to twenty feet high, near
Milbrodale, was dedicated to Baiame. The god had gone up to the sky
at Mount Yengo. The seven white stripes across his chest represented
his seven wives (fig. 10). His eyes were portrayed as enormous, because
he could see everything, and his arms immense (with a span of exactly
eighteen feet) because, as I was told, he gathered people together.

One day, Dave took me to a site (Initiation Site) near Somersby
that was threatened by construction projects. He had conducted an
evaluation for the authorities and hoped that it would be preserved.
His daughter stayed in the car because it was a place where boys

were initiated on reaching puberty and was therefore out of bounds for women. Straight lines, engraved as deeply as the contours of the large kangaroos depicted, were present on either side of their bodies or directed toward a human figure. Dave chuckled: "Some years ago, a researcher published them as spears passing through the animals' bodies! In fact, the lines indicate the path that must be followed by the supplicant during the initiation ceremony. He passes from one figure to the next and stops there for the appropriate rite before proceeding to the next stage." He also told me that the kangaroos' tails pointed toward the sacred Wonderbane Mountain. Nothing was left to chance, everything had a sense.

When we returned to his home, he showed me his report, which he had written a few months previously. Preceding the photographs provided in an appendix, there was a page carrying an admonition in large letters: "WARNING. Restricted viewing. . . . The Darkinjung Local Aboriginal Land Council advises that viewing the engravings, or images of the engravings from this site may be harmful to women." It was not a formal prohibition but more of a caution: If a woman ignored it, that was her affair; but she would bear responsibility for the evil consequences that could ensue. This conveys three bits of information: the taboo with respect to women, justified by the role of the site; the perpetuation of those beliefs up to the present day; extension of the taboo to images of the engravings (in this case photographs) rather than being restricted to the originals.

Africa

Although, in my pursuit of rock art, I have traveled to North Africa (Morocco), the Sahara (Niger), East Africa (Kenya), and South Africa (Namibia), I brought back only an assortment of anecdotes and personal experiences that have a direct relationship with this book.

Ethnological accounts are plentiful, however, and I will refer to them later. In the south, traditional rock art tragically came to a close at the end of the nineteenth century with the disappearance of Bush-

men from the Drakensberg and other sacred sites. But there is a mass of information collected in extremis by Wilhelm Bleek, to whom we owe a great debt.[7]

Here, I will make do by citing two examples:

In the course of our extensive wanderings in the Aïr Mountains and the Ténéré desert, my Tuareg friend Sidi Mohamed Iliès recounted many traditional stories to me. I gathered more than a score of them together and they were published by Éditions du Seuil under the title *Contes du désert* (Tales of the Desert).[8] Several of them are concerned with the creation of the world, such as that of the Owl, which deserves special mention.

At the beginning of the world, when the Creative Genius decided to summon a meeting of the animals to define their respective roles, he sent his wife to the Owl to pass on the message. The Owl replied that he would not attend the meeting and furthermore that he would not allow himself to be commanded by the wife. The Creative Genius was greatly annoyed by this double disrespect. As punishment, he bestowed upon the Owl the capacity to turn his head back to front, to show the world that he did not think straight. To boot, as a second punishment, he would not be able to have children. That is why, as Sidi told me solemnly, the Owl cannot lay eggs. He steals eggs from the nests of other birds, "or even snakes' eggs," and takes them back to his own nest to hatch them. In due course, little owls emerge, but they are not his sons.

This tale, which is still relevant, is reminiscent of the double curse that afflicts the Owl everywhere and forever. A nighttime bird, he rotates his head in a way that does not seem "natural." As a result, he is often associated with sorcerers or with forces of evil and hence persecuted. Could the Chauvet cave owl, whose face is represented in frontal view while the body with its wings and feathers is seen from the rear, be the first known example in the world of an interpretation of this bird as a supernatural animal?

The second example is an extract from the minutes of the Clerk's Office of the Court of Lambaréné, Republic of Gabon (sentence passed

on April 22, 1964, at Booué). A man stood accused of having killed one of his neighbors.

> Whereas it follows from the deliberations and case file for B——
> E——, on the afternoon of 13th September 1963 he went hunting;
> ... that he saw a chimpanzee approaching beneath the foliage,
> screaming and coming ever closer, B—— saw himself obliged to
> take a shot at its head; that the chimpanzee fell and that he then
> heard a man's shout; that he got up in the form of a man and was
> able to run more than a thousand yards through the forest; that
> when E—— E—— met him and took his hand the victim collapsed
> and died without saying anything; that after they had been called
> to help the villagers arrived, recognized him and carried the body
> of d'A—— J—— to the village; ...
>
> Whereas it is common knowledge in Gabon that a man may
> change into a panther, a gorilla, an elephant, etc., to achieve great
> feats, to dispatch enemies or to receive great responsibilities ... ,
> that these are facts unknown to Western law that a Gabonese judge
> must take into account ... ; Whereas the Court is entirely con-
> vinced that A—— J—— transformed himself into a chimpanzee in
> the forest where he was out hunting unarmed and without anyone
> knowing, and that B——, a notable personage, war veteran, re-
> peatedly decorated, victorious over chimpanzees on several occa-
> sions, could not fire in broad daylight at a man with whom he had
> no prior unfavorable past history; Wherefore B—— E—— is de-
> clared not guilty of the acts of which he is accused. Recorded at
> Lambaréné, the 25th May 1964.

Asia

The largest, the most diverse, and the most heavily populated of all the continents is also, to my great regret, the one that I have visited the least, at least until now. From a few studious weeks spent in India (2004),[9] in Thailand (2008), and in China (2000, 2014), I admittedly

gained direct experience of the rock art in certain regions of those countries, but gleaned relatively little direct or indirect information with respect to the problems of meaning. That is due to the loss of traditions relating to rock art, sometimes attributed, as is often the case, to mythical heroes or to good or malevolent supernatural spirits.[10]

In India, however, tribal life has continued to thrive in certain regions, and some forms of tribal art are strikingly reminiscent of themes and techniques that are found in rock art. For example, "In India, [the] tradition of printing hands on the gates of houses, temples, sacred sites at ritualistic ceremonies, auspicious occasions like the birth of a child, marriage ceremony, etc., is still continuing."[11]

Among the Saura in the south of Orissa, in eastern India, certain groups, traditional hunter-gatherers who engage in a limited amount of agriculture, live symbiotically with supernatural spirits, according to the researcher who has studied them the most. They "live in close interaction with supernatural entities. When the primitive mind fails to comprehend the cause of unnatural tragedies like illness, killer epidemics, earthquakes, lightning strokes, attacks by wild animals, etc. it attributes the cause to malevolent spirits and gods . . . which need to be propitiated and appeased by drawing icons."[12] And their "art, prompted by sources of beliefs and myths, forms a part and parcel of the Saura life in their struggle for existence."[13] This art, which is located inside dwellings or on doors, has remained unchanged since it was discovered.

The three stages of the creation and use of art by the Saura have been summarized as follows:

In stage one, the shaman identifies the spirit or the power that has caused the disease, or death or that needs to be propitiated for the welfare of the family, whose icon is to be drawn. In stage two, the icon is drawn on the house wall either by the artist (*Ittalamaran*) or the shaman (*Kuranmaran*) if he knows how to draw. And in stage three the icon is consecrated by the shaman through an elaborate ritual involving invocations to all gods and spirits of the Saura world and the particular spirit in whose honor the icon is

prepared, to come and occupy the house. All sorts of fruits, roots, grains, corns including wine were offered and finally either a goat or a fowl is sacrificed.[14]

The role of the hand and its specific image, the vital importance of the art, the conception of a world in which everything has meaning and images play a major part in relationships with the spirits, propitiation ceremonies, all of that cannot fail to bring to mind the lives and beliefs of Paleolithic people.

A recent voyage to Siberia allowed me to acquire direct experience. In connection with a lecture on shamanism in Paleolithic art that I gave in 2008 at the Pitié-Salpêtrière Hospital, Isabelle Célestin-Lhopiteau, psychologist/psychotherapist in the Pain Unit at the Trousseau Hospital, showed me some images recorded in Siberia, near Lake Baikal, where a Buryat shaman performed a ritual in front of prehistoric rock engravings that he touched purposefully. She described the experience and the underlying conception of the world as follows: "When he emerged from his trance, he explained that this enabled him to reestablish contact with the ancestors, those who had engraved the images, and simultaneously with the animals, the spirits and the elements."[15] Indeed, "shamanism, according to the shaman's own words, is the cult of nature. Shamanism is a conception of existence; a human is not in nature but 'is' nature. The essence of shamanism is that everything in nature is animate, deified but also bound, interconnected. Shamanic rituals exist to recreate bonds with the group, stones, animals, others, the universe, and the sprits."[16] Later on, she invited me to participate in a new journey, whose events would be filmed, in the company of another traditional shaman, Lazo Mongoush, whom she already knew, and a Siberian prehistorian specializing in wall art at the university in Krasnoiarsk, Alexandre Zaïka. The journey took place in June–July 2010.

As soon as we arrive, we go to meet Lazo in Kyzyl (Tuva Republic) some forty miles north of Mongolia. He receives us in a traditional yurt set up in the courtyard of his house. This serves as his office. Talismans are attached to the wall and hang from the roof. That same eve-

ning, we travel about forty miles from Kyzyl to a small hamlet inhabited by sheepherders for a purification ritual, indispensable on the first day, despite our fatigue and the shift in time zones, because the next day we will be going to see sites with rock art, places imbued with power. The spirits need to make our acquaintance beforehand.

The ceremony takes place on a small conical hill, on whose summit a pole surrounded by multicolored pieces of cloth is planted in a large pile of stones. Each of the men has to find a big stone and the women two little ones to be added to the pile on arriving. Lazo has brought with him food offerings (cheeses, pieces of meat). He prepares a small pile of dry wood and places the offerings in the middle. Other offerings of a similar kind and small coins are placed at the foot of the pole. At this point Lazo dons his magnificent shaman's garment, his ceremonial boots, and a headdress with big feathers. He sets fire to fragrant herbs, which produce a lot of smoke, and then makes a circuit of the people present. Men, women, and children are seated on benches on either side of the fire, facing one another, most of them with their hands clasped. Lazo purifies us in the smoke. He carries the smoke to the pole, and the participants tie their pieces of cloth around it. He renews the ceremony with his drum, playing and chanting. He passes in front of and behind every one of us. When the drum resonates close to us, one can feel it vibrate throughout the body and in the head. Impressive. Some participants touch the fringes of the shaman's garment as he passes. The fire takes hold, and the flames rise. Lazo beats his drum in front of the fire, and the flames seem to stretch toward him. In the photographs, we will see the strange forms that they take (fig. 11). When we later show him the photographs, he utters exclamations of satisfaction, but without surprise: The spirits are revealing themselves, and that is a sign that the ritual has succeeded. While the ritual is in progress, a woman rises to her feet and sprinkles sheep's milk in the direction of the four compass points. That takes place once more. From time to time, a man refills the cups used with milk. At the end, Lazo scatters handfuls of wheat: laughing, everyone rushes forward to gather them, because these grains bring good luck. The ritual takes

Figure 11. Lazo performing a shamanic ritual on the steppe, not far from Kysil, in southern Siberia. The flames stretch toward him, sometimes taking strange forms. Photograph taken by Konstantin Wissotskiy.

place very close to a large stone covered with a score of very ancient cupules, which are undoubtedly prehistoric.

Most of the time, the rituals are performed at a sacred site. Many of these exist, Lazo tells us, because there are a large number of spirits. Some of them are benevolent, but others are malevolent and harmful. They must be appeased with ceremonies. The sacred sites are "laden with power," in Lazo's own words, and places with rock art are often involved. The shaman detects this power and chooses the sites for his ceremonies. In line with this, toward the end of our journey, Lazo performed a ritual for me on my birthday on the crest of a superb cliff

covered with prehistoric paintings, between the Angara River and one of its tributaries. An excavation at this site, previously unknown to Lazo, who lives in a different region more that six hundred miles to the southwest, revealed evidence of occupations since Neolithic times. Cupules are also found at that location. My colleague Alexandre Zaïka, who conducted part of the excavations, discovered a number of bear teeth. One of our Russian companions later told me that at that locality there had formerly been an Orthodox church of wooden construction and the graves of priests. The church was destroyed by lightning. When this was related to Lazo, he of course thought that this had been the work of disgruntled spirits.

We participated in several other rituals, including a healing ceremony for our cook, Génya, who had for many months been suffering from very painful stomach troubles. For a considerable time, Lazo circled around him, beating the drum. Génya seemed to be in a stupor. Two days later, Isabelle asked him in a completely neutral fashion what he had felt. "At the beginning," he said, "I saw stars, but that then passed. It was like I was hypnotized, as if my spirit was ready to leave. It was not a flight, but it was a departure, as if it was going to leave but remained close to my body." He had the impression that his spirit was flying away, but not far and not for very long. Then, he faintly heard Lazo, from far away. Then he heard him again. He got to his feet, like a zombie. "When it was over, I felt like I do after the bagna." The bagna is a kind of Siberian sauna, very humid and very hot because of the water that is cast on piping hot stones. Afterward, one plunges into the river or rolls in the snow. The next day, Lazo gave Génya a potion made with herbs. His suffering stopped for the very first time since his stomach troubles began.

In the course of our travels, Lazo provided us with a great deal of information about the way he conceived the world, which abounds with signs and symbols for one who knows how to see and decipher them, as well as about his interpretations of particular images. On several occasions, he pointed out to us natural forms of rocks that were evocative of human figures. This mental attitude, which leads him to see spirits in flames and in nature, is shared with Paleolithic people,

Figure 12. The Iron Age idol of Taseyeva, alongside a tributary of
the Angara River in Siberia. Among the rocks surrounding it one can
see human faces that perhaps decided the choice of site.

who perceived animals in the contours of walls in the depths of caves
and completed them with their images. At the end of our stay, he pro-
vided us with another example directly connected with the choice of
site for rock art.

On that particular day, Alexandre Zaïka took us to see an Iron
Age "idol,"[17] isolated way out in the taïga, alongside a tributary of the
Angara River called Taseyeva. Because of its isolation and inaccessi-
bility, this spectacular site was not discovered until the early 1990s.
On the crest of a small hill, in the middle of an outcrop of big lime-
stone rocks there was a vertical statue representing a man's face about
thirty inches high. Zaïka tells us that bronze objects discovered at the
foot of the statue allowed it to be assigned to the Iron Age. One side of
the statue was completely flat, revealing that it was made from a slab
that had once been horizontal and had been selected in situ and set
upright. Lazo pointed out that faces could be seen in several rocks sur-
rounding the statue (fig. 12). I took a close look at them: all were natu-

ral and had not been retouched. All the same, it occurred to me that we perhaps had before us the prime reason for the choice of that site by people seeing the rock in the same way as Lazo and noticing faces. This is, of course, an untestable hypothesis, but seductive nonetheless.

The dense thickets of the taïga where the statue was situated abounded with thick clouds of aggressive mosquitoes, horseflies, and midges. Our Siberian friends had warned us in advance and we had prepared ourselves (long garments, gloves, veils protecting our heads and necks, insect repellents). But our friends generally paid no attention to the mosquitoes, which are so abundant in Siberia in the summer. On this occasion, however, following Lazo's initiative they protected themselves in an unexpected fashion. He walked up to a large anthill and struck the top of it forcefully two or three times with his hand held flat. He then held one hand quite level about an inch above the anthill and waited. I was wondering what was happening, and then I understood: under attack, the ants exuded formic acid with which Lazo covered his hand. He then rubbed his hand over his arms, over his other hand and over his face, which were thus protected. The others followed suit. To show me the effectiveness of this action, Lazo held up his bare hand, with a cloud of insects swirling around it and not one of them landing on his skin. Just imagine how many tricks of this kind have been lost since prehistoric times!

Close to the idol, Lazo pointed out to us that the sculpted slab was precisely oriented directly to the east. We verified this with a compass. This was surely not due to chance. For present-day shamans, the four compass directions play a very important role in their rituals. We had witnessed this in the rituals we had seen with offerings of milk. At the site of Bytchikha, where there are some small engravings from the Iron Age, Lazo declared that the engraved crosses were shamanic and that he had the same images on his drum. They symbolized the four compass directions. His knife, which he had fashioned himself out of a spring from a lorry, is in the form of a first-quarter moon, which is a period particularly favorable for rituals.

For shamans, animals are of very special importance because,

according to them, we live in a world where everything is intercon-
nected and fluid. For Lazo, the bear is the foremost animal: it re-
sembles humans and has relationships with them (with a preference
for women); it is present in the sky, where it can be seen in the con-
stellations; and finally its penis bone is a symbol of power. Lazo in fact
always wears a magnificent necklace made of pearls and bears' teeth.
The stag is also very important, and only one was killed each year. The
wolf is a symbol of aggression. Great respect is also accorded to the
eagle, which is imitated in dances.

Some of Lazo's interpretations reminded me of hypotheses for-
merly proposed for Paleolithic wall art in Europe. For example, Lazo
interpreted in terms of hunting magic some beautiful images of moose
engraved on cliffs near the Yenisey River at the Moyisseikha site: In
the old days, before the moose-hunting season, a ceremony was per-
formed to kill two of them, hence their representation in rock art. At
Soukhaniha, not far from several sites with engravings, also near the
Yenisey River, at the bases of two poles bearing pieces of cloth, stand-
ing at the bottom of a hill slope, there were two skulls, one of an ox
near the right-hand one and a horse skull at the foot of the one on
the left. Lazo told us that, when the skull is at the foot of the pole, the
human spirit is low, and that placing it at the top raises the spirit. Ac-
cordingly, he set about doing just that, solemnly and with reverence,
touching the skulls and talking to them. Then he attached them one
after the other at the top of its pole, using the colored pieces of cloth
to do so. Then he told us that the horse skull represented a masculine
spirit and the ox a feminine spirit. André Leroi-Gourhan would have
really liked that interpretation. [18]

During our visits to decorated sites, we saw a certain number of
human representations in which the head was crowned either with
horns or with the antlers of a deer, sometimes with a circular object
held in the hand. Not only Lazo but also Alexandre Zaïka, a specialist
in this Siberian art, and all of our guide companions accepted it as
obvious that these figures should be identified as shamans bearing a
drum, and Zaïka hence inferred the shamanic character of rock art

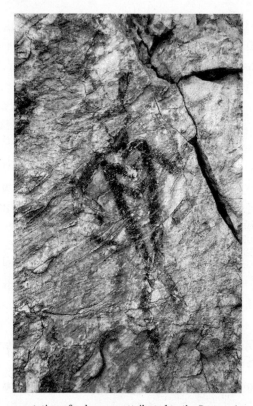

Figure 13. Representation of a shaman, attributed to the Bronze Age, at Manza II, alongside the Angara River (Siberia). Lazo told us that the oblique double lines on the sides indicate energy. This painting had been partially vandalized and its contours had recently been clumsily redone with crayons. (The shaman's right arm was half-raised, like his left arm, but the modern redrawing has represented it differently and hence distorted the visual impression.)

from the Bronze Age onward in these southern regions of Siberia. So how could one escape thinking of the "Sorcerers" of Les Trois-Frères or Gabillou?

With one of these shamans, painted in red on a cliff alongside the Angara River (Manza II) and attributed by Zaïka to the Bronze Age, oblique double bars were present on either side of the body (fig. 13). In other contexts, we would identify them as uninterpretable "geometric signs." For Lazo, it was obvious that they indicated energy.

In the course of our extensive travels, we were able to spend an entire day with another traditional shaman, Tatiana, a middle-aged

woman from Khakassia. Although she would not allow us to film or photograph the ritual that she performed for us near the river, she was quite ready to speak to us at length, both in the context of a formal interview and over the course of the day. She provided us with count-less details regarding shamanic beliefs and practices in Khakassia, including some concerning rock art. Much of what she told us con-firmed what we had learned from Lazo, a Tuva shaman.[19]

According to Tatiana, the universe has three principal superim-posed worlds. The lower one comprises seven levels and the upper one nine, each with its own characteristics and its own gods or spirits. For example, the gods of Earth, Water, Wind, and Fire inhabit the fourth level. Every individual inherently possesses these four spirits in bal-ance with one another. Among other things, the role of the shaman is to reestablish the balance between these four elements when it has been disrupted. The fifth level is the abode of the gods of the four com-pass directions (North, South, East, West), even more powerful than those in the preceding levels. This demonstrates once again the im-portance of the cardinal points of the compass.

The fundamental principles in the universe are harmony and bal-ance. For instance, in each of us there is also a balance between the upper and the lower realms. When this balance is disrupted, it has repercussions in the world at large, because everything is connected, and the shaman must then intervene.

He, or in this case she, does this through ritual and through trance. Depending on the ritual concerned, she can be an animal, such as a bird, or a spirit. "It is very difficult to explain: a trance is like diving into water," she tells us. Often, she does not understand. When she de-scends into the world beneath, she is "afraid because there is wonder-ful music and it is very hard to come back." To help people, it is nec-essary to tussle with the spirits on the mental plane. All the same, the wounds are real, and she can feel them after the ritual.

With respect to representations in rock art, she told us:

I was initiated to perform the ritual, but there is another source of knowledge locally. Here, we are in a region where there are many

engraved rocks and I see the rock paintings as engraved laws, unpublished books on shamanic knowledge. For me, these rock paintings speak, that is when I touch them and remain close to them they tell the story of the creation of the world. It is the shaman's manual. It is the transmission of knowledge, ancient information that existed long ago, to present-day shamans such as myself. What shamans did before me and what we should do now. For me, it is like a letter from the past. That is why I come. I often conduct rituals with the petroglyphs. But when I perform a ritual with rock art, it is a ritual for the ancestors and the people who transmitted this knowledge-laden message. That inspires wisdom and expands my understanding. This rock image explains the actions that the shaman must undertake and what actions are essential. There may be images of particular animals or anthropomorphic spirits, which show the animal spirits and the anthropomorphic spirits with whom one must collaborate to guide a man's soul. Often, there is also an image of the sun, the moon, a half-moon, or an eclipse, which indicates the time of the year, the season, the month, and the day on which to conduct the ritual, to collaborate with a particular spirit. These rock images are calendars of a sort. The shaman works with people but also with the surrounding universe. That is what the rock images show.[20]

She explained to us that fantasy animals are images of the spirits. A boat with men aboard represents a shamanic ritual: There is a shaman on the boat, together with the participants in the ritual. It is a voyage into the netherworld, that of the spirits. For her, a flat stone with concentric circles near to burial mounds, which we had seen not far from Lake Chyra, is a map of the area indicating sanctuaries, with the concentric circles representing lakes. There is also a connection with the stars and advice about what to do in the future. It is a "place of power" (an expression already used independently by Lazo for rock art sites).

The "rock images have a great deal of power," and sometimes she can detect their presence and their locality. She herself has performed a number of rituals with petroglyphs (engravings on rocks), as a way

of expressing gratitude ("thanksgiving"). A hunting scene indicates how to conduct a ritual to ensure success in a hunt. Many other complementary elements exist, such as geometric signs, which are the most important representations for her because they are loaded with symbols.

These rich and multiple experiences had a far from negligible influence on my way of thinking about problems of rock art of Holocene times on different continents, as about those of the Ice Age period in Europe.

In light of those experiences, but also taking into account diverse studies and accounts—that is to say adopting a more classical approach—I will now tackle traditional attitudes toward nature and the environment. They may concern landscapes, caves and rocks, the world in general, or animals as well. The art of people living close to nature, closer to us than those living in Ice Age times, has served multiple roles and applications, which will be called to mind, along with the problems that inevitably arise. In the process, we will see how these observations can help us to achieve a better understanding of cave art, of shelters and rocks of the European Paleolithic, and of the conceptual framework within which they can be accommodated.

Three

Perceptions of the World, Functions
of the Art, and the Artists

Following these concrete accounts of how various traditional cultures perceive the world, it is advisable to bear in mind certain facts that demand caution before tackling what we know (or believe we know) and considering the extent to which it can help us to understand Paleolithic thought patterns and the art they generated. It is essential to evaluate the relevance of our information in order to build on a solid foundation.

When we refer to ethnological explanations, regardless of the area concerned, there are two main cases. We, as archaeologists of the distant past, do not have the slightest indication of the significance of any fact, regardless of whether it concerns everyday life, beliefs, or cultural or religious customs. In this case, described by Anglo-Saxon authors as uninformed or etic, we rely on the intrinsic unity of humanity, which implies the existence of universals, or at least of widespread constants in cultures that are more-or-less comparable to those under study. It is these universals and constants that allow comparisons or analogies with behaviors and ways of thinking that are ethnologically well known. This is the approach adopted here (see chapter I). It goes without saying that this approach is not without risk.

In the second case, where evidence does exist, it can be of two main kinds. When one or several informants share their knowledge it is di-

rect, and we are then within an informed or emic framework. Indirect testimonies are those recounted by travelers returning from faraway countries, ethnologists, or missionaries who had lived among peoples who are no longer with us describing their customs in their own way and from their own perspectives.

Even with emic cultures, there are many problems and sources of uncertainty. A perennial problem is transformation of interpretations over time, even for identical images.[1] When cultures change, so do their beliefs. Take, for instance, current tales told by the Aborigines of the Kimberley concerning the elegant rock paintings that were named Bradshaws after their Western discoverer, and that they call *Guion Guion*.[2] The paintings are of uncertain age but undoubtedly several millennia old. We are far from certain that those tales are perpetuations of ancestral beliefs that prevailed at the time when the paintings were created and first used, rather than being much more recent inventions. From our point of view, this would in fact not be a major drawback, because the conceptions of the world that are expressed, within the framework of a long tradition surrounding this art, are what matters, and not necessarily the original meanings with all their details.

In all honesty, those details will forever remain beyond our reach. Robert Bednarik, who has spent time with particular Australian Aborigines all his life, aptly explained the mechanisms that render illusory any attempt to acquire a complete understanding. The first obstacle is that of language. One can either depend on an interpreter and on his command of the language along with his own interpretations (*traduttore traditore*), or learn for oneself the language of the group under study, but with no hope of mastering all the fine distinctions and subtleties.

The second major problem is the specificity of knowledge and of explanations. In this subject, nothing is simple, and nothing is unequivocal. Moreover, knowledge does not constitute a right, either for all members of the culture being considered nor a fortiori for any external observer of this culture. These constitute two major obstacles. As Westerners, and even more so as researchers, our inclina-

tion is to try to acquire knowledge of everything in the deepest, most exhaustive, and most reliable manner possible. This is, after all, the main driving force of science. Yet such a concept is alien to traditional ways of thinking, for which knowledge is contingent. Some forms of knowledge, certain images, as we saw with respect to Australia, are reserved for women and others for men, and the penalty incurred by transgression can be dire.

Knowledge hence varies according to gender and/or the initiation level of the individuals involved. Bednarik received two very different interpretations of an identical fact, separated by a quarter of a century, with the second being far more complex than the first. When he expressed surprise at this, he received the reply: "But, twenty-five years ago, you did not know very much."[3] In the metaphor he used, explanations can be contained one within another in the manner of Russian dolls, without any certainty that one would ever manage to reveal the final one. A meaning that is accessible to all can in fact hide deeper levels of significance that are available only to the initiated.[4]

Finally, let us remember from chapter 1 the futility of attempting to formulate precise explanations of an alien art form within a framework restricted to our own prejudices and Western conceptions. One of the most striking (and most amusing) examples in this context is that of Murru Murru. At the time of the Darwin Congress in 1988, my old friend Antonio Beltrán undertook an expedition to the Australian bush with an Aboriginal artist named Murru Murru, who had shown him particular sites and provided him with explanations. They returned to these locations a little later with a group of congress delegates. Among them was an American feminist colleague who stopped in front of two negative hand stencils on the wall of a rock shelter. One of the prints, larger and more crudely fashioned, was located above the other. She began to offer an interpretation: "It is obvious that the hand above is male, and is placed as it is above a female hand to symbolize the domination of man over woman and a chauvinistic attitude." Beltrán told her gently that it might be better to ask the Aborigine, as he would know. They fetched Murru Murru and questioned him about the hands. He grew angry, sensing criticism: "Yes, I know!

The top one is spoilt. I had placed my hand too high. If you think that it is easy! But the other one, which I did afterward, is lower and easier to reach, and is just fine!"

When asked why he had produced these hand stencils, Murru Murru replied with a shrug that he had stayed for several days in the vicinity during the rainy season, and that he had made the stencils because he was bored. If this is true, as is quite possible, the prints would have no more value than simple graffiti, but did he really speak the truth to strangers that were merely passing through? In contrast, in other regions of Australia, a hand stencil can be a status symbol: In the southeast (Blue Mountains), I was told in 2006 that the length of a portrayed arm reflected the importance of the person who made it (Shield cave). It is evident how difficult it is to provide an interpretation without access to precise information.

The so-called Macintosh experience is less of a caricature. In 1952, this Australian researcher studying art in a rock shelter in the southeast of Arnhem Land had documented the eighty-one paintings that were present. While doing so, he worked in a manner that we would all qualify as "objective," precisely describing all the subjects represented. Yet an Aborigine who had lived in the region and knew the meaning (or rather the *meanings*) of these images later consented to talk about them with one of his eminent colleagues, Professor Elkin. Things turned out to be very different. Simply at the level of his identifications, which were seemingly quite secure, Macintosh had been more-or-less wrong in 90 percent of cases! Two decades later, he revisited his interpretations and rectified them. For instance, a drawing diagnosed as that of a woman was in fact "not only a *gen-gen* or water lizard, but a *gen-gen* whose spirit home was in Mataranka water" and was in fact a totemic figure.[5] He concluded, among other things, that we require "particular knowledge to differentiate correctly between sexes, and between ordinary people, people engaged in ritual, disincarnate human spirits, and spirits which have never been human."[6]

These few examples suffice to show that we must exercise the utmost caution, while not going as far as to give up completely. There is after all a wide spectrum between striving to understand everything

and adopting a nihilistic pessimism. There are levels of meaning that are accessible and especially *conceptual frameworks* within which they develop. Although the details noted by Macintosh in his second stage of interpretation will always remain beyond our reach, it is entirely appropriate to examine those basic frameworks modestly and conduct research on them.

Attitudes toward Nature

For modern Westerners such as ourselves, things are very clear. We live *hic et nunc*, here and now. Our world is concrete, material, and—at first sight—comprehensible. We know its limits—albeit galactic—and its principal properties. With suitable scientific instruments we can study and quantify it, define its principles and rules, exploit it rationally, or even modify and dominate it. It is *our* world. Its limitations are as constant and as firm in Time as they are in Space. The past, close or distant, is fixed for all eternity, even if the research conducted by specialists is always likely to reveal additional details and undiscovered aspects.

This is by no means the case with many traditional peoples. For the Australian Aborigines, the *Dreaming* is an essential concept.[7] This does not refer solely to past mythical events such as, in other contexts, Earthly Paradise or the Fall, even if it is filled with creator spirits to which we owe the world as we know it, the rivers, the animals, and humans. These spirits provided the laws that rule the universe and the interactions among its beings. They drew on the walls of the rock shelters and in fact often incorporated themselves, with their likeness and essence preserving their original power and characteristics. These spirits are in fact intrinsic, and we still live within the Dreaming. Past, present, and future are inextricably linked and are essentially one. In the northern part of the Kimberley in Australia, the aforementioned Wandjinas (fig. 9)—who created the land, the sea, and human beings—control the clouds, lightning, and rain, and hence the fertility of nature and of all life, of both animals and men. They painted themselves on the walls, yet they remain vulnerable and must be revived

from time to time so that their power will persist. The individual who repaints them does (or did) this within the context of the Dreaming, of which he is simply an instrument.

This complexity, associated with a lack of insuperable boundaries, is present in four major concepts that cannot be effectively separated from one another, because they proceed from the same conception of the world.

The first is the _interconnection_ of species. For example, in Central Asia robust symbolic relationships between the Horse, the Bull, and the Stag have been noted: horses were buried with horns or antlers in the Pazyryk (Sako-Scythian) culture of the Altai.[8] Similarly, among Native Americans: "The beliefs of North American Indians are imbued to such an extent with this kinship among animals that metamorphoses or transformations of one kind of animal into another are completely normal phenomena."[9]

This interconnection also applies to humans and their relationships with animals. In a number of North American cosmologies, for example, humans were created by spirits that possessed human qualities, but who subsequently transformed into animals. This resulted in a fundamental affinity between humans and animals, explaining why Native Americans imitated animals under certain circumstances.[10]

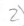

The second concept, linked to the first, is that of the _fluidity_ of the living world. Animals, endowed with extraordinary traits and powers, deified even, are conceived in our image and interpreted according to one aspect or another of the culture that contemplates them. For example, during a trip to the southeastern part of the United States (Tennessee, Kentucky), I was surprised to see an engraving representing a turkey in a deep cave, far beyond the reach of daylight. One of my colleagues then told me that, almost a thousand years ago in the so-called Mississippi culture, the turkey symbolized a brave warrior, as he carried the scalp of his defeated enemy, represented by his wattle. This powerful protective spirit was accordingly engraved at the ends of some of these deep caves, which are given the generic label _mudglyph caves_, as the images are often produced using fingers on the soft walls or in the mud.[11] This type of identification, if it proved to be cor-

rect, would be the outcome of a world conception in a warrior cul-
ture that scalps its enemies and assimilates animal traits into a specific
human reality.

If we are that close to animals, it goes without saying that, through
particular rites or under certain circumstances, humans could entirely
or partially transform into animals, and vice versa. There is abundant
evidence of such beliefs for all cultures and all religions: the serpent/
Satan (endowed in another manifestation with an animal's tail and
horns, or transformed into a goat); numerous gods, goddesses, and
other characters[12] in various pantheons or mythologies: Egyptian (the
lion-headed Sekhmet or the falcon-headed Horus), Hindu (the popu-
lar elephant-headed Ganesha), Greek (centaurs, sirens), and many
others. Not so long ago, our rural compatriots believed in werewolves,
and beliefs centering on transformation into predators continue to
exist in some parts of Africa (see chapter 2). In our Western culture,
such ambivalence concerning humans and animals was even mani-
fested in the past by judicial condemnation, conviction, and punish-
ment of unfortunate animals, treated as equivalent to human crimi-
nals, when accused by the Inquisition of some misdeed or other.

 Another way of thinking that is common to traditional cultures
is unequivocal acceptance of the *complexity* of the world, regardless
of whether animals or natural phenomena are concerned. This accep-
tance is expressed linguistically. Nowadays we tend to make reality
synthetic. We will employ a very general word to refer to a given phe-
nomenon, such as "snow," which is then rendered more precise by
using adjectives or parenthetical clauses: light snow, cold snow, hard
snow, soft snow, snow that falls heavily, and so on. The Sami of north-
ern Norway and Lapland, on the other hand, employ a new word in
each case. They therefore have hundreds of terms to refer to snow.
This also applies to animals, of which the most important for the Sami
is the reindeer, with which they lead a symbiotic existence. In fact,
they do not have just a single world to designate this animal as we do,
but over six hundred different terms,[13] according to age, sex, color (85
words), fur (34), antlers (102), and many other attributes.

In this way of thinking, concepts differ from those with which we

are familiar. To express an action, age, or sex, we have to add an adjective or a verb, thus uncoupling the essence of the animal ("the reindeer") from its existence, from what it is or from what it happens to be doing right now. For the Sami, by contrast, all of these elements are indissolubly linked, and changing any one of them creates another reality. Traces of these ancient modes of thinking still persist in modern Western languages, with the existence of very different words in relation to sex (stag/doe, stallion/mare, bull/cow, hen/rooster), or age (heifer, foal, fawn, brocket, lamb, calf) for certain animal species that are particularly important or familiar.

Adopting this viewpoint, an aggressive male bison, a young individual playing, a dead adult, and all other alternatives undoubtedly constituted the primary terms of Paleolithic speech, rather than a generic image to which a few secondary details were added, contrary to the opinion expressed by André Leroi-Gourhan (see chapter 1). Contemporaries who shared the same experience of the living world needed to characterize representations immediately, as is done today, unthinkingly, by experienced ethologists or by individuals who live or have lived for a long time in direct contact with animals. For example, in the 1990s, two Inuits and one Cree Indian—individuals of advanced age and great experience—visited some of the Paleolithic caves in the Pyrenees and Quercy under the guidance of prehistorians. Even though they were in some cases confronted with images of animals that do not occur in northern Canada, such as the ibex, they consistently maintained distinctions based on age, sex, or behavior. They also perceived the animals as "real," not only because of the naturalistic representations but also to a great extent because psychologically it was impossible for them to do otherwise. In this case, the state of mind of the modern hunter coincides with that of the Magdalenian or Solutrean artist.[14]

Finally, in this fluid and complex universe, in which everything is interconnected, *permeability* is the rule. This is the fourth fundamental concept. This permeability functions in both directions, or one could even say in all directions. The world is then no longer closed and rigid, subject solely to a succession of causes and effects of material origin

that are measurable and predictable. Spirits and supernatural forces come into play and manifest themselves constantly, causing illnesses and catastrophes when they have been offended, bestowing their blessings (health, abundance of game, love, fulfillment of wishes or projects), or ensuring an essential equilibrium (sequence of days and seasons, coming of the rain), when the appropriate rites have been conducted. Nothing is assured, everything is in the process of emerging through their good graces. Far from confining themselves to a distant and inaccessible Olympus, their presence is immanent everywhere; they pervade and govern all. Occasionally, they make physical appearances, much more frequently than in the "major" religions, where apparitions exist but remain exceptional and "miraculous." Moreover, some people can deliberately make direct contact with them, either physically or through the spirit. Stories abound of people who entered into the world beyond, generally located in rock or deep water, and who, after surmounting formidable obstacles, gained access to the Lord of the Animals or other supernatural powers to seek their aid, before reemerging and returning to the everyday world.

These concepts, no matter how fundamental they are, do not suffice to define an ideal type of traditional culture and do not apply universally in an indiscriminate manner. The complexity inherent to each culture would render any such assessment naive and illusory. Because it is so fundamental, it is worth repeating that these are mental frameworks, very different from our own, that can be found more-or-less everywhere, albeit with variations in one or other element according to the culture concerned. They will enable us to better approach and try to understand the people of the Paleolithic, based on the clues that they have left us. They will illuminate their attitude toward sites in general and caves in particular, and toward the walls in the latter context. We will then proceed to tackle their relationship with animals, their diverse uses of art, and what we can ascertain of their myths, before finally addressing the question of the authors of these images.

Attitudes to Sites

In Europe, the term "cave art" is commonly used to designate Paleo-lithic art.[15] This is both true and false. It is false in the sense that the overwhelming majority of the images were produced in daylight, either in rock shelters or on freestanding rocks. In our current state of knowledge, about half—one would be tempted to say *only* half—of known Paleolithic art is found in the total darkness of deep caves. For the most part, the other sites are rock shelters,[16] individual rocks, or cliff faces. With the exception of the engraved rock at Campome in France (Pyrénées-Orientales), the latter type has been found only in Spain (Siega Verde, Piedras Blancas) and, especially, Portugal (Côa Valley with its thousands of engravings, Mazouco). It is notable that these are all engravings and that they are located only in the southernmost parts of Europe. Two obvious inferences follow from this: *paintings* are not preserved at all in open-air sites and generally quite poorly in shelters; open-air *engravings* have only exceptionally been able to withstand the elements, under milder climatic conditions and when permitted by the manner of their exposure. Accordingly, we clearly have at our disposal only a minute and biased portion of Paleolithic parietal art.

Undertaking to paint or engrave so far below ground and in total darkness is not an obvious choice. Yet Paleolithic Europeans did this for almost twenty-five thousand years. Opting for darkness and such prolonged persistence of a tradition are exceptional in the history of humankind. Elsewhere on Earth, we know of drawings produced away from daylight in the Americas (*mud-glyph caves* of the Southeast of the United States, Cueva Oscura at the Sierra de San Francisco in Mexican Baja California, Mayan caves,[17] and other decorated caves in Central America or in the Caribbean), as well as in Oceania (several dozen in Australia, long lava tubes on Hawaii). Nevertheless, such uses of deep sites did not last for long and the examples are not as numerous as one might have expected, even if we know of a few others in Asia or in South America. To my knowledge, for example, no decorated deep caves have been found in Africa. It occasionally happens

(Shaman's cave in Namibia, Peruaçu caves in Minas Gerais in Brazil, or the Madhya Pradesh sites in India) that the shelter where the cave entrance is found, or the entrance itself, has been decorated, whereas paintings or engravings are completely lacking as soon as one enters the dark zone. In this case, there is clearly a refusal to work in darkness, or indeed half-light, to produce images.[18] This links up with the conception that diverse cultures are likely to have of the landscape in general and of the underground world in particular.

In fact, the choice of site was not always a result of chance or necessity. In many regions, rocks and their possibilities were abundant, so choices were available. Very often, and in all periods, external art follows the banks of rivers, canyons, or particular valleys. For the Paleolithic, this is the case for Foz Côa in Portugal or Siega Verde in Spain. Examples are obviously much more numerous for postglacial art. We can cite, among others, the great valleys of the American West (Utah, New Mexico, Arizona, Wyoming, Idaho, Oregon, etc.); the canyons of the Sierra de San Francisco in Mexico; Cueva de las Manos and other decorated caves at Rio Pinturas in Argentina; the rock shelters of Rio Peruaçu in Brazil (Minas Gerais) or of the Pecos River between Mexico and Texas; the art of the banks of the Yenisey and Angara rivers in southern Siberia, of the Chambal Valley or of Chaturbhujnath Nala in India (Madhya Pradesh), and of the valley of Fergana that crosses several countries of Central Asia. And there are many more.

Equally frequent, whether associated with valleys or not, are the spectacular landscapes that were selected for production of rock art: deep and tortuous canyons (Baja California, Arizona); gigantic cliffs (Hua Shan area in China), sometimes with caves or poorly accessible shelters (jungles of Kalimantan on Borneo, Indonesia, or of Pachmarhi in India); old volcanic craters (Arakao in Niger); colored rocks (Utah, Mont Bego near Nice, France); contrasting landscapes such as the fjords and seashores of Scandinavia (Alta and Ausevik in Norway); or even the glacial scenes at high altitude on Mont Bego, accessible only in summer, when impressive storms break. The environmental context augments the works with a dimension that can be anticipated

and is known to be essential to the ways of thinking of the artists and of their cultures.

A phenomenon that is widespread across the entire world is one that we could call "the sacred mountains" of rock art. These include isolated massifs rising in a spectacular manner from the surrounding desert (Uluru in Australia, the Brandberg in Namibia, the cliffs of the Drakensberg in South Africa), as well as hills or mountains, sometimes with a peculiar shape, where there is a notable accumulation of many decorated sites, as in the Matopo Hills in Zimbabwe or the Tsodilo Hills in Botswana.

During the Paleolithic, this phenomenon played a role in the choice of caverns for decoration. The most striking example is undoubtedly that of Monte Castillo, in the province of Cantabria in Spain. The mount evokes the shape of the top of a mammoth's body and paintings are found in four major caves there. This site was heavily utilized throughout most of the Middle and Upper Paleolithic, as evidenced by successive occupations of the cave entrance of El Castillo, extending from the Acheulian through the Magdalenian. Niaux and the Réseau Clastres are similar neighboring caves in the Massif of Calbière (Ariège). A confluence of rivers also attracted a concentration of decorated caves, as in the Basin of Tarascon-sur-Ariège, with six caves within close proximity: Niaux and the Réseau Clastres in the Vicdessos valley, Les Églises and Fontanet in the valley of Ariège, as well as Bédeilhac and Pladière a few kilometers to the northwest.

An essential dimension that—*mutatis mutandis*—is found in caves is selective localization of the paintings or engravings in the landscape and what we can infer from this. Thus, some sites can only be reached with considerable effort, because they are located in difficult terrain (Kalimantan on Borneo) or long distances away from settlements (certain rock shelters in the Kimberley or in Arnhem Land in Australia). Others, in contrast, are found alongside major routes (*koris* [dry valleys] of the Aïr Mountains, in Niger), where the artworks were engraved in full view, limited to a narrow strip just a few yards or tens of yards wide. This choice is even more evident given that thousands

of undecorated rocks cover the flanks of a hill and that the art is confined to its very base (Arakao, Anakom, and Tanakom, in Niger; Foum Chenna, near Zagora, in Morocco). These choices reflect a contrasting logic. Sometimes, the art is evident and visible to passersby, while in other places it is hidden, demanding a more-or-less substantial effort to seek it out and contemplate it.

One might think that access to a site of the latter type was not permissible for all. We have examples of such exclusions in Australia. George Chaloupka one day suffered a bitter experience of this kind. He had been made aware of an important new rock art site that was a very long distance away, and he had the opportunity to go there by helicopter. But this sacred location was reputed to be dangerous and reserved for advanced initiates, as it was dedicated to Algaigho, a female divinity with four arms and a head surmounted by cervid antlers, who burns all who cross her path (fig. 8). Chaloupka nevertheless visited the site, but when he wanted to return the helicopter would not start. He and his crew had to walk for days on end to escape from this predicament and return to civilization. When, a few days later, a team returned to repair the disabled helicopter, it had been burned. For the local Aborigines, it was evident that Algaigho had thus punished the misdeed using her preferred means of destruction.

Recently, Tilman Lenssen-Erz conducted a study of the landscapes selected for the art of the Brandberg, in Namibia. He distinguishes seven scenarios. According to him, the last of these ("class G")—defined by a particular configuration of the rocks, the creation of an enclosed space, with restricted or difficult access—is comparable to the conditions applying to the European decorated caves, both with respect to the ritual and religious functions and also because it is significant in its own right.[19]

How were these locations chosen? Sacred or profane stories—which, as we know, are not necessarily distinguishable from each other in traditional cultures—determined these choices and the nature of the sites. Among the component elements of myths suggested by the above observations, one might mention the role of water and of rivers, either subterranean (Volp caverns, Montespan) or not (Foz

Côa), the spectacular nature of mountains, canyons, or particular geological formations (le Pont d'Arc, near Chauvet cave in the Ardèche valley), the importance attributed to certain selected regions that harbor an accumulation of dozens or even hundreds of decorated sites (Serra da Capivara in Brazil, Toro Muerto in Peru, Bhimbetka in India, Tassili n'Ajjer in Algeria, Acacus in Libya, Kakadu and Pilbarra in Australia), or even the need to pass on knowledge.

The perception of the locality as a site of power, where the presence of the spirits and supernatural forces had been felt (or not) long ago, was undoubtedly one of the strongest factors determining the initial decisions. This is barely mentioned, if at all, as it leaves no vestiges that can be concretely quantified. Yet this must have been a major driving force, regardless of whether the entrances of caves, rock shelters, or cliff bases were concerned. We have seen (chapter 2) that the Siberian shamans perceived the power inherent in particular sites and chose or discarded them for ceremonies according to their feelings and personal responses. Such subjective criteria for settling on or rejecting a location would explain why some easily accessible caves that would seem to us to be highly suitable in objective terms were neglected and contain no Paleolithic images.[20] This is the case for the Sabart cave, in Tarascon-sur-Ariège, situated a few kilometers from Niaux, facing in a similar direction, at the edge of the same waterway, the Vicdessos, and easily visible in the landscape. Niaux was transformed into a major sanctuary, yet Sabart was ignored. Perhaps one was perceived by the Magdalenians as welcoming and potentially beneficial, while the other aroused contradictory feelings.

Attitudes to Caves

In fact, in traditional thought caves are not seen as simple accidents of nature stemming from geological phenomena.

They are thresholds. According to the most common conception, they open onto (or themselves constitute) a world beyond. Stories about them are innumerable, everywhere and always. We know the tale of the man who for some reason or other enters a cave, where

he meets formidable beings that are the guardians of the passages. Having won them over or having succeeded in passing by without awakening them or arousing their ire, he continues his underground journey and eventually meets one or several powerful spirits who present him with a gift that he brings back to the world of the living. Sometimes, the story can also have an unhappy ending (Orpheus and Eurydice).

It is likely that people did not approach caves in the same way as when moving around the familiar landscape during their daily lives. I refer particularly to the deep caves that Louis-René Nougier pleasingly and aptly called "mouths of shadow," opening up into the world of darkness and spirits. Appropriate gestures or words were probably needed, following the example of Percy Trezise, in Australia, who announced his presence before entering a decorated shelter where the Wunambal lit a propitiatory fire before showing us their site. A more prosaic kind of danger lay in wait for the intrepid, as many caves served as lairs for bears or other predators, such as hyenas, lions, panthers, and wolves. Apart from any rites of conjuration, Paleolithic people approaching these places surely sniffed the air to detect any revealing odors, much like our Brazilian guides before entering a site at Rio Peruaçu where a puma was known to dwell (see chapter 2).

Some decorated caves that are generally not very deep (Marsoulas, Lascaux, Tito Bustillo, Le Placard, Pair-non-Pair), their entrances (Fontanet, Le Mas-d'Azil, El Castillo, Isturitz), and especially rock shelters (Gourdan, Laussel, Cap-Blanc, Roc-aux-Sorciers) were nevertheless inhabited for lesser or greater periods of time. In this case, daily activities took place at the foot of the decorated walls. By contrast, the galleries of very large caves, even when not particularly difficult to reach (Niaux, Rouffignac, Chauvet), were not occupied for extended periods. This need not be regarded as entailing any contradiction. Within a single conception of the world, a single religion, signs or symbols of supernatural power that constitute the images can play diverse roles: telling or perpetuating founding myths, acting to protect or cure, and many others. These roles are prone to vary according to location, time, or person; but this changes nothing regarding the fundamental unity

of beliefs. In the Catholic religion, the symbol of the cross is found on the altar before which the priest says Mass, but also on the headboards of pious individuals, on graves, or erected at the top of a mountain. Living spaces, whether in a decorated shelter or not, were not immune to the beliefs of the people of the tribe or the invisible powers that, according to them, ruled the universe and demanded respect, and whose favor must be earned.

Some habitats, however, were endowed with a particular function. Thus, in the Ariège, the Enlène cave is connected with that of Trois-Frères by a narrow passageway that is strewn with vestiges indicating that the Magdalenians frequently used the passage to move from cave to cave. Yet, while Trois-Frères is a major decorated cave, with hundreds of engravings, but also with limited signs of occupation and with only two engraved objects, Enlène contrastingly exhibits hardly any parietal art (a few red lines right at the back of the cave), yet contains extraordinary portable art. In fact, dozens of engraved or sculptured objects made of bones or reindeer antlers and, most notably, 1,160 engraved flat stones were found there. Enlène was inhabited as far back as the Salle du Fond, situated far from the light of day. The Magdalenians lived there. They made fires there and cooked their food, knapped flint, manufactured decorative objects, and engraved flat stones before casting them aside, breaking them or reusing them as paving stones or hearth pads.[21] La Vache cave, also in the Ariège, serves a comparable role in relation to Niaux. The two caves are located on either side of a small river, the Vicdessos. It takes about half an hour to get from one to the other. Niaux, the well-known decorated sanctuary, was never inhabited by the Magdalenians, not even its gigantic entrance chamber. La Vache, conversely, was inhabited for a long time. It is not a decorated cave, yet its portable art is stunning because of its quality, quantity, and variety.[22]

These habitations, so rich in decorated objects, obviously had a special function, in direct connection with neighboring sanctuaries. Were they perhaps used for specific preparations, relating to rites of initiation or apprenticeship, of purification, of healing, of increasing the abundance of game and suchlike, before entering the nearby cave

where these rites would take place? The physical properties of caves
have often caused them to be likened to female genital organs. The
Tainos of the Caribbean believed that the cave was the original mother
of humans, the womb from which their first ancestors emerged be-
fore going on to populate the Earth. A number of rites and religious
practices were accordingly devoted to the cave.[23] That caves carried a
female meaning, in the Paleolithic and later, is beyond any doubt. The
abbé Henri Breuil and André Leroi-Gourhan drew attention to this
some time ago.[24] The entrance of the cave of Parpalló, not far from
Valencia in Spain, is shaped like a vulva.[25] It is perhaps not entirely by
chance that this cave, which contains a number of parietal artworks,
was selected as the site where a very particular gesture was performed,
one that was repeated there over some fourteen thousand years, from
the Gravettian through to the end of the Magdalenian: deposition of
painted or engraved flat stones. Excavations have in fact revealed a
succession of archaeological layers in which more than five thousand
decorated, engraved, or painted flat stones were discovered.[26] This site
hence testifies to the persistence of magico-religious beliefs and pre-
cise rituals that occurred there, in a place that was undoubtedly per-
ceived as a primordial womb.

Further examples also attest to the feminine character of Paleo-
lithic caves. For instance, in Gargas (Hautes-Pyrénées), a relatively
large chamber in the cave has been painted entirely red. In Le Com-
bel at Pech-Merle (Lot), there are stalactites with a shape reminiscent
of breasts that have been adorned with reddened tips. Contours of
the natural shapes of the wall, fissures or hollows have been high-
lighted using engravings (Bédeilhac) or paintings (Cosquer) in order
to emphasize the appearance of female genitalia. In the deep gallery
of Niaux, André Leroi-Gourhan noticed and reported the presence of
barbed signs (male, according to his system of interpretation) near
two evidently female "alcoves."

These deep caves, probably perceived as either completely or par-
tially female, constitute a strange and alien world. Total darkness re-
quired either the use of lamps with animal fat, which had to be re-
plenished regularly and had wicks that needed replacing, or armfuls

of pine wood torches. If these went out, they could easily be relit with a lighter using an ore such as pyrite or marcasite that could be struck with a flint to create the requisite sparks, or else with a wooden fireboard that was used to light the fire with the aid of friction. A number of modern experiments have demonstrated the effectiveness of these techniques.[27] When a person moved around in the cave, the flame, which illuminated only a limited zone around the bearer, flickered and the shadows on the walls moved ceaselessly, animating and accentuating surface details that would soon return to darkness. These conditions, partly imposed by the constraints of the means of illumination, must always be borne in mind if one wants to reach a realistic understanding of how Paleolithic people perceived the caves and their walls.

Additional strangeness is generated by what specialists call speleothems or cave formations: stalactites and stalagmites of all different kinds and origins. These formations with their bizarre shapes—from the thin eccentric ones that seem to have grown in all directions at once, in bunches or convoluted filaments, to the enormous columns rising toward the vaults—could not fail to inspire human imagination. After all, they exist nowhere in nature outside of caves and belong exclusively to the mysterious subterranean domain. A netherworld must necessarily possess distinctive features. They assail the spirit of those that enter, demand explanations, and are likely to have beneficial or evil properties. We will see the uses that might have occasionally been made of them.

The Mayas of Central America, who for hundreds of years assiduously frequented deep caves for their rites, paid particular attention to speleothems. Examples of the breaking and reuse of such formations are known from dozens of caves and have been the object of extensive study.[28] Some were reworked and transformed into idols. Others were found outside, hidden on dwelling sites, included in altars or associated with burial places. These particular uses of cave formations provide "a good indication that cave formations are thought to have some type of power or *mana* (a Polynesian word used to denote spiritual power)."[29] Furthermore, "there is evidence among the modern Mix-

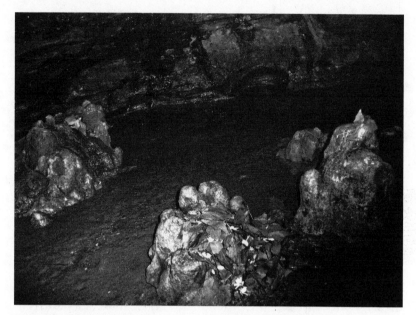

Figure 14. In Jatashankar (Madhya Pradesh, India), the stalagmites at the entrance
of a small cave are still objects of devotion and inspire offerings of flowers and leaves.
They are sometimes painted in red, the sacred color of the god Shiva.

tec and in the archaeological record that speleothems may have been
regularly kept as part of the collection of objects of power that pro-
tected every household."[30] These beliefs in the supernatural powers of
caves and their contents, and indeed of their surroundings, along with
their associated uses are not restricted to the Mayas. On the Tibetan
plateau, far from Central America and Polynesia, caves are sacred sites
and "Pilgrims may take earth, water, stones, plant parts, and other
objects from around the cave. *Gnas* saturates these objects, providing
benefits to their possessors."[31]

In India (Pachmarhi region in Madhya Pradesh), I was able to visit
a number of sanctuaries dedicated to Shiva where people had de-
posited fragments of stalagmites or convoluted stones covered in red
paint at the bases of sacred trees or in rock shelters. Sometimes, in
the entrances of caves, it is the stalagmites themselves that have been
honored, colored with sacred red and covered in flowers and leaves
(fig. 14).

Let us return to the Paleolithic caves. No cave is identical to any

other. Even if Paleolithic people of thirty-five thousand or fourteen thousand years ago behaved in the same way in the subterranean environment, penetrating right to the back everywhere, slipping into small recesses, exploring adjacent galleries, and leaving their traces, it is possible that they perceived caves differently. Perceptions may have diverged according to whether they were gigantic, like Niaux, Rouffignac, La Cullalvera in Cantabria, or Nerja in Andalusia, with vaults and galleries that disappeared into the darkness, or, by contrast, represented relatively narrow passageways (Marsoulas, Font-de-Gaume, Massat, Gabillou), or small caverns in the half-light (Pair-non-Pair) that could be accessed without problem or risk. In the Niaux cave, it is noticeable that after the undecorated entrance chambers, the passage, which is markedly smaller than the deeper galleries, bears lines on both its walls that the visitor can see when walking in the middle of the passageway, even in the weak light of torches or lamps of animal fat. Further into the cave, after the Great Junction, the galleries widen and only the right-hand wall, which the conformation of the site invites the visitor to follow, is decorated, apart from a few geological formations that are clearly visible such as hanging rocks in the middle of the gallery.[32]

As far as the distribution and localization of paintings is concerned, in many caves they bear witness to two different logics. These can be described as the "logic of the spectacular" and the "logic of remote locations."

The superb compositions of the Hall of the Bulls in Lascaux, the Black Salon in Niaux, or the Great Panel in the End Chamber in Chauvet are prominent examples of the first type. The comparatively vast chambers would have been able to accommodate relatively large groups. The drawn or painted images are detailed, sometimes complex, and of considerable size. They are visible from a distance, like the big red and black horse of Labastide (Hautes-Pyrénées), which was painted on a large rock right in the middle of the passageway, with its outlines surrounded in white as a result of scrapings. The images at these sites are sometimes inextricably superimposed one on top of the other in certain panels (Sanctuary at Trois-Frères; Apse at Lascaux).

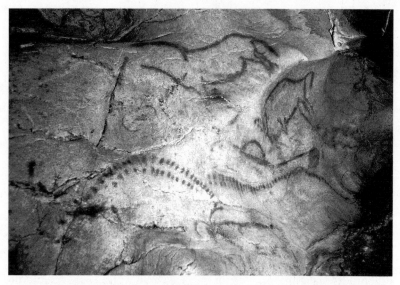

Figure 15. A single person can slip into the narrow recess of the cave of Le Portel
(Loubens, Ariège), whose walls and vault are covered in paintings.

This suggests participation in collective ceremonies, which might
have been either frequent or rare. These meticulously prepared and
very visible images might have played a social role in the celebration
of rites, in the perpetuation of beliefs and of perceptions of the world,
and in recruiting the aid of invisible powers.

In other cases, and sometimes in one and the same cave, the draw-
ings were executed in a small recess with room only for a single per-
son, such as the Camarin du Portel (Ariège), where the walls and vault
are entirely covered in images that cannot be seen by a group (fig. 15).
The same goes for the Cabinet of the Little Reindeer at Trois-Frères,
the Sanctuary of the Hands at Gargas (Hautes-Pyrénées), or the Cham-
ber of the Red Vulvas in Tito Bustillo (Asturias). In Lascaux, the very
narrow Chamber of the Felines, thus named because of several en-
graved lions—the only ones in the entire cave, which undoubtedly
has some significance—was frequented only rarely, judging by the ab-
sence of traces on its soft and unprotected wall surface. Frequent pas-
sage would inevitably have led to them being marked. Here, the logic
of the spectacular is thus complemented by a logic of the remote and
secret location, of the drawing per se, to which only the creator of the

images or an initiate of a particular rite had access. Others truly con-
stitute "theater stages," as with El Pendo in Cantabria.[33] This dual logic
is noticeable from the Aurignacian of Chauvet to the Magdalenian of
Trois-Frères and of Portel, passing through the Gravettian of Gargas
and the Solutrean of Lascaux. It has thus persisted across ages and cul-
tures and is an integral part of Paleolithic ways of thinking and, as a
consequence, of the manner in which the caves were utilized.

This comes as no surprise. Regardless of the particular religion,
revered sites need not be sacred in a homogeneous fashion. In a
church—where the holy of holies, the chancel, will hold the conse-
crated host, tangible presence of the God of the Faithful—a chapel
might be consecrated to St. Anthony of Padua, who supposedly favors
the finding of lost objects, to one of the numerous incarnations of the
Virgin Mary, or to any other saint with specific virtues for healing or
protection.

The Mayas, who assiduously frequented the caves of Central Amer-
ica for their ceremonies for hundreds of years, had much in common
with European Paleolithics in their manner of tackling the subterra-
nean environment, which they also considered to be female.[34] Like
them, they moved about the caves barefoot and illuminated them
with torches. Like them, they ventured very far below ground and
were not deterred by the physical obstacles in their way.[35] Finally, like
them, they did not behave in a uniform fashion when inside. In this
context, Andrea Stone[36] refers to a "sacred geography" in which not
only the entrances to this supernatural world but also the most re-
mote locations (the farthest and most difficult to reach, located near
a water inlet or an underground river) were charged with meanings
and particular powers and were the object of ritual ceremonies and
offerings.

So what about the individuals that had access to the sacred caves
in Paleolithic times? The "artists" undoubtedly enjoyed special status,
and we will see further on what we can make of this fact, but they were
not (or at least not always) alone. Traces and footprints provide some
information on this matter, but never enough. Indeed, these fleet-
ing and highly vulnerable traces are not preserved in the majority of

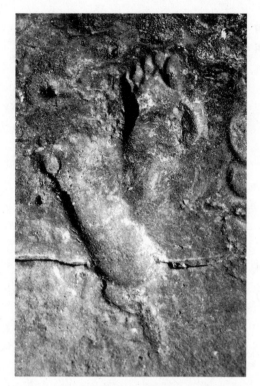

Figure 16. In the cavern at Niaux (Ariège), two prehistoric children
left prints of their naked feet in a muddy side passage.

caves. This is the case, for example, where the floors are too hard, or
any traces have been destroyed by the actions of nature (flow of water,
formation of deposits) and especially by the feet of the first subse-
quent visitors, who would have ignored them. Thus, in the huge cave
of Niaux any prehistoric prints have disappeared because the floors
have been trampled everywhere for centuries. The only traces that
have survived to the present day are found in a low-roofed side pas-
sage—and were hence naturally protected—where two children at
two distinct points in time left prints of their bare feet in the mud (fig.
16).[37] However, we do not in fact know whether they were contempo-
raries of the artists.

This latter problem does not arise when caves were frequented only
during one era, as was the case in the Magdalenian for the upper net-
work in Tuc d'Audoubert or for the cave of Fontanet (Ariège). Human

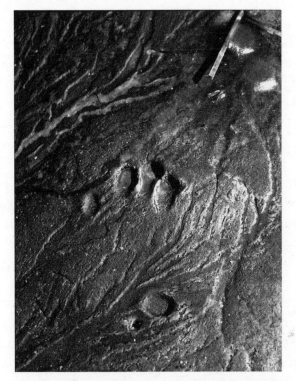

Figure 17. A child's handprint on the floor of Fontanet cave
(Ornolac-Ussat-les-Bains, Ariège).

footprints, especially of adults, are quite numerous in the deepest gal-
leries of Tuc d'Audoubert. But there are also two notable prints of a
child of about four years old at the edge of the current passageway.
The child slid down the slope and slowed its descent by curling its toes
in the clay.[38] Right at the end of the cave, not far from the famous clay
bison, we have known since the site's discovery in 1912 of footprints
of several children or adolescents that had participated in some form
of ceremony in the Chamber of the Heels, where they pressed down
only with their heels rather than with their whole feet.[39] In Fonta-
net, adults entered the cave, most of them with bare feet, although
one was wearing a kind of soft moccasin, something that is other-
wise totally undocumented up to that point in the Paleolithic. The
adults were accompanied by younger individuals (fig. 17), including
at least one child, about six years old, who left a very clear handprint

on the floor.[40] In Chauvet cave some twenty footprints belonging to a preadolescent (about four feet three inches tall), "probably a boy," were studied by Michel-Alain Garcia, who thought that he might have been accompanied by a dog.[41] Torch marks along the raised path have yielded dates close to 26,000 BP. Other caves have also preserved footprints (Montespan, Cosquer, L'Aldène, Pech-Merle) or other traces (hands in Gargas, finger tracings at Rouffignac) ascribable to children.

All of this indicates that individuals of all ages, that is, not just adults but also very young children (Le Tuc d'Audoubert, Fontanet) and preadolescents, were allowed access to the deep galleries. This also means that younger individuals were not excluded from some rites. Proof of this comes from Tuc d'Audoubert in the Chamber of the Heels, but also from Cosquer, where a child's hand was pressed into the soft surface of a wall at some seven feet above the floor. This child was deliberately carried or lifted by an adult (fig. 18).[42] This is also the case at Rouffignac, where a child (judging from the size of the fingers, at least) was also lifted to make complex finger tracings on a vault.[43] Similarly, in Gargas, a baby's hand was held against the wall by an adult to produce a hand stencil by blowing pigment.[44]

Determining the sex of adults that frequented the decorated caves is much more difficult, as footprints cannot be sexed. The only material elements on which we can base assumptions regarding sex are a person's size and the shape of the hands. Two attempts of unequal value have been made to this end at Chauvet and at Cosquer. In Chauvet cave, there are several panels bearing large red spots that were produced by applying a paint-covered hand to the surface of the wall. Quite frequently, partial finger marks have been preserved. Yet two of these panels were each created by a different person. The first, consisting of forty-eight "spots," was fashioned by an individual of relatively small size, matching "the hand of a woman or adolescent." The second panel contains ninety-two punctuations created using the same method, of which the highest are "situated at seven-and-a-half feet above the present-day floor, corresponding to a man with a stature of roughly six feet."[45]

At Rouffignac, some of the finger tracings or flutings on the ceiling

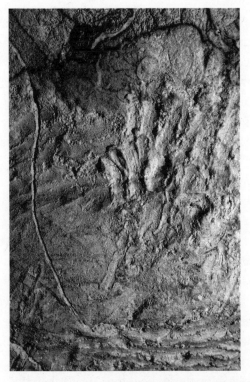

Figure 18. In the cave at Cosquer (Marseille, Bouches-du-Rhône),
a child has been lifted up by an adult so that it could imprint its hand
into the soft surface of the wall, about seven feet above ground level.

are "now in places just reachable by a man six feet in height stretching
on tip toes."[46] In Cosquer, an engraved animal on a high vault could
only have been created by a person standing on an ancient stalagmitic
ridge. Study of the site showed us that this was the only possibility
for production of the engraving and that there were no signs that a
ladder or scaffolding had been used. Accounting for the distance in-
volved, the author of the drawing was at least six feet two inches, and
was therefore most probably a man.[47]

By contrast, in the same cave, the hand stencil that first drew the
attention of Henri Cosquer when he discovered the paintings was
always considered to be female because of its proportions and gra-
cile wrist.[48] In 2006, Jean-Michel Chazine and Arnaud Noury tried to
determine the sex of the creators of the hand stencils by using the

so-called Manning index (digit ratio). This stems from research by John Manning on the relationship between the lengths of the index and ring fingers. Statistically these two fingers should be of similar length in women, whereas the ring finger should be longer than the index finger in men. According to this criterion, in Cosquer complete female hands would be more numerous than their male counterparts. However, this method has since been criticized because of its many uncertainties and has now been abandoned.

In any event, it is highly likely that men, women, and children would all have visited the mysterious depths of the decorated caves, at least under certain circumstances. Many questions suggested by behavior recorded in ethnologies remain unanswered: Did they go there together or separately to participate in specific rites? Did they all have access to the same sites, or were some sites taboo for certain individuals, based on gender and level of initiation? Were the caves always accessible for ceremonies or only at particular times of the year?

We do know, however, that frequentation of caves extended over time. It is rare, as is the case in El Castillo or at Llonín, that a chamber served as a habitat throughout the Upper Paleolithic and that deep extensions of the caves were frequented over the course of the many millennia over which this occupation persisted. Far more frequently, different visits occurred at points in time that were sometimes several millennia apart. This is the case in Chauvet, where we have proof that the Aurignacians went inside the cave on various occasions about four thousand years prior to one (or more) later Gravettian incursion(s). In Cosquer, it is the Gravettians that preceded their Solutrean successors by six to seven thousand years. In Trois-Frères, the Gravettians were the first to produce a few drawings, but it was during the middle Magdalenian, some twelve thousand years later, that the cave was used and decorated most. One could provide a multitude of such examples (Peña de Candamo, Cougnac, Pech-Merle, Le Portel, Font-de-Gaume, La Garma, Altamira, Tito Bustillo), even if culturally homogeneous caves are the most numerous for all eras (Gargas, Cussac, Lascaux, Rouffignac, Niaux, Bédeilhac, Fontanet, Montespan, Le Tuc d'Audoubert, Pindal, Ekain).

These visitations spread across millennia raise several problems. It is clear that, once the collapse of the cliff has sealed its entrance (Chauvet, Cussac), a cave is no longer physically accessible from that point onward. But in cases where the cave was reused several thousand years after the first visits, this argument has no validity. What could have happened? Was the entrance deliberately closed to bar access to the cave, or was it subject to taboos that eventually petered out? If future excavations are carried out in the entrances of decorated caves that are currently obstructed, it would be interesting to search for possible traces of ancient deliberate blockage. In any case, the question remains open.

Deep caves were not subject to frequent visits. They occurred in small numbers in Europe, and many images are located in places that are not accessible to groups, even small groups. These two facts conflict with any notion of pure representation of myths with a didactic goal, where sacred knowledge was transmitted or sustained for use by the community, whose diverse members would gather at the base of decorated walls for collective ceremonies. André Leroi-Gourhan, echoing others before him, evoked this question very clearly: "One fact that struck prehistorians (first and foremost H. Breuil), is that the sanctuary caves do not all show traces of intensive frequentation, and some, which are not the least elaborate, such as Niaux, even seem to have been visited very rarely." Accordingly, he followed this with: "Personally, I have often asked myself whether the fact of knowing that this organized world existed at the heart of the earth was not the most efficient representation and whether humans, or competent (if not to say initiated) humans, were not able to visit it, in body or in spirit."[49] In this case, knowledge about the existence of the deep sanctuaries would have persisted for a long time, and they would only exceptionally have been reopened or frequented again, perhaps by the initiated and only under rare and special circumstances.

The second problem raised by such visits at long intervals is that regarding the attitude of later arrivals toward their predecessors, their works, and their traces, which they could hardly miss. One can well imagine the emotion and apprehension of a small group of Gravet-

tians entering Chauvet cave and discovering the Recess of the Horses or the Great Panel of the End Chamber in the halos of their smoking torches.

Three principal kinds of response are conceivable. Acceptance of these images, works imbued with powerful magic and bearing sacred stories central to the ancient myths of the tribe, was most likely the most common response. Indeed, in the overwhelming majority of cases, the artworks were respected and left as they were.

Traces of deliberate destruction that bear witness to an attitude of refusal or a desire to desecrate, reflecting a completely different state of mind, are rare but do exist. In Chauvet, in the Hillaire Chamber, several representations of reindeer were partially erased or crossed with engraved lines with the aim of eliminating them. In Cosquer cave, fifteen hand stencils (six red and nine black) met the same fate (fig. 23). These observations raise more problems than they can resolve. First, the precise date of these disfigurements: Can they be ascribed to people who visited the cave much later, as one might logically assume, or rather to the creators of the drawings themselves or their contemporaries for reasons unknown to us? No formal proof exists either way. Then, why destroy some drawings but not others? At Cosquer, about fifty other hand stencils were respected and left untouched.

Finally, there is the third and quite frequent attitude observed, apparent indifference toward ancient works, where these are covered with new drawings. Several scenarios are imaginable. When it is a singular panel, deliberately chosen for an accumulation of drawings that are superimposed and entangled (the Apse at Lascaux, the Sanctuary at Trois-Frères), one might think of a process of sacralization: the wall stores power that is magnified by each additional image. We are then not very far from the conceptions of abbé Henri Breuil, according to which palimpsests would be the result of an accumulation of separate magical operations, repeated over time at the same location.

By contrast, erasing an image and replacing it with another, as seen in Chauvet (horse's head superimposed on a crossed-out reindeer; partial scraping of the rhinoceros engravings on the Panel of the Horses

prior to realization of the black drawings), suggests that the earlier images had lost their power or interest. This "priming of the wall," as we tend to call this in our highly technical culture, might therefore have other meanings, more complex and deeper than simple practical gestures aimed at obtaining a virgin surface, much like how one would wipe a blackboard clean before writing on it again. In Chauvet cave, bear claw marks are found in their thousands. Scraping these over a certain area, as done in the particular case of the End Chamber, would indeed generate a "white" surface that would be favorable to drawing. However, does this not go further, and shouldn't we see in this action a desire to destroy the "bear's magic," which dominates the entire cave to such a degree? At the very least, this question is a valid one.

Finally, indifference due to the passage of time, or to forgetting and the accompanying loss of function, is indisputably indicated by two series of observations. In some inhabited decorated rock shelters, it happens that painted or engraved walls end up being covered by archaeological layers, formed bit by bit by the detritus of the people living in close proximity (Le Placard in Charente; Gourdan and, partially, Marsoulas in Haute-Garonne). This means that they had lost the power, the role, and the importance that had been allotted to them for a certain period. The same state of mind seems to have dictated the uses of the engraved flat stones. In the cave of Parpalló, several thousand of these were deposited and might constitute a type of votive offering. In contrast, in Enlène (Montesquieu-Avantès, Ariège), twinned with Trois-Frères, as in other caves, they were used deep below ground before being shattered, discarded, or reused with other stones as paving.

Attitudes to Cave Walls and Speleothems

Let us stay in the caves, the ideal environment for striving to understand the attitudes of those that frequented them toward the walls and their physical peculiarities. The preserving environment of a deep cave in fact possesses a huge advantage compared with rock shelters or open-air sites: Remains left behind by prehistoric people that manage

to survive to our time do so in the exact place where they were left, while those that are found during excavations are almost always in a secondary or tertiary position, fragmented and dispersed. As for the traces preserved on the subterranean walls and floors, traces that have disappeared long ago in the rock shelters or out in the open, they are very revealing with respect to behavior.

Four major types of behavior can be observed in connection with walls and floors. These concern the choice of walls for drawings, the interpretation of natural surface structure, the actions suggested by the walls, and the specific uses made of speleothems.

The Choice of Walls

We have seen that the choice of location, whether exterior or subterranean, for producing paintings and engravings, was not a simple matter and followed diverse logics. The same applies to the interior of caves of substantial size. In cases where we have just a simple passage (Marsoulas, Font-de-Gaume) or small-sized chambers, the phenomenon is less apparent, because there was less scope for choices to be made. In contrast, in any of the more extensive caves (Niaux, Chauvet, Rouffignac, Pindal, Tito Bustillo, Nerja, La Cullalvera) there is a notable presence of walls that would have been perfectly suited for drawings yet were never used. In Chauvet cave, the first chamber (Chamber of the Bear Wallows) is the largest in the cave and its walls, smooth and white, would seem a priori to be highly suitable. But paintings are present only right at the back. This came as such a surprise to me that, at the beginning of our research in the cave, I asked the geologists on the team whether some form of superficial degradation caused by natural phenomena (air currents, water flow, superficial calcification) might have occurred that could have destroyed any artwork. Their response ruled this out. The absence of any images was hence really due to choice and not to subsequent erosion.

That choice might have two underlying reasons, which are not necessarily mutually exclusive. In Chauvet was it perhaps necessary to produce the drawings in total darkness, far away from the light

of day? In the rather extensive cave of Mayrière supérieure (Tarn-et-Garonne), the only two bison that are portrayed there are found exactly at the edge of the "point of daylight," that is to say at the precise location where one is already standing in the dark but can still perceive the weak light from the entranceway.

It was undoubtedly also necessary for the wall to accept the image and for the applicant to sense this acceptance. We have seen current or recent examples of this type of behavior from the American Southwest (see chapter 2). Prior to any work on the wall, rather than searching for a surface where it would be technically easy to produce an image, it is legitimate to believe that the painter tried to perceive whether he was welcome or not. The artist needed to know whether this particular wall was suitable—not physically, but spiritually—for affixing an image and for what kind of image, or whether, on the contrary, the wall refused it or was devoid of power.

Acoustics may have played a role in the choices of a location and a particular wall. In the vast cave of Niaux, the Black Salon, where the great majority of drawings were created, is the only part of the cave where the walls serve as a sound box: Sounds are amplified and reverberate as in a cathedral. Did this natural phenomenon indicate this location to be a sacred site that was favorable for images? This is likely, as the Magdalenians must have been impressed and would have interpreted it in their own way. Several specialists—Iégor Reznikoff, Michel Dauvois, and Steve Waller—have studied the acoustic characteristics of decorated caves and shelters[50] and concluded that, in a certain number of cases, accumulations of paintings coincided with places of maximal resonance, which would provide strong support for this hypothesis.

The Importance and Interpretation of Natural Relief

Strictly speaking, belief in a supernatural power of the wall is vital, as it suggests certain representations. This alone can explain the constant utilization of natural contours, that is to say multiple reliefs of the wall: hollows, bumps, fissures. It is one of the major phenomena,

perhaps the most important, of all Paleolithic art, one that cannot be sufficiently emphasized. From the Aurignacian of Chauvet until the end of the Ice Ages, it is noticeable that fissures were used in the representation of an ibex or a mammoth (Chauvet), that a hollow that naturally resembled a stag's head was endowed with two antlers on its edges (Niaux), that small stalagmites served as penises for the men of Le Portel that were drawn around them, that reliefs were transformed into bison (Altamira, El Castillo), into a horse's head (Pech-Merle), into the chests or backs of Irish elk (Cougnac, La Pasiega), into ghostly heads (Altamira, Vilhonneur, Foissac), and hollows into vulvas (Bédeilhac, Cosquer). The diversity of subjects represented in this way demonstrates that it was indeed a general state of mind, and not a search for a particular animal or theme. The constancy of this phenomenon—one that is by no means self-evident—throughout the twenty-five thousand years of cave art and across the whole of Europe is clear evidence that this attitude was and continued to be fundamental.[51]

Becoming aware of this ourselves and striving to look at the wall from a perspective close to that of Paleolithic people led to several discoveries that confirmed our standpoint. Others will no doubt follow. For instance, in 2004, I led a tour of Niaux for a group of participants in an international symposium that had just been held at the Prehistoric Park in Tarascon-sur-Ariège. I was showing them the Black Salon when the light of my torch highlighted fissures at the ends of two long black lines. Those lines were known to those familiar with Niaux, but had been previously considered to be of no great importance, or, at best, to constitute a geometric symbol. On this occasion, an ibex's head appeared to me, composed of natural fissures for the head and chest and completed by the two converging black lines for the horns. A rapid examination confirmed my first impression.

During a later visit, I had the idea of looking to see whether the use of natural shapes, comparable to this one, might help to explain another, very basic, ibex, on the extreme left of the same panel, consisting of a line for the back and two others for the horns. By varying the direction of the light, it quickly became apparent that, when the

light source was held to the far left of the animal, a relief evoking a head could clearly be seen. This relief is underlined by a curved line, no doubt engraved, placed where the jaw would be. This had never been noticed up to that point.

These two ibexes were hence created, perhaps by the same person, or at least in the same frame of mind, entailing careful searching for animal forms in the rock. While the natural contours of the right-hand ibex are visible or can be guessed depending on where one holds the torch, this does not apply to the other, whose head only really emerges when the light is held clearly to its left and very close to the rock face. Illumination with a burning torch or animal-fat lamp will only have accentuated this phenomenon, serving to breathe life into these immanent animals in the rock.[52]

Other discoveries were also made. In 2009, I revisited La Pasiega with Marcos Garcia, who was then the director of the caves, and José-María Ceballos del Moral, whom we called Chema and who was the local chief guide for an extended period. In gallery B, there is a bird that consists almost entirely of a prominent relief of the wall, and only the eye and legs have been added, showing that the resemblance to a bird had not escaped the Paleolithic visitor (fig. 19). Very close to this, on the same wall, there was an isolated curved line, made of red dots placed side by side. It occurred to me that it might represent the belly of an animal, yet I searched in vain for any relief that might complete it. So this was not the answer. But what if it was the line of a back? This conjecture was immediately confirmed, and we saw the emergence of a head and chest of a possible horse with the line of red dots constituting the back and beginning of the neck (fig. 20). After having verified this find, not without some surprise, my friend Chema, for whom the Cantabrian caves and particularly those of Monte Castillo hold no secrets, exclaimed: "I know of another one." He hurriedly led us to a neighboring chamber, where for a century a doe without a head had been known to exist. In the beam of the torch, inclined to accentuate the reliefs, the head appeared: the doe was complete. Chema did not forget this experience. Toward the end of 2010, he told me that he had recently been back with colleagues to visit the cave of Llonín, in the

Figure 19. La Pasiega cave (Puente Viesgo, Cantabria, Spain). A natural
shape evocative of a bird has been completed with an eye and legs in red paint.

Asturias, and was shown the two engraved, and apparently isolated, ears of a doe. To everyone's surprise, using the beam of light he made the head, consisting of a natural relief, emerge from the shadows.

Various reliefs that can be transformed in the same way were no more obvious than the doe's head of Llonín. This applies to the Irish elk of La Pasiega, where the artist started with the head and hump visible in the rock, materialized through natural fissures (fig. 21), or to the "dying bison" in the deep gallery of Niaux, created using a concavity that demanded a display in vertical position. A long search was necessary to reveal these reliefs. One must assume that those who visited the caves, on rare occasion, in the weak light of their torches, paid particular attention to the shapes that appeared and disappeared, in their halo, on the walls of these strange places. Did they see spirits, whose power they hoped to capture or at least contact by completing

them through drawing, ready to emerge from the rock where some of their bodily contours could be detected?[53] In any case, Paleolithic people were not the only ones to have acted in this way. I have already cited the use of natural contours in the art of Baja California in Mexico. Examples are even more numerous in the sacred caves of the Tainos in the Caribbean.[54]

Holes and crevices in the cave wall, in addition to the uses already mentioned, could play another role in the creation of images. In Asia, it was noted that "Numerous Asian shamanic mythologies express the belief that rock crevices such as these, along with holes in the earth and simple caves, were the gates to the world of spirits."[55] A similar attitude toward the subterranean world would lead to seeing breaches in the rock as vistas into the hereafter. Animal spirits could enter or emerge from these, becoming loaded with a female supernatural power that determined certain rites. In fact, numerous observations lead in this direction. In the Magdalenian art of Niaux, on the

Figure 20. La Pasiega cave (Puente Viesgo, Cantabria, Spain). Right next to the bird in figure 19, a curved line of red points completes a natural shape where one can distinguish the head (on the left) and the chest of an animal.

Figure 21. La Pasiega cave (Puente Viesgo, Cantabria, Spain).
A large megaceros stag, with exuberant antlers, has been painted exploiting
natural fissures to represent the head and the hump of the back.

first panel in the Black Salon, two bison have been drawn on either side of a large median fissure as if emerging from it. In Chauvet cave, almost twenty thousand years earlier, similar examples abound: ibex, aurochs, bison with only the forequarters represented, the rest of the body seemingly still trapped in the rock surface (fig. 22); rhinoceros or horse seeming to emerge from a hollow.

The strangest aspect of the same cave is the composition of the Recess of the Horses, one of the two main panels in Chauvet. The walls, covered in remarkable paintings, converge to form a recess with a hole some six inches in diameter at its bottom. When there are heavy rains lasting for several days, water accumulates in the pockets of the karst and begins to flow away through this hole before reaching and flooding the neighboring Skull Chamber, which lies a little lower. This

exceptional phenomenon, which we experienced two or three times in fifteen years, is preceded by a strange gurgling that arises from the depths of the rock. How could we not think that the Aurignacians might have been impressed witnesses to this, attributing a particular magic power to this place? The second major panel of Chauvet, in the End Chamber, also consists of two sections, one on each side of a small central niche from which a horse seems to emerge, with its hindquarters partially hidden by the relief of the wall (fig. 22, bottom right).

The cave, because of its nature and owing to certain particularities, interpreted through traditional beliefs, was accordingly important in its own right, playing a determining role in the creation of the artworks. Before applying them to the walls and proceeding to perform

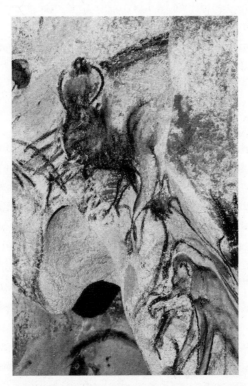

Figure 22. In the Salle du Fond at Chauvet cave (Vallon-Pont-d'Arc, Ardèche), the forepart of a bison (at the top) was deliberately represented as if it were emerging from a fold in the rock.

their ceremonies, the cave's visitors examined the walls carefully, striving to detect their potential and decipher their deeper meaning.

In a certain way, paintings and engravings allowed them to enter into contact with the supernatural reality. The image could have multiple functions: recreating a myth, passing knowledge of it on to the uninitiated, reminding others of it in the great chambers, but above all, perhaps, capturing a power and perpetuating it by drawing it. Other gestures bear witness to a desire to enter into direct contact with the powers of the world beyond.

Entering into Contact with the Wall and What It Conceals

According to the traces that have survived to reach us, we can distinguish three main means of achieving such contact: negative or positive hand stencils, finger tracings and touching, and finally inserted bones, on which we dwell longer because these modest and poorly known remnants are actually quite important.

HANDS

Placing a hand on the wall and defining its contours by blowing paint is a universal gesture. In some contexts, it has no more meaning than graffiti or a signature. We have seen examples of this in Australia, where these handprints, also called hand stencils, can have diverse meanings. But this explanation does not apply to the decorated caves, for several reasons. To start with, these negative hand stencils are often found in deep and remote locations (Trois-Frères), on the edge of an abyss (Cosquer), in a special recess (the Sanctuary of the Hands in Gargas), or even as a component of complex compositions (Great Wall of Hands in Gargas). In other words, they do not in any way fit the conditions that one would expect for casual, meaningless gestures. Their close association with other themes of parietal art, such as the presence among them, in Gargas, of children's hands—including one in a special niche and the other, that of a baby, held and applied to the

wall by an adult hand—allow us to reject the hypotheses that they are fortuitous actions or signatures.

Here, we are not in just any given environment, place of passage or living space, but in deep decorated caves that were the focus of rare incursions and had a spiritual value that needs no additional demonstration. Among many peoples, however, the paint was not a simple neutral material; it was the product of detailed investigation and elaborate preparations surrounded by rites. It is easy to imagine that, in placing a hand on the wall and expelling sacred paint onto it, the hand merged with the rock and acquired the same color, red or black, establishing concrete contact with the spirit world.[56] This gesture was a direct link echoed by a phantom of the hand after the ceremony. It was doubtless the same for positive hand stencils, for which a paint-covered hand was applied to the rock, or for the child's hand in Cosquer cave, printed high up on the soft surface of the wall (fig. 18).

As always, we have to content ourselves with a simple and basic explanation, and it is certain that many complexities elude us. Sometimes in the same caves (Gargas, Cosquer), without us knowing why, some negative hand stencils are complete while others have incomplete fingers with diverse configurations (fig. 23). Three distinct explanations have been given for this intriguing phenomenon.

The first was that these were ritual mutilations, such as exist in Australia or elsewhere, connected with initiation ceremonies or signaling mourning. The second invoked pathological mutilations (frostbite[57] or illnesses that cause necrosis of the extremities, such as Raynaud's disease or Ainhum syndrome).[58] The possibility of ritual amputations cannot be dismissed out of hand, if one considers the (very) rare cases of such mutilations in the Upper Paleolithic. In this context, it is important to recall the discovery of a skeleton in Mursak-Koba in Crimea, from a woman who had undergone, seemingly during adolescence, removal of the terminal bone (distal phalanx) of the little finger on both hands. More recently, in Oblazowa cave in Poland, left-hand thumb phalanges were discovered in association with diverse objects deemed to be religious. They most likely resulted from amputations.[59]

Figure 23. Cosquer cave (Marseille, Bouches-du-Rhône). Two hands (the one at
the top to the left is barely visible) with incomplete fingers, which are probably
folded back. The hand at the bottom has been "obliterated" with diagonal lines.

Following the discovery of Cosquer, however, the pathological hy-
pothesis must definitely be abandoned. Otherwise—given that they
are not the same hands in the two caves—one would have to accept
that distinct human groups contracted the same disease or suffered
from similarly severe frostbite despite being hundreds of kilometers
apart and in very different environments (Cosquer in Marseille, Gar-
gas at the heart of the Pyrenees). It would also have to be accepted that
they responded in identical ways, expressing their infirmity with the
same techniques in the depths of the caves. Such a hypothesis seems
barely plausible.

The most likely hypothesis was formulated by André Leroi-
Gourhan.[60] According to him, this represents a coded gestural lan-
guage, as practiced by many hunting peoples, in which folding par-
ticular fingers transmits precise information.[61] Using such codes, not
only for the hunt but also to address the spirits, makes sense. In con-
trast, it is not possible to know their meaning, or to know whether the
colors used for the hand stencils, generally red or black, played dif-
ferent roles. Several researchers (for example, Jean Courtin and Marc

Groenen) verified experimentally that folding of their fingers would produce results analogous to those observed with the Paleolithic hand stencils. They reconstituted all the known configurations, so that this matter now seems settled.

INDETERMINATE OR INCOMPLETE CONTOURS,
FINGER TRACINGS, AND TOUCHING

Since parietal art was first discovered, we know of innumerable examples of tracings on cave walls that, for us, seem to represent nothing at all. They are on different scales, but might be hallmarks of similar intentions, comparable to those suggested for the hand stencils. For a long time, these modest traces were neglected, even held in contempt. The abbé Breuil spoke of "parasite lines" on or near the panels where the splendor of the portrayed animals was on display.

André Leroi-Gourhan had the virtue—once again—of drawing attention to what he called "the unfinished contours," that he described as "one of the elements that conformed the least with the scientific traditions of prehistory,"[62] and which he was very keen to emphasize. He attached importance to these "surfaces that have been covered in meanders, bundles, 'comet-shaped' lines, lines of engraved rods, animal figures that are often very incomplete, but sometimes very finely executed."[63] He stated that they were found in all eras, commonly in the vicinity of the first large composition, "as if many individuals, who did not necessarily have a gift for engraving, had superimposed, on the only available surface close to the great works, replications of the central theme or simple meanders."[64] He concluded that these tracings were "certainly linked to religious life, to the conception of the sanctuary," which is why in his chapter on rites he spoke of: "all these facts . . . leading to the idea that the rites during which figures of the same type as those decorating the large walls, but simplified and accumulated, were traced, as on the flat stones."[65] He did not take this any further and hence did not address the question, which presents itself in an obvious fashion, of the nature or meaning of such rites, in which individuals other than the great artists participated.

Figure 24. Cosquer cave (Marseille, Bouches-du-Rhône).
Example of finger tracings that cover a wall. Engravings (rectangle
bottom right) and the forepart of a black horse have been superimposed.

Finger tracings result from movement of fingers across a wall or
a vault with a structure that is sufficiently malleable (clay, moonmilk)
to allow these actions to leave indelible traces (fig. 24). Animals (La
Clotilde) or vague shapes were sometimes drawn with this simple and
elementary method, which Leroi-Gourhan includes among the un-
finished contours. In many deep decorated caves, however, there are
entire panels, sometimes occupying hundreds of square feet, that are
covered in straight and curved lines that cross and intertwine with
each other, with no apparent indication of any kind of order or the
slightest naturalistic representation.

According to a progressive logic that envisaged parietal art start-
ing out in a coarse manner, before gradual improving over the course
of millennia, Henri Breuil attributed these ubiquitous tracings to the
very beginnings of cave art, to his Aurignaco-Perigordian cycle.[66] Sub-
sequently, it was observed that these tracings did indeed exist in the
most ancient phases, for example, in the Gravettian (approximately
27,000 BP) of Gargas, Trois-Frères, or Cosquer, and perhaps in the
oldest, that is to say in the Aurignacian (Baume-Latrone), although

without the same magnitude or certainty (La Clotilde). But they are also found in a Solutrean setting (Las Chimeneas) and also later, as in Rouffignac, Covaciella, or Le Tuc d'Audoubert, where the context is uniquely Magdalenian (about 14,000 BP). This is hence a simple gestural product that was repeated during most of the Upper Paleolithic.

Repetition of these tracings is neither accidental nor insignificant. In Cosquer cave, some visitors climbed into high breaches to brush their fingers along the wall at the highest point they could reach or crawled into lowered passages in order to do the same at the farthest point. This all suggests that the creators wanted to produce tracings at the limits of the possible.[67] These extreme contexts allow us to reject the hypothesis of a mechanical gesture, as might occasionally have occurred.[68]

A particularly significant example is that of Rouffignac. Two of our colleagues, the sadly departed Kevin Sharpe and Leslie Van Gelder, after having carefully studied the finger tracings (or flutings) on a vault of this cave, concluded that at least one child had been lifted by an adult to produce some of them. The process had been relatively complex, as the adult had moved a distance of several yards while the child marked the surface of the ceiling. So, it was not a case of simply producing the drawings just anywhere, as was clearly noted by the authors: "One question worth asking is why the adults present (and some were, given the width of some of the flutings) did not flute the ceilings without using the children. The youngsters could have fluted where they could reach and the older people could have marked, not only these sections, but sections where the youngsters could not reach. But here they sometimes raised up the children to flute. Why? Further, the low sections of the walls that children could comfortably flute by themselves show no flutings." Moreover, "Those holding the children were at times not only walking, but moving rotationally from their hips, perhaps in whole body movement such as dancing."[69] This was hence clearly a rite, in a place and on a surface that had been selected, in which children were intended to participate.

Finally, in some cases, no doubt far more often than currently believed, given the absence of specific research, rites took place that in-

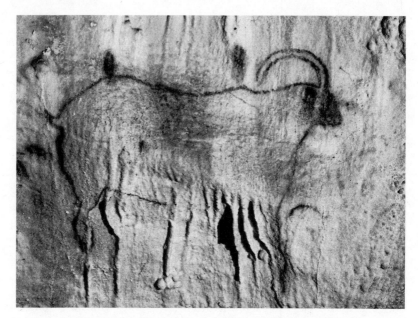

Figure 25. The black marks of twinned fingers have been applied on
and around this large red ibex at Cougnac cave (Payrignac, Lot).

volved touching of the walls. The first example to be reported, to my
knowledge, is that of Cougnac (Lot). Immediately after the discovery
of this cave, whose entrance had been sealed for millennia, Louis
Méroc and Jean Mazet stressed the presence of red and black finger-
prints, mostly twinned, that were applied to the wall (fig. 25).[70] Later,
Michel Lorblanchet commissioned an analysis of the pigment in a
large paint stain on the floor and of that used for the red traces on the
walls, confirming that they were identical. He concluded as follows:
"Everything seems to indicate that the prehistoric visitors dipped their
hands in the existing accretion of ochre on the ground, at the entrance
to the chamber, and that they then touched the decorated wall in sev-
eral places by pressing the tips of their fingers on the images and con-
cretions that surrounded them. Often they also simply rubbed their
painted hands against the calcareous bumps where they left scattered
traces."[71] Two corresponding radiocarbon analyses, around 14,000
BP for the black finger traces, which were made using charcoal, place
these gestures in the Magdalenian, whereas the first drawings were

attributed to the Gravettian. "Some ten millennia later, the wall of Cougnac was still being subjected to ritual use."[72]

Another remarkable example is provided by the Chauvet cave. In the End Chamber, when we traced the right-hand panel together with Marc Azéma, we recorded multiple traces of touching, occasionally also taking the form of finger tracings (fig. 26). The observed super-impositions show that some of these traces are prior to the animal images, while others are subsequent. We must hence accept that these gestures (passage of fingers across the wall) closely accompanied the creation of the drawings. These superficial marks, visible in tangential light, could never have been very visible. In this regard, they differ from the classic finger tracings, such as those of Gargas or of Rouffignac. Rather than *tracings*, these are hence truly *traces*, resulting from deliberate and repeated actions, but ultimately small in number. In

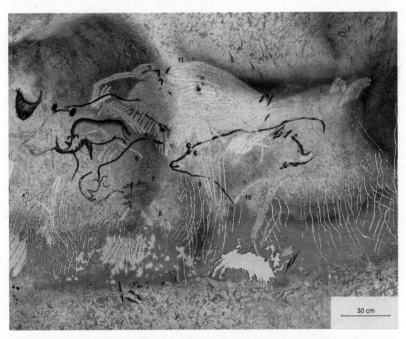

Figure 26. End Chamber at Chauvet cave (Vallon-Pont-d'Arc, Ardèche). Traces of more or less disorderly touches accompanied the creation of the black figures. At the bottom, the white vertical grooves are scratches made by cave bears prior to the drawings. Tracing by Marc Azéma and Jean Clottes.

this case, the action itself is of importance, not the result, as the effect does not remain very visible. Only the conjunction of a wall that lent itself to such traces and its excellent preservation allowed us to detect and study them. Others exist on diverse panels of Chauvet cave. Unlike the aforementioned unfinished contours, these are not outlines of drawings or aborted sketches. Instead, these traces testify to an indisputable desire to enter into direct contact with the surface of the rock through the hand.

Similar practices exist all over the world, in magico-religious contexts, regardless of the religions involved.[73] Touching or marking the wall, even in a partial or modest fashion, could establish a strong link between the person and the rock or the powers that it is thought to contain. This could be done with the aim of capturing a fragment of supernatural power, or to test the accessibility (spiritual, not physical) of the wall for drawing. Would the rock accept the planned drawing or the person wishing to create it? We will never know all the details, but these traces demonstrate the complexity of the processes. Besides paintings and engravings, the act of drawing in the deep caves, and undoubtedly in other contexts, was evidently accompanied by all kinds of gestures, including various forms of repeated touching of the walls.[74]

INSERTED BONES AND DEPOSITIONS

In the cave of Enlène (Montesquieu-Avantès, Ariège), numerous bones (splinters, rib fragments, horn tips, two spear points) were wedged forcefully into crevices in the walls, at various heights, between two and seven feet above the current level of the floor, apparently following no particular pattern. The chosen crevices can be horizontal, vertical, or more or less diagonal; some of them intersect. The bones barely protrude from the openings of the fissures. Their outer ends are broken, and the fractures are ancient. This phenomenon was first observed by Robert Bégouën. We began to study examples together,[75] and I then extended the work thanks to discoveries in other caves.[76]

The cave of Enlène remains the site where the largest array of in-

Figure 27. At the bottom of Enlène cave (Montesquieu-Avantès, Ariège), small fragments of animal bone were inserted into numerous fissures during the Magdalenian.

serted bone fragments has been found. A systematic inventory of these fragments reveals a certain ubiquity, as they are found more or less everywhere, albeit with some variation in concentration. The densest zones are found in the Chamber of the Dead, just above the narrow gallery that gives access to the Trois-Frères, in part of the passageway between the Chamber of the Dead and the End Chamber, in the End Chamber itself, and finally in a zone of paintings discovered at the end of this latter chamber, that is to say in a portion of the cave that was uninhabited in the Magdalenian but took on a certain importance. In fact, although the entire wall of this zone is riddled with fissures, inserted bones are found only close to the paintings. Up to five or six bones have been placed side by side, in each of ten distinct fissures (fig. 27). Above a zone that is weakly colored in red, three incisors (two from a reindeer, one from a bovine) were deposited side by side in a fissure in the wall five feet above the floor. The rear end of this cave, which is distinct from the area of habitation, evidently played a special role, as we observed there two unmistakable series of red lines, a coating of red pigment on some rocky projections, spraying of paint

on the walls, deposition of teeth, and crevices with numerous inserted bone fragments.[77]

The deliberate character of these insertions is indisputable. In any case, they cannot be ascribed to a natural phenomenon such as flooding or to any other geological or accidental cause. We envisaged the hypothesis of a "practical" reason, such as supports for threads or tie-lines, but this had to be rejected, as the disorderly nature of their distribution ruled it out. For example, a number of fragments placed in fissures are set at an angle, or hidden in a fold in the rock with blind angles. So they could not have served to secure anything at all.

In the Chamber of the Dead, we uncovered a bone placed vertically in the floor. During our excavations in the End Chamber (entrance and anterior extremity), fifty-nine objects were found in this position, in two separate groups, each with distinctive features. These objects were put in place when the cave was first occupied in the middle Magdalenian. Regardless of their size, they disappear into the floor entirely or barely protrude. The apparent goal was to insert them as deeply as possible.

No functional or natural explanation could account for the established facts. These objects did not get there by accident: The majority were vertical, and inserted deeply into a compact and untouched clay soil, whose nature had not changed since the Magdalenian. This excludes the possibility of random placing due to stamping or any entirely hypothetical arrival of water or sediments. If they had been intended to hold something in place on the floor (skin, tie, or attachment of some kind), we would expect them to encircle a specific area. This is not the case: Their distribution, in the zones where they are found, is scattered, which makes symbolic spatial demarcation very unlikely. Moreover, if they served as some kind of peg, their size should not lie below a certain limit. Yet three teeth that have been reworked to various degrees are part of the assemblage, which also includes a burin and a flat piece of sandstone. Moreover, one of these teeth is pierced and placed with the root pointing upward and hence cannot have been used to hold anything in place on the ground. Finally, a random collection made with the aim of salvaging materials for practical uses

would certainly not have generated the observed set of objects, which includes among other things decorated spears.[78] So these were objects that had been chosen deliberately to be stuck in the ground, from which they barely protruded.

Similar observations have been made in Le Portel, at Montespan, at Fontanet, and at Labastide, as well as in the area of the Paleolithic entrance in Chauvet cave, where two cave bear upper arm bones some thirty feet apart were set in the floor with half of their length protruding, each close to a cave bear skull. As for the bone fragments and flints inserted in the walls, these are found in a large number of decorated caves in the Pyrenees (Bédeilhac, Le Tuc d'Audoubert, Enlène, Montespan, Troubat, Labastide, Gargas, Isturitz, Erberua), as well as in the caves of the Dordogne (Lascaux, Bernifal, Le Pigeonnier), of the Lot (Sainte-Eulalie and Les Fieux), Burgundy (Arcy-sur-Cure), the Aveyron (Foissac), and of the Basque Country of Spain (Altxerri, Ekain), of Cantabria (La Garma, La Pasiega), and of Asturias (Llonín).

This phenomenon persisted for some considerable time, at least thirteen to fourteen thousand years. As the bone fragments of Gargas are closely associated with the negative hand stencils in this cave, a date of 26,800 ± 460 BP for one of these seems logical. This Gravettian date was confirmed by the discovery of a bone fragment that was similarly associated with the negative hand stencils in the cave of Les Fieux (Miers). One inserted bone from Brassempouy might also be very old, and this also holds for those of Foissac. Magdalenian dates are certain for most of the Pyrenean caves (Enlène, Le Tuc d'Audoubert, Labastide, Montespan, etc.), just as for Sainte-Eulalie in the Lot. The discovery of Troubat (Hautes-Pyrénées) confirms the continuation of this custom up to the end of the Magdalenian.

For a great many millennia, Paleolithic people performed these very similar gestures in a large number of decorated caves in France and Spain.[79]

In all of the decorated caves the art is a result of magico-religious practices. A virtually general consensus regarding this topic explains why they are so often described as "sanctuaries." These practices went beyond parietal drawings, and some of them necessarily left traces.

It is the specialists' job to try to find them. Such work is just as "archaeological" and essential as excavation, dating of portable or parietal vestiges, or their precise description and interpretation. Forgoing this would be just as absurd and unjustified as deciding to study only the paintings and not the engravings, or the portable bone but not the portable stone objects. With appropriate methodology, we should only envisage actions that are of a magic, religious, or ritual nature for those facts that—for us—do not fit any possible functional explanation. Now the objects mentioned cannot be assigned any functional explanation in the way that we would understand it,[80] or indeed any natural explanation. Their number and the conditions under which they were deposited demand that we discard any notion of objects lost or forgotten as a chance outcome of wanderings, carried there by water or animals, or deposited through casual gestures, as supports for tie-lines, or as tools that served a local purpose. Moreover, in all cases where such discoveries have been made, the caves involved are decorated and not merely inhabited. The bones, flints, and other stone and bone objects were often deposited or inserted with some direct connection to parietal artworks. Special gestures were hence performed in very particular locations.

Observations and testimonies concerning similar practices, around the world and in very diverse contexts, are numerous. The basic motivation is a desire to go beyond everyday life, to pierce the veil of physical reality, and gain access to, in one form or another, supernatural powers, either through an offering—even a symbolic one—or by touching them directly. Very frequently, for example, when Orthodox Jews go to pray before the Wailing Wall in Jerusalem and deposit rolled pieces of paper with their supplications in the crevices between the stones, they come one step closer to approaching a divinity at a site regarded as sacred.

Here is a further example concerning a cave and a sacred place: In the 1980s, in my role as the director of prehistoric antiquities for the Midi-Pyrénées region, I had to step in to facilitate an urgent rescue excavation in Lourdes before working in the zone around the "Œuvre de la Grotte." On this occasion, my colleague André Clot drew my at-

tention to a small cavity belonging to the same karstic system as the famous cave of Massabielle, where Bernadette Soubirous experienced her vision of the Virgin Mary. But this was a few hundred yards away, remote from the places normally visited by millions of pilgrims. On one side of this small cave, a natural hole, with a volume equivalent to about a hundred gallons, had been two-thirds filled with offerings and various other contributions: spectacles, wallets, coins, messages. In this case, it is the subterranean environment, sanctified by close proximity to a miraculous cave, which was and still is regarded as a stopping-off place imbued with power. It goes without saying that these "pagan" offerings were made without the permission, or indeed the knowledge, of the ecclesiastical authorities in charge of the site.

I have already recounted the story of the propitiatory ceremony in California in 1991, during which our Native American guide asked us to insert strands of native tobacco into fissures in the wall below some of the paintings. Ten years later—on this occasion in the Northwest of the United States, at Arrow Rock in Montana—I saw small coins, cheap pearls, cigarettes, or stones that had been more-or-less polished, placed in the fissures of a rocky wall in which spirits, called the Little People, were thought to reside.

Insertion of diverse objects in rock crevices in the depths of the decorated caves evidently resembles the examples mentioned. Although the basic notion—the desire for contact with the netherworld—is hardly in doubt, it can be manifested in two ways, according to the nature of the objects and the way in which these were treated: deposition for some and insertion into walls or floors for others. By leaving offerings, no matter how minor or symbolic, one establishes a one-way link, from our world to the other, without expecting an immediate return. This may be some form of benefit, protection, or impunity during the time spent at the locality, or even thereafter. It is the expression of an allegiance, a favor or an exchange.

Thrusting objects into crevices or into floors might be acts of a similar nature but with minor differences. In fact, in this case there is deliberate piercing of the veil that separates the world of the living from that of the occult powers.[81] So it was not the object itself that was

of importance, but rather the gesture, the will to enter into contact with the power hidden within the rock or in the floors and to harness a fragment of this power to come to terms with some of the eternal problems of life (illness, luck, acquiring food, etc.). These were perhaps uninitiated individuals, sick individuals, or children that participated in their own ways in the ritual. The persistence of these gestures throughout the entire Upper Paleolithic reinforces the deep sentiment of unity that inspired European parietal art.

USING WHAT WAS FOUND INSIDE THE CAVES

Taking into account everything that went before, it was inevitable that those who visited the depths of the caves sought to take advantage of what they found there. They undoubtedly occasionally did so without their actions necessarily leaving traces that we can discern.

In some cases, however, we have proof that certain things were taken from the caves. At the time of discovery of Le Tuc d'Audoubert in 1912, the young discoverers and their father, Count Henri Bégouën, noticed that, among the cave bear bones littering the floor, there were several skulls that had been relieved of their canines. One of the skulls had even been smashed on a stalagmitic mound to facilitate removal of the canine teeth. They concluded that the aim was low-cost collection of particularly spectacular items for adornment.[82] But it was impossible, then and since, to determine whether other bones had been carried away. For the canines, it is a certainty; for other bones from the skeletons we know nothing at all. At any rate, an interpretation that objects were harvested for adornment is but one possible hypothesis among others (protective talismans, medicinal uses).

During the initial visits that Jean Courtin made to Cosquer cave, he noticed that vast surfaces of the walls and accessible ceilings had been scraped away, often quite deeply. Yet at the foot of the areas in question very little could be found of the white material of which the walls are composed. This meant that the powder generated had been removed from the cave. The hypothesis that we proposed then, not

without some puzzlement, invoked body painting or various domestic uses.[83]

Almost a decade later, I noticed that, in the same cave, stalactites and stalagmites had been broken in various places. This was not gratuitous vandalism or destruction aimed at facilitating movement from one place to another, as most cases were found in areas where they would not have been obstacles. We then carefully examined the concretions situated in the higher parts of the cave, galleries that had remained inaccessible to the prehistoric people and devoid of any traces or charcoal: These concretions were never broken. This proved that the observed damage could not have had a natural cause, such as earthquakes, as in that case other concretions in the cave would have suffered similar consequences. Moreover, in a great majority of cases, the broken extremities were never found. These speleothems, just like the moonmilk, had thus been broken deliberately, harvested, and removed from the cave.

We then undertook research concerning uses of the concretions and moonmilk.[84] The oldest uses for stalactites and stalagmites, following crushing and reduction to powder, are found in Chinese pharmacopoeia in the fourth and first centuries BC. In the nineteenth century, also in China, and in the eighteenth century in Europe (including moonmilk), such powder was used as a remedy against all kinds of illnesses and for various treatments: triggering sweating during fevers, treating heart conditions (with diets poor in calcium), arresting bleeding and diarrhea, relieving coughs, promoting lactation in wet nurses, mending broken bones, drying out abscesses, and curing ulcers and wounds. Nowadays, calcium carbonate ($CaCO_3$) is used to treat osteoporosis (in conjunction with vitamin D), to aid regeneration of bones, to palliate growth problems, as a supplement for pregnant and lactating women, to combat tiredness, and so on.

The prophylactic role is not limited to the calcium that constitutes the major part of speleothems. A recent thorough reexamination of clay extraction activities observed in the Mayan caves concluded that in many cases, "the clay extracted may have been used in a ritual in-

volving geophagy, the consuming of earth." Besides, in Guatemala and these regions, "the clay is recognized by modern residents as having medicinal value and is eaten by the local people to cure diarrhea"; it is also given to pregnant women. The authors conclude that the "caves are associated with both illness and its cure, so there are logical reasons why cave clays would be sought for medicinal purposes."[85]

More than twenty millennia earlier, a similar attitude must have prevailed in Cosquer. There, in the depths of the cave, men or women scraped powder from the walls and carried away chunks of concretions, doubtless because they believed that these mineral materials possessed supernatural powers. The fact that poultices and medicines would have been successful in some cases surely did not escape notice, and this probably explains the persistence of this practice. It is possible that in Cosquer cave, in association with abundant wall art, we have the first concrete examples of the use of particular specific medicines in the history of the world.[86] Since our discoveries, we have found further examples (or these have been pointed out to us) of the breaking of concretions in decorated caves and disappearance of the fragments (Gargas, Cougnac, Hornos de la Peña, Las Monedas, El Castillo). It is probable that many others remain undetected.

Attitudes toward Animals

In the Masai Mara, in Kenya, I saw an antelope giving birth yet continuing to walk throughout the whole process, while another female circled around her to protect her or distract potential predators that might be attracted by the event. During the annual migration of gnus, I was lucky enough to observe them while they crossed a river, creating huge splashes as they tried to cross the waterway as quickly as possible because of crocodiles. A group of baboons, before risking entering an open space, observed, retreated, took all kinds of precautions. They looked very vulnerable. Being pursued by a buffalo is something that has happened to me. On another day, when I had ventured on foot into the bush, in a place that was seemingly devoid of danger, I saw from afar (fortunately), before making a cautious retreat, a lioness

following some giraffes. Imagining these situations is nothing out of the ordinary. But one has to have witnessed or have been the involuntary actor at the center of such experiences, which are so frequent and trivial in this wild environment, to realize and appreciate the extent to which our Paleolithic ancestors must have been attentive at every moment to the animals surrounding them, to their appearance and actions, regardless of whether they were predators or potential prey.

These conditions, which they would have experienced across the millennia, shaped not only their behaviors but also their ways of thinking, of apprehending animals and their roles in the world. Hence, according to the specialists, "animals . . . were integral to the evolution of the human brain to the extent that the encoding of animal forms seems to have become a dedicated domain of the visual cortex."[87] Such evolution was logical, as seeing and recognizing animals was an essential condition for survival. Animals are an integral part of humans, even more so for hunter-gatherers. This basic premise must be kept firmly in mind when we consider Paleolithic art and the concepts that inspired it, which we try to grasp through study.

In the "hunting magic" of abbé Breuil and Count Bégouën, animals were essentially prey that had to be appropriated through suitable rites. "It is indeed with the aim of bewitchment that Paleolithic man represented the animals that he went to hunt."[88] Hunting magic for the animals taken as food, fertility magic to make them reproduce in abundance, and destructive magic for dangerous animals: we have seen (chapter 1) that all were explicitly aimed at subduing them through the power of images.

In fact, the relationships of hunting societies with animals are far more complex. There are, for instance, many Northern American Indian cultures in which a Lord of Animals exists, one who protects animals and whose permission must be sought to hunt them. Animals themselves can regenerate after death, which ensures their persistence and hence the possibility of future hunts.[89] The rites performed have the goal of inducing an animal to accept its own death to favor the survival of a group of humans, its brothers. The game animal offers itself freely and surrenders to the hunter (Americas, Siberia). A

countergift is given in exchange: "No gift can exist without a counter-gift."[90] One must show respect to the animals that one fishes or hunts. The respect given will contribute to its rebirth and the continuation of its benevolent aid. Here, we are far removed from the magical constraints imposed by a dominating human being at the center of everything.

We have seen that some of the fundamental beliefs documented throughout the entire world, particularly in shamanic cultures, imply an interconnection of species, including between humans and animals, because of the deep affinity that unites them. Thus, with reference to the shamanic vocabulary of the peoples of Greenland, Joëlle Robert-Lamblin indicates that "The child of man is described with the same term as the offspring of the dog or of the bearded seal, thus recalling the existence of a sameness of the human and animal worlds in mythology and in beliefs."[91]

Among American Indians, man, who is "at the heart of, and not above Nature . . . therefore quite logically does not create anthropomorphic deities."[92] This leads to a better understanding of the absolute predominance of animals in Paleolithic art. They were the ones that incarnated the spirits that rule the forces of the universe. It was on them that people depended not only physically, for food and for survival, but also—and perhaps especially—spiritually, to guarantee health, equilibrium, and harmony in all facets of life.

We can also understand the presence of composite animals in the art, combining in one body the characteristics of different species, such as those of horse and bison (Cosquer, Cussac), or of fantastic animals endowed with unrealistic attributes (the unicorn of Lascaux) or bizarrely deformed bodies (Le Tuc d'Audoubert, Le Portel). Composite creatures, simultaneously human and animal (Les Trois-Frères, Gabillou, Cosquer, Lascaux, Pech-Merle, Cougnac, Hornos de la Peña, Candamo, Los Casares), are hallmarks of the same conception of the world in which animals are our equals, our brothers, and sometimes our gods.

Animals are endowed with special virtues and powers, often attributed to them because of perceived or supposed relationships with

particular phenomena. For example, in Zuni mythology (Arizona), amphibians and others "are water beings in both a literal and a metaphorical sense. Not only are they creatures who live in or near the water, but their image are used in several ritual activities aimed at bringing water to Zuni in the form of rain."[93] As for the Cape eland, it is right at the top of the hierarchy of spirit animals for the San of Southern Africa, playing a vital role in ensuring fertility and also making the rain come. It is considered to be imbued with powers, and as a consequence the rock shelters that were decorated with numerous images of elands represented veritable reservoirs of supernatural power.[94]

We can assume that this is also true of the caves and decorated rock shelters of the Paleolithic, and that the animals portrayed similarly possessed particular powers and were the props and heroes at the heart of myths. We will see some examples of this. As to their hierarchy, this may have varied across time and space, because we know that animals that were predominantly represented during the Aurignacian (the most dreaded and the least hunted) differed from those of later ages, whereas certain species occur more frequently in the art of some regions than of others.

This essential role played by animals evidently explains the small number of representations of human beings. In the Paleolithic world, humans were not at the center of the stage. Occasionally, people are surprised by the absence of a natural setting, as neither landscapes nor trees nor heavenly bodies are represented, at least not in a way that is immediately understandable to us. Paleolithic art was not a descriptive art that would have been equivalent to precise and comprehensive photography of the human's living environment. It told stories and was suffused with the power that was essentially attributed to particular animals.

On the other hand, many symbols that we call geometric are associated with the animals. In these, specialists have successively tried to see stylistic representations of weapons, then symbols with sexual value, and finally entoptic signs such as those perceived during a trance.[95] We actually know nothing of their precise meaning,

beyond the fact that they are too numerous and too oft-repeated to have no specific significance or role. But let us now shift our attention to myths.

Paleolithic Myths

Every religion has its myths that convey, in an image-rich and narrative fashion, the beliefs of the group and the interpretation that it has forged for itself of the natural and supernatural world in which it lives. It is hence inevitable that the cultures of the Upper Paleolithic not only had their own myths but also transcribed them, in one form or another, in their parietal or portable art.[96] One can even go further and claim that most parietal representations are props for myths or were created within the framework of traditional mythical tales, as is the case for the images present in Christian churches or Hindu temples.

Myths have various roles. Among their multiplicity and their complexity—to gain some impression of this, see Testart (1991)—we will distinguish three principal features, which are evidently interlinked to each other and are separated only to facilitate their discussion.

Their first role, both major and foundational, is explanatory. Faced with mysterious and incomprehensible natural phenomena, humans have always sought to explain them. A peculiarity of human beings (*Homo spiritualis* in the broad sense), beyond the material contingencies of survival that they share with other animals, is their ability to project themselves into the past or the future, to ask questions about themselves and of the world that surrounds them, to seek out and elucidate its mysteries and take advantage of them.

This is why there are so many myths that meet these needs. Among the most common are creation myths concerning the origin of the world. They detail the diverse stages of creation, by the gods, the spirits, in whatever particular form they come, or by alien beings, and of the successive events that often determine future relationships among humans, as well as with the physical forces of nature or with animals. Construction of myths relating to the creation of the envi-

ronment one inhabits is a process that counts among the universals of human thought. These myths can take on an infinite variety, with some constants here and there. Thus, in North America, the cosmos contains a particular number of superimposed worlds and the community concerned passes from one to the other in the course of a long quest, gradually conquering their humanity and progressing over time. Mythical heroes, animals, and spirits aid them in this quest. The aid they provide and their roles are narrated in the sacred legends.[97] All these elements are likely to find a place in their art. For example, for the Mojave or Quechan peoples, the geoglyphs of Blythe, at the boundary between California and Arizona, commemorate the creation of the world by the divinity called Mastamho.[98] Other myths explain spectacular or catastrophic natural phenomena (thunderstorms and lightning, volcanic eruptions, torrential rains, floods and climatic changes [myth of the Flood], etc.), as well as their causes, ways to avoid the worst, and also their consequences. Many are concerned with animals, with their role, with their importance, with their relationships with humans and with nature.

The appearance of humans on Earth and their adventures (in the Christian religion, the myth of Heaven on Earth, of Adam and Eve, of Cain and Abel, of temptation by the serpent) are integral parts of creation myths. Interactions of humans with one another and complex notions of status, of their own roles, of alliances, taboos, of divisions or hostilities (both within the group as well as between groups), frequently emerge from mythical stories, that the Australian Aborigines, for instance, place in the Dreamtime.

This brings us to the second major aspect of myths: *their social role within the group*. Myths are not only essential to the identity of the group, for which they perpetuate the history along with its events, but also constituent parts of its identity, all the more so in cultures with oral tradition, as we have seen with the murals in the church in Zuni (chapter 2).

Another important social role is played by a tale with moral connotations, that recalls, for example, culpable behavior and its consequences. For instance, in the extreme northeast of Australia (region

of Laura), a decorated shelter exhibits two images of women. One has a leg folded back so that the heel covers her genital parts while she is seated, whereas the other has negligently placed her heel a few centimeters away from her genitals, so that they are visible to all. I was told by Percy Trezise when he took me to this shelter, that the guilty woman, named Gen-Gen, repeated the offense, despite being warned by an elder who placed his hand before his eye and exclaimed: "Oh, my eye, my eye!" to express his disapproval. He repeated his warning several times in vain. Later, Gen-Gen seduced her son-in-law, thus breaking one of the most powerful Aborigine sexual taboos. As a consequence, she suffered the curse of the ancients and died soon afterward. Her story is a reminder of the taboos and a warning to would-be vamps.

Finally, and this is their third major role, *myths and the images that give them shape can be imbued with power in and of themselves.* Through their representations, appropriate ceremonies then allow us to act upon the world or on its events. Let it be reiterated that traditional peoples do not dominate nature, like modern Western culture. They constitute one of its elements, like their fellow animals. They are aware of their weakness and vulnerability within a complex and dangerous world, but do not resign themselves to this. They think that in this universe, where everything is connected—the past with the present, humans with the spirits, animals, and, more generally, the whole of nature—it is possible to act to resolve problems and improve their condition. This is where the image intervenes, perceived as an emanation of the subject represented. The image retains an affinity—and sometimes is completely identical—with the subject and in turn allows one to contact or control it, or receive aid from it.[99] Images that are materialized and breathe life into the myths are thus endowed with power, like the Wandjinas of the Kimberley in Australia, those potent spirits of creation linked to the life-bringing rains that they control. We also have much closer and more recent examples in European churches, where particular saints that are represented are thought to cure this or that specific illness. Thus, in the church of Loreta, in Prague, Saint

Stapimus is called *Patronus contra dolorem pedum*, Saint Liborius *contra dolores calculi*, and Saint Ottilia, the virgin, *contra doloris oculorum*.

It is certain that, among the Paleolithic images that have survived for us to find, some participate in the three major roles of myths, probably especially the last. However, in the absence of direct explanations, which are impossible to obtain for these cultures that disappeared long ago, an understanding of the myths and their moral or social implications is obviously beyond our reach. We have suites of images, of which we know that they were suffused with meaning and which remain just as mysterious as they are fascinating. This should not stop us, however, from taking an interest in specific cases that represent determinable actions that are outside of the ordinary to such an extent that one can—maybe?—detect the transposition of a myth in which the broad strokes become apparent, even if the details will forever remain beyond our grasp.

This proposition can be illustrated with three examples taken from portable and parietal art. Despite their dissimilarities, they do show certain points in common.

The Venus of Chauvet

In the End Chamber of Chauvet cave, an isolated hanging rock tapers to a point that is a little over three feet above the ground. It is right in front of and a few yards away from the spectacular Panel of the Lions. This rock is decorated on several sides. The one that is seen first when entering the room, at right angles to the wall where the Panel of the Lions is located, was interpreted as being decorated with a "Sorcerer," that is to say with an upright composite being, seen in profile, whose upper body is that of a bison, while the lower part consists of a slightly flexed human leg. Initially, we did not know what might be on the other side, facing the main wall. It was at that time impossible to circle around the hanging rock as the floor of the cave in this part of the End Chamber is loose, and any contact would leave permanent modern traces, something that was out of the question.

A few years later, my colleague Yanik Le Guillou hit upon the idea of exploring the hidden side of the hanging rock by taking a blind photograph, using a digital camera affixed to the end of a retractable pole. After several attempts, he thus discovered the black line drawings of a mammoth, a musk ox, and a lion, as well as the complement of the so-called Sorcerer, which was quite different from what had been believed initially. In fact, immediately in front of and below the "bison," there was a very naturalistic pubic triangle, first sketched then filled with black and completed by a vertically engraved vulval furrow, a little less than two inches in length. On either side of this, the legs of the woman, viewed from the front, ended in points, without feet (fig. 28). According to her discoverer, "This woman is entirely classically portrayed. Her proportions, the stylistic elements, the choice of anatomical elements represented are characteristic of the Aurignacian or Gravettian Venuses, known especially from the statuary of Central and Eastern Europe. Among Paleolithic parietal artworks, it is the Venus of Laussel that seems to be the closest to that of Pont d'Arc."[100]

Above and to the right of the feminine representation was the forepart of a bison, whose anterior member did not end in a hoof but in an array of lines pointing downward, identical to the representations of hands on many humans in Paleolithic art (fig. 28). It thus represents a composite being that is simultaneously human and bison. This creature was created later than the woman and in close contact. The techniques applied for producing the two subjects are identical, so one might assume that the same person created them.

We are thus confronted with the indisputable association of a woman, reduced to the lower half of her body, with the pubic triangle and vulva strongly accentuated, together with a bison of a discrete but probably composite nature. This brings to mind countless mythological examples, such as minotaurs and others, stemming from a multitude of ethnographical complexes, where mortal women have sexual relations with gods or transformed spirits with partly animal form.

The localization of this "scene," facing the entrance to the End Chamber and in the close vicinity of the main decorated panel of the cave, that is to say in a prime location, underlines the importance that

Figure 28. End Chamber at Chauvet cave (Vallon-Pont-d'Arc, Ardèche). On a hanging rock, facing the large Panneau des Lions, the bottom part of a woman's body was drawn (legs as seen from the front, pubic triangle, and vulva). A bison with what seems to be an arm that ends in a hand is partially superimposed.

it must have had for the artist and for the myths accepted by his or her group.

The Shaft of Lascaux

The Shaft in Lascaux is renowned for the presence of one of the rare obvious scenes in Paleolithic parietal art, even though it retains most of its mystery. All of the figures are drawn in a black paint with a manganese dioxide base. There is a spindly bird-headed man with an erection, falling backward with arms spread, in front of a bison that is charging toward him, with its head lowered and its guts trailing behind from a wounded belly. A long, barbed line is superimposed

Figure 29. The famous scene in the Shaft at Lascaux (Montignac, Dordogne).
After a photograph by Norbert Aujoulat (Aujoulat 2004).

on the animal's hindquarters. There is a similar line, with a double barb, alone below the man. A bird, with a head identical to that of the human figure, is perched on a rod with a single barb at its base (fig. 29). On the left of the scene, a rhinoceros is moving away into the distance. Like the bison, it has a raised tail. Six dots are aligned in pairs to the right of the rhinoceros's hindquarters. On the opposite wall, the front view of a black horse has also been drawn.

To gain access to the Shaft, one must go to the rear of the Apse, after having passing through the large Hall of the Bulls and moving through the Passageway (a short gallery where the air current has erased most of the paintings). At the time of its discovery, access to the Shaft was apparently relatively difficult. It was necessary to crawl for six feet before reaching a thick mound of red clay that partially blocked the way in. Young, intrepid visitors could nonetheless descend the few yards without any problem using a simple rope.

This impediment has been completely eliminated and one can now gain access to the bottom of the Shaft with a metal ladder. Norbert Au-

joulat pointed out that, according to the accounts of the discoverers, Jacques Marsal and his friends, the clay was bulging out, and lumps were detached and fell to the bottom at each descent. Previously, this fact had been interpreted as an indication that there had been only a very small number of prehistoric visits to this place, the most secret and remote in the cave. Aujoulat went further. According to him, the Shaft had another entrance, now sealed, that allowed more-or-less horizontal access.[101] In this case, it would not be one of the galleries of Lascaux, but a second decorated cave in the same hill. This arrangement is found elsewhere too, for example, in the Pyrenees with the three caves of the Volp (Enlène, Les Trois-Frères, Le Tuc d'Audoubert), Niaux and the Réseau Clastres, the two caves of Gargas and the three of Isturitz-Erberua-Oxocelhaya, or in Cantabria with the four caves of Monte Castillo (El Castillo, La Pasiega, Las Chimeneas, Las Monedas). But even if it did have a separate entrance at the time, the representations in this small gallery are linked, as mentioned, to those of the rest of Lascaux. The horse's forepart is identical to its numerous counterparts in the other galleries, and the "spears" or "geometric signs" have exact equivalents elsewhere in the cave. As pointed out by André Leroi-Gourhan, the six black dots below the rhinoceros's tail recall six red dots arranged in the same manner far back in the Chamber of the Felines.

The Shaft is characterized by an elevated level of carbon dioxide, which accumulates in this low-lying space. As a rule, a machine now extracts the gas. But when this fails to work, the very high and dangerous concentrations can cause immediate and serious discomfort, according to accounts by Marc Sarradet and Jean-Michel Geneste, former curators of Lascaux cave who learned this the hard way.

In the famous scene in the Shaft, two repeated elements could provide the key. First of all, the bird theme, one that is extremely rare in parietal art, appears twice: the backward-falling man is endowed with a bird's head while below him perches a bird with an identical head. Second, the notion of death is also represented twice: through the man collapsing in front of the bison and through the mortally wounded animal itself.

Following the discovery of the cave, this scene was interpreted very literally, like the tale of a hunting accident, despite the incongruity of the man's bird head. Some even went as far as to envisage excavating at the foot of the wall to search for the possible grave of the unfortunate hunter.

Yet we have seen that conceptions of the world in hunter-gatherer societies are far removed from the simplicity that has wrongfully been attributed to them, and that their drawings on rocks only rarely served an anecdotal purpose, especially at sacred sites. Very often, they expressed themselves through metaphors, according to the sacred myths and legends of their tribe.

In Lascaux, the scene can be read on two levels, while bridging the repeated features already mentioned. Would the notion of death not have some relationship with the adverse effects of the carbon dioxide that is omnipresent nowadays at the bottom of this gallery, if a similar condition had prevailed in the Paleolithic? With this in mind, the theme of the bird could also evoke the soul flying away to reinforce the message.

We can go one step further and envisage that the death theme relates not to the primary but rather to the secondary level. It may refer to the trance and to the shamanic journey, to that strange moment when the spirit of the officiant leaves his body to pass on to the supernatural world and meet the spirits that he wishes to solicit. In many shamanic cultures, death is the metaphorical equivalent of the trance. For example, in central California, the idea of killing a bighorn sheep (animal of the rain and of fecundity) signified that the shaman traveled in spirit—that is to say was "dead"—to make the beneficial rain come thanks to his action.[102]

In this way the scene would acquire its full meaning, as it would relate to an activity that was of crucial importance to the group, perhaps favored by the particular characteristics of the locality where it was painted.

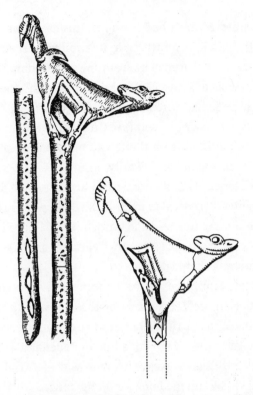

Figure 30. Spear-throwers made of reindeer antlers representing the fawn with bird theme, from the Magdalenian of the French Pyrenees. On the left, that of Mas-d'Azil (Ariège), after Saint-Just Péquart. On the right, that of the cave of La Vache (Alliat, Ariège), after Romain Robert.

The Fawn with Bird

The theme of the fawn with bird, documented at several sites (fig. 30), seems to be characterized both in time, the middle Magdalenian (Labastide, Le Mas-d'Azil, Saint-Michel d'Arudy), and in space (the Pyrenees), the most distant exemplars being no more than 150 miles apart. That of Bédeilhac might equally well belong to the final Magdalenian as to the middle Magdalenian, because both eras are well represented in this cave.

It was the discovery of the fawn with birds in Mas-d'Azil by Marthe and Saint-Just Péquart in 1940 that popularized this extraordinary theme: a fawn turning its head to observe two birds perched on the

material extruded from its body. In 1950, Romain Robert discovered the fawn of Bédeilhac, astonishing in its similarity: the same subject and a comparable posture, apart from the positioning of the legs — folded in Bédeilhac but extended in Mas-d'Azil — and the presence of a single bird in Bédeilhac instead of two (fig. 30). In 1988, Hans-Georg Bandi pointed out that, on a sculpture from Saint-Michel d'Arudy, the material being expelled from the fawn's body was located near the vulva rather than the anus.[103] Finally, in 1991, Robert Simonnet reported the existence of another fawn that his father had discovered in Labastide (Hautes-Pyrénées) in 1947.[104] The body posture is very similar, but the absence of the head and unfortunate damage to the area of the tail prevent us from unreservedly treating it as equal to the other three, despite some shared details.

In fact, these four pieces share the following elements: substrate (reindeer antler), object (end of a spear-thrower with the hook on the hindquarters), technique (full relief), theme of a young animal (fawn), underlined edge of the back (with a line in Bédeilhac, Labastide, and Le Mas-d'Azil, with a cross-weave in Saint-Michel d'Arudy and Labastide), parallel streaks on the hook (or on the birds).

These discoveries yield insights into the conceptual universe of the Magdalenians, which is the primary focus of interest here, and also give rise to a certain number of questions.

The first question, which generated scholarly discussions, concerns whether this is a representation of defecation or birth. Following Péquart,[105] most authors accepted the interpretation of defecation, although the fecal pellets "of antelopes, of caprids and of cervids are approximately spherical, small, numerous and separated from each other."[106] Bandi, however, demonstrated convincingly that it was in fact a birth, due to the proximity of the vulva and especially because "all specialists agree in stating that defecation in animals in general (apart from cases of illness, etc.) is not accompanied by looking. Elimination is brief and of no particular interest,"[107] whereas — and this is essential — females giving birth frequently look backward to monitor the process. The extruded mass would then, far more logically, represent the placenta expelled after the birth of one or more infants.

Because this interpretation surpassed the previous one in fitting anatomical, physiological, and behavioral observations, the problem was considered as resolved.[108]

As for the animal represented, the actual species has been the object of much discussion. The only certainty, regardless of whether it is an ibex or a chamois, is that it has the characteristics of an animal native to mountains and rocks, and is thus Pyrenean par excellence.

Unanimity has been reached regarding the juvenile character of these animals, because of the morphology of the head and the gracility of the body; hence the description "fawn." Whatever species it may be, it is certainly a young animal, lacking horns, that is represented in the process of giving birth.

Whether there are one or two birds of indeterminate species, their repeated association with the birth scene is indisputable: they are represented in the direct extension of the mass extruded from the animal's body. Hence, a bizarre nonnaturalistic concept is involved.

To summarize:

- the scene is that of a female ibex or chamois giving birth;
- the main character is a very young animal, a fact that may seem to contradict the previous observation;
- the presence of the bird (or birds) similarly does not correspond to any behavioral reality;
- these objects, which were perhaps not utilitarian, were found in what some regard as privileged locations;
- finally, this theme was repeated several times and in several places with certain variations, but with surprising consistency regarding details.

This final observation raises a number of questions. Since these spear-thrower tips were discovered, knowledge regarding taphonomy has progressed. We know that the remnants that have survived for us to find represent merely a tiny fraction of the totality of prehistoric output.[109] The fawn with bird must accordingly have been a very well-known Pyrenean theme during the Magdalenian, materialized on nu-

merous substrates in a more-or-less stereotypical form, from one end
of the mountain chain to the other. If this hypothesis is correct, in
view of the frequent travels documented for the Magdalenian and the
mutual influence between regions, it is not at all implausible to expect
that one might one day find other examples elsewhere.

Does this mean that these objects are the products of the same
hand, or of the same group? In other words, did they have a very re-
stricted origin, which would explain the originality of the theme?

In fact, we have no certainty at all regarding any presumed con-
temporaneity of these pieces or of their ages relative to one another,
as they could well be assigned to various times extending over several
hundreds of years. One could say the same for the "Lion Men" discov-
ered in Hohlenstein-Stadel and at the Hohle Fels, in the Aurignacian
of the Swabian Jura.

It would seem more likely that the theme in question might have
corresponded to a legendary story of the Pyrenean Magdalenians—a
hypothesis envisaged by Camps[110]—that has been independently ma-
terialized, in different localities and perhaps at different times, by art-
ists that may not have known each other but were basing their work
on the same sources of oral traditions. The fact that some of these ob-
jects were deposited in very special places shows that people clearly
attached great importance to them.

At the root of this myth is the tale of a juvenile animal, a fawn, that
is apparently somewhat too young to give birth, but nevertheless does
so. This first possible break with reality is joined by another one: the
bird or birds. The scene actually suggests that the bird is the product of
birth. One senses here a very complex story, such as those that exist in
all traditional cultures, where interspecific transformations have been
documented in abundance.

We have seen that in Paleolithic art there are numerous instances
of composite beings, combining human and animal traits, including
some with a bird's head: Lascaux (see above), Pech-Merle, Cougnac
(see fig. 1). We also find composite animals (stag with a bison's head at
Les Trois-Frères, lion with ungulate hooves in Chauvet, etc.). In this

context, a prepubertal fawn giving birth to a bird is not particularly unusual.

Whatever their exact meaning, it is fitting to take these portable objects and these parietal images for what they are, namely, privileged witnesses to sophisticated thoughts, to a world of the imaginary that can be glimpsed only rarely and with difficulty. A world where the relationships of animals with each other and with humans go far beyond the long-assumed simplicity of the elementary link between the hunter and his prey, or of servile reproduction of scenes of everyday life.

In fact, the feature common to the three selected examples above is the inseparable mixing, throughout the whole of the Upper Paleolithic, of fully recognizable naturalistic characters with others that are evidently removed from reality: the relationship between a woman and a being that is part man and part bison; the bird-headed man; the young fawn giving birth to a bird.

This calls to mind the fact that the fundamental characteristic of many traditional societies, and in particular of those that practice shamanism, is fluidity (see above): fluidity between the real world, in which they live, and the spirit world that one can enter through visions or, more concretely, by visiting the subterranean depths; fluidity, too, between the human and animal worlds, so that constant interactions are induced between them, interactions that are recounted in the myths.

Who Produced This Art?

Documentation of visits to the caves by members of both sexes and by children means that identifying the authors of paintings and engravings, particularly the large frescoes and naturalistic representations, remains problematic.

For some considerable time, it was implicitly assumed that the artists could only have been men. Since then, with the rise of schools of feminism and changing mentalities, it has become politically correct

to attribute the art to women, although this standpoint is no better supported than its predecessor. Thus it is that, since June 2009, one can see, in the excellent Prehistoric Park of Tarascon-sur-Ariège, an animated reconstruction of one of the main panels of Chauvet cave, with a young woman drawing the images portrayed. It is, indeed, the case that many conceptions of prehistoric life follow the transformation of prejudices and shifting opinions over time, as our colleague Claudine Cohen demonstrates very well in her book *La Femme des Origines* (Primordial Woman).[111]

In fact, we know virtually nothing concerning the sex of the artists, apart from a few exceptions, like the engraving in Cosquer cave, that is so high up that it must have been created by a very tall person, and hence most likely an adult man. Negative or positive hand stencils, or indeed hand-dotting (Chauvet), when they indicate the possible sex of their authors, simply indicate that both sexes had access to the walls and ceremonies. There is a major difference between the traces of direct simple contacts between the person and the wall (hand stencils, finger tracings) and the elaborate drawings that exhibit a surprising mastery of individual strokes and can have quite different roles.

To venture hypotheses concerning the sex of the painters, we cannot rely on anything other than two sources: ethnological examples and the contents of the art.

It has long been known that the Aborigine cultures of Australia clearly distinguish between a domain that is reserved for men (Man's Business) and another that is the prerogative of women (Woman's Business). Some kinds of knowledge and certain images of one sex must remain inaccessible to the other. In consequence, both masculine and feminine decorated sites exist. Claire Smith stressed these facts to counteract the habitual male chauvinism that led to wrongfully attributing everything connected with art to men. She also emphasized the fact that we know of examples of rock art that were created by women in other parts of the world, such as at various localities in North America or in Sri Lanka.[112]

Women had access to the decorated caves and participated in cer-

tain actions and ceremonies. So it seems highly likely that they would have drawn on the walls there. The same comment also applies for men. Was there a distinction comparable to the one known from Australia and elsewhere for masculine and feminine actions, regarding the themes, the techniques, or locations chosen? This might be expected, yet there is no clear evidence for this from the current state of research.

At the time when the Cosquer cave was discovered, we proposed this type of hypothesis with respect to an observed difference between paintings and engravings. Paintings are generally larger and more numerous than engravings, but the latter frequently bear signs while paintings are generally devoid of them. These signs, often barbed or feathered, can be compared with throwing weapons. Yet weapons, especially cutting and piercing weapons—those that make blood flow—are almost always the prerogative of men in hunter-gatherer societies.[113] Consequently, we concluded that: "Perhaps, in Cosquer cave, one could envisage, hypothetically, that it was the men who traced the engraved animals, often associated with arrows, and that the animal paintings that are not like this were produced by women? Whether we will ever be able to prove anything in this field is doubtful, but the problem still deserves to be mentioned, even if only in the form of a question."[114]

For a quarter of a century a masculine origin of the drawings has had an uninhibited and sometimes provocative champion, namely, Dale Guthrie, biologist and hunter.[115] The basic premise can barely be disputed. In all hunter-gatherer societies, it is the men who go off to hunt, especially for the larger game animals, and it is the women who do the gathering. Both these generalities are prone to exceptions, however, as men do occasionally gather mushrooms or wild fruits, and women may kill smaller animals that come close enough, or act as beaters during large-scale collective hunts. But on the whole, Man is the provider of large game, and Woman the provider of vegetable resources. Even if it is more spectacular to bring back a bison than a basket of edible roots or berries, thorough studies showed long ago that the contribution by women was more consistent and more important

in the long term, covering about two-thirds of the group's food re-
quirements.[116] Women ensure that ordinary needs are met in a more
stable manner. So it is not a question of hierarchical organization of
tasks that are more or less noble, but a distribution that corresponds
to the optimal possibilities of the two sexes. Men are endowed with
greater brute strength, run faster, and are more available, being un-
encumbered by pregnancies and the care of very young children. They
are also prone to exposure to the dangers of the big hunt, being less
prized for the survival of the group than women.

Yet, of the three main themes of rock art (geometric signs, humans,
animals), even if geometric signs are the most numerous, it is the
large animals that occupy the greatest part of the visual space. Small-
bodied species (birds, rabbits/hares, fish) are rarely represented. The
most commonly portrayed animals throughout the Upper Paleolithic
are horses, bison, aurochs, mammoths, reindeer, deer, ibex, and less
often woolly rhinoceros, bears, and cave lions. These are hence the
themes of hunters, confronted with their game animals, predators,
and other large animals of their environment. On the contrary, plants
of any kind are absent, as are children, babies, scenes of childbirth, do-
mestic scenes, and other themes that we might associate more readily
with women. It would hence seem that the choice of themes related
far more strongly to "masculine" rather than "feminine" subjects,
even if continued caution is warranted regarding this topic.

Guthrie went much further, down paths along which we certainly
cannot follow him. He not only inferred that this must be an art of
hunters, but also further concluded that the large number of repre-
sentations of naked women reduced to the sexual essentials (breasts,
buttocks, vulva, outline) and of isolated vulvas were in fact erotica. At
the same time, he made amusing and provocative comparisons be-
tween images of women in parietal and portable art and photos pub-
lished in *Playboy*. He concluded that "The Paleolithic art that has been
conserved seems to have been made by men in connection with mas-
culine preoccupations,"[117] that is to say with the hunt and with women
as objects of desire. This art, which—according to him—has the scent
of testosterone, would have been the work of young boys, adolescents

who would have amused themselves in this way in the caves. As might have been expected, there was a flood of criticism.[118] Young people (boys and/or girls) could and should have had access to the subterranean sanctuaries, and some may have produced a few drawings within the framework of the rites that took place there. We need not go into the culturally highly relative nature of eroticism and of the complex meanings often associated with representations of sexual organs.[119] Considering all that we know of the particular character of the deep caves, it is quite inconceivable that—for more than twenty thousand years across the whole range of Europe—they would essentially have served solely as a playground or as the object of dares for boys driven by their hormones.

The extraordinary capacities of certain autistic children that have been called "autistic savants" attracted attention and led to a hypothesis that they may have contributed, at least in part and in one form or another, to the production of Paleolithic art.[120] Indeed, it does happen that very young autistic children, who are otherwise severely mentally handicapped, exhibit exceptional innate artistic gifts.[121] Comparison of cave art with drawings, especially those of animals, spontaneously created by a young English girl, Nadia, who had a mental deficiency and barely spoke, revealed "surprising similarities in content and style."[122] The author does not conclude that the art should be attributed to autistic individuals who were selected as such, but suggests instead that the Paleolithics did not necessarily have the same mental capacities as we do and that their limitations, for example, in the domain of language, comparable to persons with autism, might explain their artistic gifts.[123] This hypothesis, vigorously attacked as soon as it was presented, did not prevail. In point of fact, Paleolithic art does not exist in a vacuum. After almost one-and-a-half centuries of excavations and research, we know enough about the portable art of the Paleolithics, their adornment, their techniques, and more generally their ways of life, notably regarding comparisons that can be made with hunting economies elsewhere in the world, to discard the hypothesis that their mental development was structurally inferior to our own.

As for the role of autistic children in the Paleolithic culture, where they must have existed as they do everywhere, that is a completely different problem. It is not impossible that those who possessed "savant" capacities may have been the object of special consideration, being "marked by the spirits" due to their originality. Nevertheless, we know of no ethnological examples where they would have a specialist religious role, where they would have been chosen for drawing on the walls of shelters or rocks; probably, and this is crucial, because these activities would have been difficult to uncouple from the rest of the religious practices that would have remained beyond their reach precisely because of their limitations.

One remaining fact demands to be given some thought: the outstanding graphical quality of Paleolithic parietal art and what this implies regarding its creators. The caves that are decorated with paintings or with engravings demonstrate an impressive mastery of shapes and of techniques, that is to say the presence of true artists with a perfect grasp of their subject matter, are far too numerous to be a product of coincidence. From the Aurignacian of Chauvet to the Magdalenian of Altamira, Niaux, or of Le Portel, whether in France or in Spain, masterpieces abound. The visual impact of many works was achieved through diverse means. In some cases, in Chauvet, on the Panel of the Horses or on that of the Lions, the artist has crushed charcoal and mixed it with the soft whitish substance that covers the walls to obtain shades that range from black to dark blue, and he (or she) has skillfully spread the pigment inside the head and the body in order to create the contours, using the process currently known as "stump drawing." One of the most remarkable examples is found in Lascaux, where a cow has been drawn in a distorted manner, that is to say deliberately represented in an unrealistic but very clever fashion, because of its position high up in the wall, such that the spectator standing below could see it as having perfect proportions. Most of the paintings could not have been created by beginners, children, the handicapped, or anybody lacking an artistic sense. These facts, which are impossible to quantify (it would be difficult to attribute scores to any particular drawing), are no less obvious for that reason.[124]

Various consequences follow from this. The first is the necessary existence of organized and traditional teaching. In its absence, we would not see such sustained mastery or the perpetuation of such a long-lasting tradition. This teaching must have related both to the replication of animal forms (themes, conventions, and techniques) and to their significance (myths, social importance, cultural role, power), the two being inseparable. Elders must undoubtedly have transferred their knowledge to the younger members of the group. The idea was suggested that engraved flat stones, which are abundant in some caves (Enlène in the French Pyrenees, Parpalló in Spain), or at open-air sites (Gönnersdorf in Germany), might have played an educational role. Although this is not impossible, it is far from certain, as the flat stones certainly had an inherent value, at least for a while, because they were deposited in particular places for millennia (Parpalló) or were closely associated with decorated caves (Labastide, Bédeilhac, Enlène/Trois-Frères). One should instead imagine teaching that was dispensed for the most part in the open, in rock shelters or outside, perhaps using substrates that are not preserved, such as wood, bark, skins, or clay on the ground.

The high quality of the art also prompts the question of the role played by aesthetics. Are the drawings that are impressively naturalistic imbued with greater spiritual or magical value than those that are more schematic and crude? On islands in the Pacific (Hawaii, Easter Island, the Marquesas Islands, etc.), it was necessary for an image drawn on the rock to be perfect for it to have the required effectiveness. The slightest error could lead to a result opposite to that desired, or might even be regarded as a grave transgression that would lead to drastic sanctions.[125] In the Christian religion, on the other hand, the same spiritual, if not social or financial, value is attached to a simple wooden cross of crude manufacture and to a superb cross made of gold or silver and bearing an array of precious gemstones. The answers are undoubtedly not simple and will vary in accordance to circumstances.

As a final point, the frequent masterpieces of parietal art, most of them realized without regrets or restarting, logically lead us to

think that their creators were naturally gifted. The indispensable process of education accompanies and favors their accomplishment, but does not create geniuses. It is hence logical to think that in Paleolithic groups throughout the entire twenty to twenty-five thousand years during which the deep caves were decorated, one would have chosen as far as possible individuals who exhibited innate artistic gifts. Being capable of replicating living reality, or rather of recreating it, could very well have been considered as proof that the supernatural spirits had marked this person, because he or she could exert a power of creation and/or control of animal images.

This hypothesis accounts for the striking frequency of masterpieces, but certainly not for all of Paleolithic art, in which clumsy or basic sketches abound, sometimes in the immediate neighborhood of prestigious creations (Chauvet, Niaux). As we have seen, individuals other than the "great artists" participated in the ceremonies and had access to the walls, so that they could touch them and add their own drawings.

What was the status of these artists? We can imagine that they held a very special place within the groups allotted to intermediaries between the day-to-day world and the immanent, formidable, and all-powerful world of the invisible forces. We know that in shamanic societies choosing a shaman is of major importance because of the role that individual will play in maintaining the equilibrium between the natural world and the supernatural world, and ultimately in ensuring the survival of the group. Among the Inuit, "certain individuals are predestined for this function due to singular or extraordinary signs that have been manifested from the day that they were born.... Other persons, finally, are chosen from a very early age or at adolescence by a venerable shaman avid to pass on his experience to a disciple that seems to exhibit a particular disposition or exceptional gifts."[126]

Given the special place occupied by parietal art in Paleolithic cultures in Europe, its characteristics and localization, as well as the perpetuation of such a tradition demanding a strong constraint on beliefs passed from generation to generation, artistic capacities may have been part of these "exceptional gifts" that indicated to all that a par-

ticular child had been chosen by the spirits to become a shaman and contact them thanks to his or her artistic talents.

A Shamanic Conceptual Framework

We have seen that, despite some inevitable uncertainties, the number and import of the answers that we can provide today is far from negligible concerning both the role played by Paleolithic art and the conceptual framework within which it was produced. Advances are due to new discoveries, progress in research, and deepening contemplation, founded on personal experiences.

One of the major certainties, underlying all others, is the identity of thought structures throughout the entire Upper Paleolithic on a pan-European scale. We have many sources of evidence of this. For more than twenty-five thousand years, the deep caves were occasionally visited in order to produce drawings there, which in itself testifies to the durability of beliefs regarding the underground world and how to approach it. The double logic of isolated locations and of locations with spectacular compositions is surely found from the Aurignacian of Chauvet to the Magdalenian of Niaux. Broadly speaking, throughout that entire period, the drawings follow the same rules and conventions, which have long been recognized: the preeminence of animals, especially those belonging to the largest-bodied species, the abundance of geometric signs, the marginal role of humans, the presence across all eras of composite creatures, and the scarcity of scenes. Moreover, certain gestures were accomplished in an identical manner across many millennia: deposition of decorated flat stones at Parpalló; insertion of bone fragments into the crevices of various decorated caves of Spain and France. This means that people not only approached the caves with the same perspective, but also often repeated the same actions in them. This is a capital fact.

Of course, within this continuity, some changes occurred according to time and place. These mainly concern the subjects represented. Thus, negative hand stencils probably began as occasional features in the Aurignacian (Chauvet, El Castillo); they then became numerous

and can be dated precisely to the Gravettian (Gargas, Cosquer, Fuente del Salín), but we know of none that can be dated with certainty as belonging to the Solutrean or Magdalenian. Does this mean that our knowledge is incomplete and that we might one day obtain datings of hand stencils that can be attributed to these cultures, or does it indicate that the tradition was interrupted? We do not know. Another important change is the dominance within Aurignacian art of impressive species that were hunted rarely or not at all (especially lions, rhinoceroses, and mammoths), followed the inversion of this tendency from the Gravettian onward. Other changes occurred with respect to themes and techniques, but on the whole it is continuity that predominates.

The obvious conclusion is that this is a religion with conceptual foundations that remained sufficiently stable across more than twenty millennia to generate identical behaviors on the scale of Europe as a whole. In consequence, it is legitimate to seek those foundations, which constitute a particular way of thinking and of perceiving the world. This is the task that we have just undertaken.

As has become apparent in the course of the discussion, all clues point to a religion of shamanic type, with basic concepts consisting of *permeability* of the world or worlds and *fluidity*. Even though certain shamanic elements (visions) exist in almost all religions, one can speak of shamanism only when the concepts are sufficiently strong and instrumental to constitute a long-lasting framework of beliefs and practices. What we call the trance, which would nowadays rather be described as an altered state of consciousness, represents the key agency. The continuity of Paleolithic art, together with the rituals associated with it over so many millennia, reveals a remarkable degree of conceptual organization and tradition, without which this religion—and it is indeed a religion in the broad sense—would have inevitably ceased to exist long before the end of the Ice Ages.

It is within a framework of beliefs that the caves were visited, no doubt for exceptional occasions, given the relatively small number of decorated deep caves (less than two hundred for the whole of Europe, for a period of twenty to twenty-five thousand years). A large part of common practice of the rites must have taken place outside, where

few traces, or none at all, have survived. In this connection, we should not see the art of the deep caves in opposition to that found in the open air, any more than we would see the regular celebrations of Mass inside churches in opposition to the less frequent celebrations that occasionally occur outdoors.

It is plausible that the deep caves served among other things as sites at which to seek visions, given the hallucinogenic character of the subterranean environment, where one is cut off from time and external stimuli. Following our initial publications, we became aware of numerous accounts of contemporary speleologists and even archaeologists who had been the victims of hallucinations, obviously not sought after, following long periods spent in the silence, humidity, and darkness.[127] This phenomenon would not have been perceived as anything other than favorable by people in the Paleolithic who ventured below ground, convinced that they were entering the netherworld and expecting or even seeking strange experiences.

That does not mean that the images were produced during these visions. Some have thought that we were proposing that interpretation, despite the fact that this was never the case; our writings being really extremely clear on that point.[128] The mastery involved in the artwork, the studied and contemplative character and the sophistication of the methods so frequently employed in themselves suffice for this possibility to be rejected. There can be exceptions, as, for example, in Pergouset (Lot), a decorated cavern for which this hypothesis was explicitly formulated,[129] because the engravings become increasingly distorted and psychedelic as one ventures deeper into the narrow, low-slung galleries. But such exceptions are extremely rare. On the other hand, it is plausible that some of the themes represented—but certainly not all considering the complexity inherent to myths—might have originated in these visions, as this is often documented in cultures that practice both the art and shamanism.[130] This could, for instance, be the case for a number of geometric symbols, as well as for animals, whether composite or not.

These people did not venture into the depths of the caves for this reason alone. "In traditional societies, where the links between na-

ture and culture are thought of not in terms of rupture but of continuity, where the separation between the beings and things of the world is blurred, or even ignored, the essential shamanic function is to ensure the good management of relationships between the universe of humans and that of the spirits."[131] If they paid this strange subterranean world a visit, sometimes alone, sometimes accompanied by those in need of aid, perhaps sick individuals, children, or adolescents at the times of initiations and rites of passage, it was to meet the spirits that inhabited these mysterious and frightening places and resided in the rock, where sometimes their shapes could be glimpsed in the flickering light of torches. They entered into contact with them thanks to painting or engraving, in order to restore harmony, solicit their good will, or acquire a small part of their power.

Considered from this viewpoint, the images in the caves acquire more meaning and logic than with earlier theories. The shamanic hypothesis can explain the large number of works that take advantage of natural reliefs, such as those close to fissures, or the rear ends of galleries, or chasms that offer vistas toward the depths in the rock. Indeterminate contours, awkward and clumsy representations, traces of touching the walls, all of these could have been produced by those accompanying the shaman. They thus participated, in their own way, in the ceremonies, while their experienced guide produced the most accomplished drawings. The hand stencils allowed them to go even further. When an individual placed a hand on the wall and sprayed paint onto his or her hand, this merged with the rock and took on its color, red or black. The hand then disappeared into the wall, establishing a direct link with the spirit world and capturing its power. The presence of hand stencils belonging to very young children (Gargas, Cosquer, Rouffignac) is then by no means extraordinary, no more than that of the mundane bone splinters wedged into the crevices of so many decorated caves.

Beyond the observations conducted in the caves themselves and the ethnological comparisons that these have inspired, two major arguments reinforce the hypothesis that there was a religion of a shamanic type during the Upper Paleolithic.

First, there is the widely accepted fact that shamanism has a special link with hunting economies, because of their particular relationship with nature and with animals. "Hunting has been recognized since Andreas Lommel as the privileged context, or indeed the environment of emergence, of shamanism."[132] "We agree today to define shamanism like a system of thought and action characteristic of hunter societies, but that one finds, modified to lesser or greater extent, in other types of society."[133] As it is certain that Upper Paleolithic cultures were hunter-gatherers, this renders the likelihood that the shamanic hypothesis holds for them statistically far more probable than any of the alternatives.

Second fact: Until recent times, a blanket of shamanic cultures covered the entire northern region of the planet, from Asia and Siberia to Scandinavia, and extending to the New World. Shamanic beliefs and practices are at the root of the American Indian religions of Canada, the United States, and even of Central America and northern South America. Resemblances between the practices of the shamans of Siberia and those of the New World have often been noted. This similarity can be interpreted in two ways, both reinforcing in their own fashion the hypothesis of a Paleolithic shamanism. It could involve simple convergence, due to the ubiquity of shamanism as a result of its neurophysiological basis and its association with hunting societies. However, the people who, in the Upper Paleolithic, gradually populated the American continent brought with them their own conception of the world. The very wide distribution of American Indian shamanism hence gives rise to the idea that this conception was shamanic. That this lasted for many millennia in the Americas is not at all surprising, as we well know that religions and their associated practices evolve far less rapidly than the material aspects of civilizations. Besides, we have just witnessed their long persistence in European caves, where the thought structures and their manifestations changed only marginally until the upheaval at the end of the Ice Ages that terminated one of the longest artistic traditions, and the most extraordinary, ever known to humanity.

Conclusion

From the moment when I took up my post as the director of prehistoric antiquities for the Midi-Pyrénées region, in January 1971, that is to say some forty odd years ago, I was occupied with the discovery of the Réseau Clastres (Niaux, Ariège) and had to attend to the many immediate problems that arose. I knew very little about cave art at the time, my area of specialization being concerned with recent periods, the Neolithic and the Bronze Age, and more particularly the dolmens that were the subject of a thesis on which I had been working for ten years. My colleague and friend Robert Simonnet had far more experience and was a great help. It was together that we first visited this deep site. We returned there several times to study it.[1]

At the beginning, everything seemed simple: in a cavern far removed from the entrance of Niaux, about a mile away, speleologists had found five animal images, three bison, a horse, and a mustelid carnivore (weasel or stone marten), as well as a large pile of glacial-period sand that was covered with the prints of bare feet. In order to access these unknown galleries, the speleologists had crossed a siphon in diving suits and had then emptied three successive lakes by pumping. Between two of these lakes a mustelid skeleton had been found; so surely there must have been a connection with the image that had been seen?

In fact, our thorough examination revealed a much more complex reality. We noticed that, between the first siphons and a fourth lake, which was only rarely filled, we could find no trace of humans. On the other hand, right after this fourth lake and all the way to the back, traces were abundant (numerous footprints on seventeen dif-

ferent sand heaps or clayey floors; charcoal on the floor; torch marks on the walls). This meant that prehistoric people had come in through another entrance, one that was now sealed off. Topographical studies demonstrated that this was a neighboring cave, called La Petite Caougno. So we were visiting the cave from the wrong direction.

Study of the black images prompted two major observations: They showed the same conventions as those of the animals in the Black Salon in Niaux; but, unlike the latter, they had been created hastily. The visitors had not lingered in these places. The footprints (more than five hundred in all) seemed to confirm this. They belonged to just a few individuals, only three children and two adults.

Through careful examination we were in fact able to discover that the footprints must be far more recent than the creation of the paintings. This was confirmed by dating of the charcoals and torch marks that we commissioned the Laboratoire des Faibles radioactivités in Gif-sur-Yvette to conduct. A number of visits, several thousand years apart, occurred after the creation of the drawings. The torches that were used were made of Scotch pine. During some of these visits, the visitors made music by striking very fine stalactite draperies. Several of these had been broken.

As for the small animal skeleton, it belonged to a stone marten, whose traces we were able to find and follow. It entered a high gallery through a fissure, fell into the Chamber of the Paintings, desperately tried to find a way out and moved in the direction of Niaux. It had then crossed the first pockets of water, which were perhaps dried up at the time, and had died between lakes 2 and 3. Carbon dating demonstrated that this event occurred thousands of years after the drawings were created. It would have been a nice story, but we had to accept the evidence: The marten had nothing to do with the mustelid in the image.

This brief summary of our research and of our discoveries in the Réseau Clastres shows the inherent difficulty of the undertaking when one seeks to understand what the Magdalenians or their predecessors actually did in the decorated caves, and to what extent our first impressions can be misleading.

At the time of these studies, I did not even contemplate address-ing the question of the significance of the images, or the concep-tual framework within which they had been conceived and created. I was far more preoccupied with down-to-earth matters: what exact traces could be found (drawings, footprints, charcoals, torch marks), and from what time? A return visit to the cave in 1989, that is to say seventeen years later, led us to make certain discoveries, such as the selective breakage of stalactite draperies, or the shifting and deposi-tion of concretions in recesses. We had by then acquired considerable experience and were thus able to make observations that had at first eluded us.

It is only later that the questions concerning the "why" of the art and associated actions arose, after I had studied, most of the time as part of a team, several other decorated caves (Le Placard, Le Travers de Janoye, Mayrière supérieure, Niaux, Le Tuc d'Audoubert, and, espe-cially, Cosquer and Chauvet). It is that experience that led me to write the present account that retraces the genesis, development, and out-come of those questions.

Can it be claimed that the shamanic hypothesis, which currently seems to provide the best match for the established facts concerning Paleolithic art, represents a conceptual revolution that can explain Paleolithic art while overthrowing and replacing the other theories proposed during the twentieth century? Obviously not. There is a large enough framework to accommodate a reality with inescapable complexity,[2] within which all proposed explanations have their place. If Paleolithic people did not practice art for art's sake, they quite evi-dently did strive to find an aesthetic quality in their portrayal of ani-mals that is exceptional in rock art around the world. Considering that we can see such excellence extending from the beginning (Chauvet) to the end (Niaux), it must be assumed that the naturalism of the ani-mals represented, the accuracy of their proportions, and the desired visual effect played a significant role in their beliefs, their rituals, and the effectiveness of the latter. As we have seen, this implies an initial selection of individuals that had some talent for drawing, who were then taught and trained.

As for totemism, we know that it can in no way exclude shamanism. The Kwakiutl of Western Canada, totemists par excellence who are renowned for their spectacular sculpted totems of mythical figures, practiced shamanism.[3] This also holds for certain aboriginal cultures in Australia, where totemism is very widespread, but who equally devoted themselves to shamanism.[4] Within the same community, several clans, or even different individuals, can each have their own totem, which would explain the diversity of the species represented, as well as the occasional predominance of some among them.

The magic of the hunt naturally has its place in shamanism, in various guises. It cannot explain everything and, as a consequence, long persisted as an attempt to provide a general interpretation. In contrast, we know, from multiple ethnographic examples, that ceremonies performed with the goal of favoring the hunt are still organized by hunting peoples. Rather than bewitchment in the strict sense, which would imply a constraint, the goal is to persuade the animal, or the Lord of the Animals, to deliver itself to the hunter or to allow the animal to deliver itself to him. The difference between a magic that constrains and the shamanic practice of negotiating and persuading the powers of the world beyond is fundamental. However, the power of the image postulated in the traditional theory, as well as the concept of drawing realized, in certain cases, for their own sake, are certainly concepts that are found in shamanic cultures.

Structuralism, proposed by Max Raphael, Annette Laming-Emperaire, and André Leroi-Gourhan, is located in a very different context when it comes to understanding the images, as it is concerned with their organization within the cave and not their meaning. It is more the "How?" that finds an answer than the "Why?" It goes without saying that the distributions of animals and signs as a function of their own nature and the physical particularities of the caves are not incompatible with a shamanic conception of the universe and their implicit implementation, which is necessarily structured.

Finally, occasional attempts have been made to see "the myths" in opposition to the shamanic hypothesis, which is one way of doing away with the problem. The intimate link between parietal creations

and myths would be "the most suitable to account for the internal coherence of parietal art."[5] Myths are obviously a part of all shamanic beliefs. As we have seen, they necessarily vary over time and regionally, and the same applies to images. That the animals and signs painted or engraved on the walls stem from myths is thus highly likely.[6] What is far less likely is the hypothesis that cave art is nothing but a simple representation of myths, as we are then confronted by several major conflicts with established facts: the drawings created for their own sakes in the recesses; the relatively small number of deep caves and especially the rarity of visits made to them.[7] These facts are incompatible with some of the major roles of myths (transfer of sacred knowledge, strengthening of social cohesion), which imply the presence of more-or-less numerous participants and spectators at the ceremonies.

The parietal art of the Ice Ages and the beliefs that prompted their creation as we know it simply cannot be reduced to a single explanation, regardless of which it is. We are dealing with fully human societies, that is to say societies that were necessarily complex, and endeavored to understand the world in their own way and to take full advantage of it. Their originality relates to the way in which they exploited the subterranean environment, where their achievements and traces were preserved infinitely more often and better than out in the open. In all likelihood, they held shamanic beliefs. Here, there is a very broad explanatory framework. It cannot explain the details of the representations or their precise significance, but it can account for a multitude of observations that render it credible, and it fits harmoniously within the array of human religions.

At the end of the day, if we have only very few certainties, by exercising caution and building on what is known and what is probable, I feel that we are able to approach these distant hunters of the Paleolithic with somewhat greater success. We can then begin to distinguish their vague outlines, bustling around and living their short and precarious (but always rich and complex) lives, in a haze that is now a little less dense.

Notes

INTRODUCTION

1. Following the publication of Clottes and Lewis-Williams 2007, in which we recorded the objections to our hypotheses and the astonishing virulence of the attacks launched upon them, things have barely changed. For example, in a book released at the end of 2009, Jean-Loïc Le Quellec described my work as "mania" and as "an obsession that elicits from his most eminent colleagues nothing other than harsh criticism or polite silence" (Le Quellec 2009, p. 236).

2. Lewis-Williams and Dowson 1988.

3. Lewis-Williams and Clottes 1996, 1998a, 1998b; Clottes and Lewis-Williams 1996, 1997a, 1997b, 2000, 2001a, 2001b, 2009.

4. Clottes 1998, 1999, 2000b, 2001b, 2003a, 2003b, 2003c, 2004a, 2004b, 2004c, 2005a, 2006, 2007a, 2007b, 2007c, 2008, 2009.

5. "Intensive" instruction for twenty-five to thirty hours on rock art given at the Universities of Neuchâtel (Switzerland), Girona (Spain), and Victoria (Vancouver Island, Canada).

6. A former president of the Leakey Foundation, my friend Bill Wirthlin, amiably encouraged me to write this personal account, recounting anecdotes and diverse experiences to elucidate rock art.

7. In writing this book, to the extent that they were relevant to the themes concerned, I have occasionally made use of extracts from certain articles that I previously published in various journals. References to those articles are provided in the bibliography.

CHAPTER ONE

1. Lorblanchet 1988, p. 282.

2. Bahn 1998, p. 171.

3. Chakravarty and Bednarik 1997, pp. 195–196.

4. Gould 1998, p. 72.

5. Malinovski 1944, pp. 13, 16.
6. Lartet and Christy 1864, p. 264.
7. These hypotheses have often been developed in the specialist literature. A summary is provided here in order to highlight problems and the status of research. If greater detail is sought, the reader is particularly advised to refer to Laming-Emperaire 1962; Ucko and Rosenfeld 1966; Groenen 1994; Delporte 1990; Clottes and Lewis-Williams 1996 (pp. 61–79), 2007 (pp. 69–91).
8. Cartailhac 1902.
9. Halverson 1987: pp. 63–71 for his article, pp. 71–82 for commentaries and criticisms from eleven different reviewers, and pp. 82–89 for his response.
10. Leroi-Gourhan 1964, p. 147.
11. Reinach 1903.
12. Breuil 1952; Bégouën 1924, 1939.
13. Bégouën 1924, p. 423.
14. Bégouën 1939, p. 211.
15. Clottes and Delporte 2003.
16. Raphaël 1945.
17. Laming-Emperaire 1962; Leroi-Gourhan 1965.
18. Leroi-Gourhan 1965, p. 120.
19. The structuralist approach and its accompanying methods have in fact been pursued and developed by certain disciples of André Leroi-Gourhan (Vialou 1986; Sauvet and Wlodarczyk 2008).
20. Eliade 1951.
21. Lommel 1967a, 1967b; La Barre 1972; Halifax 1982; Smith 1992.
22. Lewis-Williams and Dowson 1988, 1990; Lewis-Williams 1997, 2002.
23. Clottes and Lewis-Williams 1996, 1997a, 1997b, 2009; Lewis-Williams and Clottes 1996, 1998a, 1998b.
24. Clottes 1998, 1999, 2003a, 2003c, 2004a, 2004b, 2004c, 2005a, 2007b, 2007c.
25. Vitebsky 1995, 1997.
26. Lemaire 1993, p. 166.
27. Lewis-Williams and Dowson 1988.
28. Clottes and Lewis-Williams 2009, p. 23.
29. We presented and analyzed the foundation and contours of this controversy at some length in a book with a distinctive structure (Clottes and Lewis-Williams 2001a, 2007). In order to allow the reader to form an independent opinion, we published the complete text of our primary publication and followed this first with all the polemical attacks that had come to our notice and then our reasoned responses to those criticisms.
30. Hamayon 1997.
31. Atkinson 1992, p. 311.

32. Leroi-Gourhan 1984.
33. Leroi-Gourhan 1976–1977, p. 492.
34. Leroi-Gourhan 1976–1977, p. 493.
35. Leroi-Gourhan 1974–1975, p. 390.
36. Leroi-Gourhan 1984, p. 89.
37. Vialou 1986, p. 367.
38. Sauvet and Wlodarczyk 2008.
39. André Leroi-Gourhan also applied this kind of "thematic reduction."
40. Sauvet and Wlodarczyk 2008, p. 166.
41. Aujoulat 2004.
42. Leroi-Gourhan 1965, p. 81.
43. Hempel 1966.
44. Wylie 1989; Lewis-Williams 2002.
45. The requirements for scientific hypotheses in the realm of archaeology, along with the false problem of "proof" and the validity of ethnological comparisons, are effectively discussed by David Lewis-Williams and Thomas Dowson in their renowned article published in *Current Anthropology* (Lewis-Williams and Dowson 1988).
46. Anati 1989, 1999.
47. Clottes 1993.
48. Leroi-Gourhan 1980, p. 132.
49. For an elaboration of this topic, see Clottes 2006.
50. Jankélévitch 1994.
51. Edward Taylor particularly expounded on the primordial importance of dreams during the nineteenth century.
52. Otte 2001.
53. Lorblanchet 1999.
54. Bednarik 1995.
55. D'Errico and Nowell 2000.
56. Bednarik 2003a.
57. Bednarik 2003b.
58. Zilhão et al. 2010.
59. Lorblanchet 1999, p. 133.
60. Henshilwood et al. 2002; Henshilwood 2006.
61. Texier et al. 2010.
62. Conard 2003.
63. Breuil 1952, pp. 146–147.
64. Breuil 1952, fig. 112.
65. Breuil 1952, fig. 111.
66. Leroi-Gourhan 1965.

67. Perlès 1992, p. 47.
68. See, for example, Demoule 1997 and, for a refutation, Clottes and Lewis-Williams 2001a, pp. 188–191, 223.
69. Lewis-Williams and Clottes 1998a, p. 48; Clottes and Lewis-Williams 2001a, pp. 188–189.
70. Leroi-Gourhan 1965, p. 110.
71. Lorblanchet 1989, p. 62.
72. Triolet and Triolet 2002.
73. Bégouën 1924, 1939.
74. Lemaire 1993.

CHAPTER TWO

1. I finally visited the latter in July 2014.
2. Fage and Chazine 2009.
3. Some of them have been published, occasionally in greater detail, in short articles that are now out of print: Clottes 2000a and 2003d.
4. The Maya of Central America; cf. Stone 1997.
5. Compare Chaloupka 1992.
6. I was able to do this thanks to my friend George Chaloupka, who had compiled an enormous file (letters, newspaper cuttings) on these facts and allowed me to familiarize myself with them at my leisure during the days that I spent at his home.
7. Lewis-Williams 2003, 2010.
8. Iliès 2003.
9. I did return to India for a much longer stay in January and February 2011, then in the following years, and was able to visit many decorated sites in the region of Pachmarhi and various other places of Madhya Pradesh and Rajasthan, guided by my colleague Dr. Meenakshi Pathak.
10. Clottes 2005b.
11. Kumar 1992, p. 63.
12. Pradhan 2004, p. 39.
13. Pradhan 2001, p. 62.
14. Pradhan 2001, p. 59.
15. Célestin-Lhopiteau 2009, p. 28.
16. Célestin-Lhopiteau 2009, p. 26.
17. This is the term commonly used, by specialists as well, for this statue in the Angara River region.
18. See chapter 1: "Suppositions regarding the Significance of Paleolithic art" (p. 7).

19. In a book recently published under her editorship, Isabelle Célestin-Lhopiteau included a complete transcript of the interview that we were able to conduct with the Khakassian shaman Tatiana Vassiliyevna Kobejikova on June 20, 2010 (Célestin-Lhopiteau 2011, pp. 106–114).

20. Célestin-Lhopiteau 2011, p. 113.

CHAPTER THREE

1. "The persistence of the images through millennia did not imply the permanence of meaning" (Lorblanchet 1992, p. 133), concerning Australian art, but also its Paleolithic equivalent.

2. Ngarjno et al. 2000.

3. Bednarik 2003c.

4. May and Domingo Sanz 2010, p. 40.

5. Macintosh 1977, p. 192.

6. Macintosh 1977, p. 197.

7. Berndt and Berndt 1992.

8. Rozwadowski 2004, p. 59.

9. François and Lennartz 2007, p. 86.

10. Garfinkel et al. 2009, p. 190.

11. The first to be given that label was the mud-glyph cave in Tennessee, and then this was subsequently extended to others. On the topic of mud-glyph caves, see Faulkner 1988, 1997.

12. Described by specialists as therianthropes or composite creatures, i.e. simultaneously displaying human and animal characteristics.

13. Nielsen and Nesheim 1956, pp. 80–105.

14. Clottes, Garner, and Maury 1994.

15. L'Art des Cavernes (Anonymous 1984); Clottes 2008.

16. Clottes 1997.

17. Stone 1997.

18. In Brazil, "all Traditions avoided those places that were traditionally dark" (Prous 1994, p. 138).

19. Lenssen-Erz 2008, pp. 165–167.

20. Numerous examples are known of this manner of operation. Thus, in northern Brazil "magnificent smooth surfaces have been neglected in the upper galleries where light is still amply sufficient, while a small cave recess and neighboring small shelters with rock faces that are highly irregular and far less attractive to our eyes have been chosen" for the drawings (Prous 1994, p. 139).

21. Bégouën and Clottes 2008.

22. Clottes and Delporte 2003.
23. López Belando 2003, p. 279.
24. "The cave itself, as a whole or in certain parts, played in many cases the role of the female symbol" (Leroi-Gourhan 1982, p. 58).
25. Utrilla Miranda 1994, p. 105, note 20; Utrilla Miranda and Martínez Bea 2008, p. 123.
26. Villaverde Bonilla 1994.
27. Perlès 1977; Collina-Girard 1998.
28. Brady et al. 1997.
29. Brady et al. 1997, p. 740.
30. Brady et al. 1997, p. 746.
31. Aldenderfer 2005, p. 12.
32. Clottes 2010a.
33. Utrilla Miranda and Martínez Bea 2008, p. 120. In the article cited, these two authors also stressed the dual role of decorated caves, "public spaces" and "private" sanctuaries.
34. Brady 1988.
35. Stone 1995, p. 14.
36. This "sacred geography" is equally applicable to external structures (monuments, mountains) and not just to caves. "There was an ongoing dialogue between the wilderness and the built environment among the ancient Maya" (p. 241).
37. Pales 1976.
38. Bégouën et al. 2009, p. 272.
39. Vallois 1928.
40. Clottes, Rouzaud, and Wahl 1984, p. 435.
41. Garcia 2001, 2010, pp. 36–40.
42. Clottes, Courtin, and Vanrell 2005a, p. 64.
43. Sharpe and Van Gelder 2004.
44. Barrière 1984, p. 518.
45. Baffier and Feruglio 1998, p. 2.
46. Sharpe and Van Gelder 2004, p. 15.
47. Clottes, Courtin, and Vanrell 2005a, p. 215.
48. Clottes, Courtin, and Vanrell 2005a, fig. 48, p. 67.
49. Leroi-Gourhan 1977, p. 23.
50. Dauvois and Boutillon 1994; Reznikoff 1987; Reznikoff and Dauvois 1988; Waller 1993.
51. Lewis-Williams strongly emphasized this phenomenon and its religious implications (Lewis-Williams 1997).
52. Clottes 2004d, 2010a.

53. From 1929, the canon Amédée Lemozi, who studied Pech-Merle, envisaged this hypothesis: "Inside caves the animal enjoys a kind of mysterious preexistence, its presence is manifested through vague natural contours that the artist need only underline and highlight with the addition of a few discreet lines. Here, the art, as P. Mainage said, is in the service of religion" (Lemozi 1929, p. 45).

54. López Belando 2003, p. 281.

55. Rozwadowski 2004, p. 74.

56. Clottes and Lewis-Williams 1996.

57. The hypothesis of frostbite causing partial loss of fingers was recently revived by Pilar Utrilla Miranda and Manuel Martínez Bea (Utrilla Miranda and Martínez Bea 2008, p. 123), in connection with Gargas and the cold that dominated the Pyrenees at the time. But these authors ignore and fail to cite Cosquer, embedded in a very different Mediterranean context.

58. Sahly 1966.

59. Valde-Nowak 2003.

60. Leroi-Gourhan 1967.

61. It should be noted that in this case Leroi-Gourhan resorts, even if only briefly (Leroi-Gourhan 1967, p. 122), to an ethnological comparison.

62. Leroi-Gourhan 1965, p. 127.

63. Leroi-Gourhan 1965, p. 125.

64. Leroi-Gourhan 1965, p. 126.

65. Leroi-Gourhan 1965, p. 128.

66. Breuil 1952, p. 22.

67. Clottes, Courtin, and Vanrell 2005a, pp. 220–221.

68. In the Réseau Clastres, for example, at an unknown point in time, because the cave received a number of prehistoric visits long after the paintings were created, one of these visitors trailed a hand along a few meters of the soft wall (Clottes and Simonnet 1990). In this particular case, this gesture could have been casual and without major significance.

69. Sharpe and Van Gelder 2004, p. 16.

70. Méroc and Mazet 1956, pp. 46–47.

71. Lorblanchet 1990, p. 96.

72. Lorblanchet 1994, p. 240.

73. I have had some personal experiences that are relevant here. When I was in Seville right after Holy Week, I made visits to churches, where for a month the enormous palanquins, each bearing a statue of the Virgin Mary, were exhibited. Palanquins that are the pride of the various brotherhoods and that are paraded through the narrow streets of the town. An elderly blind lady, holding her white cane, was led in front of one of these by her daughter, who whispered in her ear when they were

very close to the monument. The old lady reached out and stroked the wood of the palanquin, and then carefully brushed her hand over her eyes. The intention was obvious.

74. Azéma and Clottes 2008.
75. Bégouën and Clottes 1981; Bégouën et al. 1995.
76. Clottes 2007a, 2009.
77. Bégouën et al. 1995.
78. Bégouën et al. 1995.
79. Clottes 2007a, 2009.
80. It is in fact clear that, for those directly involved, they fulfilled a practical function within the context of their ritual.
81. Lewis-Williams and Dowson used this metaphor of the veil with respect to the San paintings of South Africa (Lewis-Williams and Dowson 1990).
82. Bégouën 1912, p. 659.
83. Clottes and Courtin 1994, p. 60.
84. Shaw, in Hill and Forti 1997: "The speleothems used in pharmacy were two— moonmilk (or mondmilch) and crushed stalactites" (p. 28).
85. Brady and Rissolo 2005.
86. Clottes, Courtin, and Vanrell 2005a, 2005b.
87. Hodgson 2008, p. 345.
88. Bégouën 1924, p. 423.
89. Garfinkel et al. 2009, p. 186.
90. Testart 1993, p. 59.
91. Robert-Lamblin 1996, p. 127.
92. François and Lennartz 2007, p. 82.
93. Young 1992, p. 125.
94. Lewis-Williams and Pearce 2004, p. 156.
95. Lewis-Williams and Dowson 1988; Clottes and Lewis-Williams 1996.
96. Clottes 2010b.
97. Brody 1990, p. 67.
98. Whitley 1996, pp. 124–126.
99. Clottes 2000c, pp. 90–92.
100. Le Guillou 2001.
101. Aujoulat 2004.
102. Whitley 2000.
103. Bandi 1988, p. 138.
104. Simonnet 1991.
105. Péquart 1963, p. 296.
106. Robert 1953, p. 16.
107. Bandi 1988, p. 143.

108. For further details, see Clottes 2001a.
109. On this subject, see Delporte 1984.
110. Camps 1984, p. 258.
111. Cohen 2003, pp. 17, 151–173.
112. Smith 1991, pp. 50–51.
113. Testart 1986.
114. Clottes and Courtin 1994, p. 177.
115. Guthrie 1984, 2005.
116. See Lee 1979 with respect to the !Kung San of southern Africa.
117. Guthrie 1984, p. 71; see also Guthrie 2005.
118. See especially White 2006.
119. For example, in Polynesian societies, sex organs have magical powers, and the female organ is harmful (it destroys *mana*) but also has the power to create.
120. Paul Tréhin, vice-president of Autism-Europe, in litt. February 15, 2002.
121. Treffert 2009.
122. Humphrey 1998, p. 165: "Comparison of the cave art with the drawings made by a young autistic girl, Nadia, reveals surprising similarities in content and style."
123. Humphrey 1998, p. 176: "The case for supposing that the cave artists did share some of Nadia's mental limitations looks surprisingly strong."
124. Clottes, pp. xix–xxv, in Heyd and Clegg 2005.
125. Lee 1992, p. 12.
126. Victor and Robert-Lamblin 1993, p. 229.
127. Fénies 1965; Simonnet 1996; Clottes 2004c.
128. Clottes and Lewis-Williams 2007, p. 217.
129. Ann Sieveking, in Lorblanchet and Sieveking 1997, p. 53: "Perhaps we have here an unambiguous example of decoration produced in an altered state of consciousness. Many factors may contribute to this. Beside the ritual context of the representation we might imagine extreme fatigue, hunger, isolation, an individual's natural ability to hallucinate, or the use of various psychotropic drugs."
130. Wallis 2004, p. 22: "In the context of shamanic art, ethnographic records suggest that the visual imagery is often a direct depiction of shamanic experiences."
131. Chaumeil 1999, p. 43.
132. Hamayon 1995, p. 418. This specialist has always emphasized the association between shamanism and hunting economies and, despite the reservations that she holds regarding the subject of the trance, she conceded the significance of the likely connections of this religion with the people of the Upper Paleolithic and declared in an interview: "I was always convinced that cave art had a connection to—true—shamanism: there is a fundamental link between shamans and the hunt. It seems highly likely to me that these societies where life depended to such a great extent on animals would resort to shamanism" (*La Croix*, December 20, 1996).

133. Chaumeil 1999, p. 43. The privileged association of shamanism with hunting economies has also been elaborated or mentioned by a number of specialists of this religion: Vitebsky 1995, pp. 29–30; Vazeilles 1991, p. 39; Perrin 1995, pp. 92–93; Hamayon 1990a, p. 289.

CONCLUSION

1. Clottes and Simonnet 1972, 1990.
2. On the topic of the complexity and diversity of shamanic beliefs and practices, despite their fundamental unity, it is useful to consult the two remarkable encyclopedic multiauthored volumes devoted to shamanic cultures on the five continents (Walter and Fridman 2004).
3. Rosman and Ruebel 1990.
4. Hume 2004; see also Lommel (1997), who witnessed shamanic ceremonies when he spent four months among the Wunambal of the Kimberley in Australia in 1938.
5. Sauvet and Tosello 1998, p. 89. In the wake of the publication of our work *Les Chamanes de la Préhistoire* (Clottes and Lewis-Williams 1996; translated as *The Shamans of Prehistory*), Yvette Taborin was far more peremptory in an interview with a journalist: "One can only say that cave art relates a mythology. The rest is imagination" (*La Croix*, December 20 1996).
6. See chapter 3, where this aspect was developed in detail.
7. This aspect has been discussed in chapter 3, in the context of the attitude to caves. See also, for a more detailed discussion, Clottes and Lewis-Williams 2007, p. 215.

Bibliography

Aldenderfer, Mark. 2005. "Caves as Sacred Places on the Tibetan Plateau." *Expedition (University of Pennsylvania Museum of Archaeology and Anthropology)* 47: 8–13.

Anati, Emmanuel. 1989. *Les origines de l'art et la formation de l'esprit humain* [The origins of art and the development of the human spirit]. Paris: Albin Michel.

Anati, Emmanuel. 1999. *La religion des origines* [The origin of religion]. Paris: Bayard.

Anonymous. 1984. *L'art des cavernes: Atlas des grottes ornées paléolithiques françaises* [Cave art: Atlas of decorated Paleolithic caves in France]. Paris: Imprimerie Nationale/Ministère de la Culture.

Atkinson, Jane Monnig. 1992. "Shamanisms Today." *Annual Review of Anthropology* 21: 307–330.

Aujoulat, Norbert. 2004. *Lascaux: Le geste, l'espace et le temps (Collection arts rupestres)*. Paris: Le Seuil. Translated as *The Splendour of Lascaux: Rediscovering the Greatest Treasure of Prehistoric Art* (London: Thames & Hudson, 2005).

Azéma, Marc, and Jean Clottes. 2008. "Traces de doigts et dessins dans la grotte Chauvet (Salle du Fond)/Traces of Finger Marks and Drawings in the Chauvet Cave (Salle du Fond)." *INORA: International Newsletter on Rock Art* 52: 1–5.

Baffier, Dominique, and Valérie Feruglio. 1998. "Premières observations sur deux nappes de ponctuations de la grotte Chauvet (Vallon-Pont-d'Arc, Ardèche, France)" [Initial observations on two layers of dot markings in the Chauvet cave (Vallon-Pont-d'Arc, Ardèche, France)]. *INORA: International Newsletter on Rock Art* 2: 1–4.

Bahn, Paul G. 1998. *The Cambridge Illustrated History of Prehistoric Art*. Cambridge: Cambridge University Press.

Bandi, Hans-Georg. 1988. "Mise bas et non défécation: Nouvelle interprétation de trois propulseurs magdaléniens sur des bases zoologiques, éthologiques et symboliques" [Birth, not defecation: A new interpretation of three Magdalenian spear-throwers based on zoology, ethology and symbolism]. *Espacio, Tiempo y Forma, Serie I, Prehistoria* 1: 133–147.

Barrière, Claude. 1984. "Grotte de Gargas" [The Gargas cave]. Pp. 514–522 in *L'art des cavernes: Atlas des grottes ornées paléolithiques françaises* [Cave art: Atlas of decorated Paleolithic caves in France]. Paris: Imprimerie Nationale/Ministère de la Culture.

Bednarik, Robert G. 1995. "Concept-Mediated Marking in the Lower Palaeolithic." *Current Anthropology* 36: 605–634.

Bednarik, Robert G. 2003a. "A Figurine from the African Acheulian." *Current Anthropology* 44: 405–413.

Bednarik, Robert G. 2003b. "The Earliest Evidence of Palaeoart." *Rock Art Research* 20: 89–135.

Bednarik, Robert G. 2003c. "Ethnographic Interpretation of Rock Art." http://mc2.vic net.net.au/home/interpret/web/ethno.html.

Bégouën, Henri. 1912. "Les statues d'argile de la Caverne du Tuc d'Audoubert (Ariège)" [The clay statues in the Tuc d'Audoubert Cave (Ariège)]. *l'Anthropologie* 23: 657–665.

Bégouën, Henri. 1924. "La magie aux temps préhistoriques" [Magic in prehistoric art]. *Mémoires de l'Académie des Sciences, Inscriptions et Belles-lettres de Toulouse*, 12th series, 2: 417–432.

Bégouën, Henri. 1939. "Les bases magiques de l'art préhistorique" [The magical foundations of prehistoric art]. *Scientia*, 4th series, 33rd year, 65: 202–216.

Bégouën, Robert, and Jean Clottes. 1981. "Apports mobiliers dans les cavernes du Volp (Enlène, Les Trois-Frères, Le Tuc d'Audoubert)" [Portable objects in the Volp caves (Enlène, Les Trois-Frères, Le Tuc d'Audoubert)]. Pp. 157–187 in *Altamira Symposium, Madrid-Asturias-Santander, 15–21 October 1979*. Universidad complutense de Madrid, Instituto Español de Prehistoria.

Bégouën, Robert, and Jean Clottes. 2008. "Douze nouvelles plaquettes gravées d'Enlène" [Twelve new engraved flat stones from Enlène]. *Espacio, Tiempo y Forma, Series I, Nueva época. Prehistoria y arqueología* 1: 77–92.

Bégouën, Robert, Jean Clottes, Jean-Pierre Giraud, and François Rouzaud. 1993. "Os plantés et peintures rupestres dans la caverne d'Enlène" [Inserted bones and wall paintings in the Enlène cave]. Pp. 283–306 in Delporte, Henri, and Jean Clottes, eds., *Pyrénées préhistoriques: Arts et Sociétés, Actes du 118e Congrès national des Sociétés historiques et scientifiques, octobre 1993* [Prehistory of the Pyrenees: Arts and Societies, Proceedings of the 118th National Congress of the Historical and Scientific Societies, October 1993.] Paris: Éditions du CTHS (Comité des travaux historiques et scientifiques).

Bégouën, Robert, Carole Fritz, Gilles Tosello, Jean Clottes, Andreas Pastoors, and François Faist. 2009. *Le Sanctuaire secret des bisons: Il y a 14 000 ans dans la caverne du Tuc d'Audoubert* [The secret sanctuary of the bisons: 14,000 years ago in the Tuc D'audoubert cave]. Paris: Somogy.

Berndt, Ronald Murray, and Catherine Helen Berndt. 1992. *The World of the First Australians: Aboriginal Traditional Life, Past and Present*. (New revised and corrected edition; first edition published in 1962.) Canberra: Aboriginal Studies Press.

Bonsall, Clive, and Christopher Tolan-Smith, eds. 1997. *The Human Use of Caves*. Oxford: British Archaeological Reports, International Series No. 667.

Brady, James Edward. 1988. "The Sexual Connotation of Caves in Mesoamerican Ideology." *Mexicon* 1: 51–55.

Brady, James Edward, and Dominique Rissolo. 2005. "A Reappraisal on Ancient Maya Cave Mining." *Journal of Anthropological Research* 62: 471–490.

Brady, James Edward, Ann Scott, Hector Neff, and Michael D. Glascock. 1997. "Speleothem Breakage, Movement, Removal, and Caching: An Aspect of Ancient Maya Cave Modification." *Geoarchaeology* 12: 725–750.

Breuil, Henri. 1952. *Quatre cents siècles d'art pariétal: Les cavernes ornées de l'Âge du Renne, Montignac* [Four hundred centuries of rock art: The decorated caves of the reindeer age in Montignac]. Périgueux: Centre d'études et de documentation préhistoriques.

Brody, Jerry J. 1990. *The Anasazi: Ancient Indian People of the American South West.* New York: Rizzoli.

Camps, Gabriel. 1984. "La défécation dans l'art paléolithique" [Defecation in Paleolithic art]. Pp. 251–262 in Bandi, Hans-Georg, Walter Huber, Marc-Roland Sauter, and Beat Sitter, eds., *La contribution de la zoologie et de l'éthologie à l'interprétation de l'art des peuples chasseurs préhistoriques: Colloque de Sigriswill, 1979* [The contribution of zoology and ethology to interpretation of the art of prehistoric hunters: Sigriswill Colloquium, 1979.] Fribourg (Switzerland): Éditions Universitaires.

Cartailhac, Émile. 1902. "La grotte ornée d'Altamira (Espagne): Mea culpa d'un sceptique" [The decorated cave of Altamira (Spain): *Mea culpa* of a skeptic]. *L'Anthropologie* 13: 348–354.

Célestin-Lhopiteau, Isabelle. 2009. "Témoignage sur l'utilisation actuelle de l'art rupestre par un chamane bouriate en Sibérie (Fédération de Russie)" [Report on contemporary utilization of rock art by a Buryat shaman in Siberia (Russian Federation)]. *INORA: International Newsletter on Rock Art* 53: 25–30.

Célestin-Lhopiteau, Isabelle, ed. 2011. *Changer par la thérapie* [Changing through therapy]. Paris: Dunod.

Chakravarty, Kalyan Kumar, and Robert G. Bednarik. 1997. *Indian Rock Art and Its Global Context.* Delhi: Motilal Banarsidass Publishers and Indira Gandhi Rashtriya Manav Sangrahalaya.

Chaloupka, George. 1992. *Burrunguy.* Nourlangie Rock: Northart.

Chaumeil, Jean-Pierre. 1999. "Les visions des chamanes d'Amazonie" [The visions of Amazonian shamans]. *Sciences Humaines* 97: 42–45.

Clottes, Jean. 1993. "La naissance du sens artistique" [The birth of the artistic sense]. *Revue des Sciences Morales et Politiques* 148: 173–184.

Clottes, Jean. 1997. "Art of the Light and Art of the Depths." Pp. 203–216 in Conkey, Margaret W., Olga Soffer, Deborah Stratmann, and Nina G. Jablonski, eds., *Beyond Art: Pleistocene Image and Symbol.* Memoirs of the California Academy of Sciences. Oakland: University of California Press.

Clottes, Jean. 1998. "La piste du chamanisme" [The trail of shamanism]. *Le Courrier de l'Unesco* April 1998: 24–28.

Clottes, Jean. 1999. "De la Transe à la trace . . . Les chamanes des cavernes" [From the trance to the trace . . . Shamans of the caves]. Pp. 19–32 in Aïn, Joyce, ed., *Survivances. De la destructivité à la créativité* [Relics: From destructiveness to creativity]. Ramonville-Saint-Agne: Éditions Érès.

Clottes, Jean. 2000a. *Grandes girafes et fourmis vertes: Petites histoires de préhistoire* [Big giraffes and green ants: Brief tales from prehistory]. Paris: La Maison des Roches.

Clottes, Jean. 2000b. "Une nouvelle image de la grotte ornée" [A new view of decorated caves]. *La Recherche hors série n° 4* November: 44–51.

Clottes, Jean. 2000c. *Le Musée des Roches: L'art rupestre dans le monde* [The museum in stone: Rock paintings around the world]. Paris: Éditions du Seuil.

Clottes, Jean. 2001a. "Le thème mythique du faon à l'oiseau dans le Magdalénien pyrénéen" [The mythical theme of the fawn with the bird in the Pyrenean Magdalenian]. *Préhistoire ariégeoise, Bulletin de la Société préhistorique Ariège-Pyrénées* 56: 53–62.

Clottes, Jean. 2001b. "Paleolithic Art in France." *Adoranten* (Scandinavian Society for Prehistoric Art) 2001: 5–19.

Clottes, Jean. 2003a. "De 'l'art pour l'art' au chamanisme: l'interprétation de l'art préhistorique" [From "art for art's sake" to shamanism: The interpretation of prehistoric art]. *La Revue pour l'Histoire du CNRS* 8: 44–53.

Clottes, Jean. 2003b. "L'Art pariétal, ces dernières années, en France" [Rock art in France in recent years]. Pp. 77–94 in Desbrosse, René, and André Thévenin, eds., *Préhistoire de l'Europe: Des origines à l'Âge du Bronze, Actes des Congrès nationaux des Sociétés historiques et scientifiques 125 (Colloque "L'Europe préhistorique," Lille, 2000)* [Prehistory of Europe: From its origins to the Bronze Age: Proceedings of the National Congresses of the Historical and Scientific Societies, No. 125 (Colloquium on European Prehistory, Lille, 2000)]. Paris: Éditions du CTHS (Comité des travaux historiques et scientifiques).

Clottes, Jean. 2003c. "Chamanismo en las cuevas paleolíticas" [Shamanism in Paleolithic caves]. *El Catoblepas* 21: 1–8.

Clottes, Jean. 2003d. *Passion Préhistoire* [A passion for prehistory]. Paris: La Maison des Roches.

Clottes, Jean. 2004a. "Le cadre chamanique de l'art des cavernes" [The shamanic context for cave art]. *Recueil de l'Académie de Montauban, nouvelle série* 5: 119–125.

Clottes, Jean. 2004b. "Le chamanisme paléolithique: Fondements d'une hypothèse" [Paleolithic shamanism: Foundations for a hypothesis]. Pp. 195–202 in Otte, Marcel, ed., *La Spiritualité, Actes du colloque de la Commission 8 de l'UISPP, Liège, 10–12 décembre 2003* [Spirituality: Proceedings of a Colloquium of Commission 8 of the l'UISPP, Liège, 10–12 December 2003]. Liège: ERAUL 106.

Clottes, Jean. 2004c. "Hallucinations in Caves." *Cambridge Archaeological Journal* 14: 81–82.

Clottes, Jean. 2004d. "Du nouveau à Niaux" [News from Niaux]. *Bulletin de la Société Préhistorique Ariège-Pyrénées* 59: 109–116.

Clottes, Jean. 2005a. "Shamanic Practices in the Painted Caves of Europe." Pp. 279–285 in Harper, Charles L., ed., *Spiritual Information: 100 Perspectives on Science and Religion*. West Conshohocken: Templeton Foundation Press.

Clottes, Jean. 2005b. *Rock Art and Archaeology in India*. Bradshaw Foundation website, World Rock Art, http://www.bradshawfoundation.com.

Clottes, Jean. 2006. "Spirituality and Religion in Paleolithic Times." Pp. 133–148 in *The Evolution of Rationality: Interdisciplinary Essays in Honor of J. Wentzel van Huyssteen*. Grand Rapids, MI/Cambridge: Wm. Eerdmans.

Clottes, Jean. 2007a. "Un geste paléolithique dans les grottes ornées: Os et silex plantés" [A Paleolithic gesture in decorated caves: Inserted bones and flint]. Pp. 41–54 in Desbrosse, René, and André Thévenin, eds., *Arts et cultures de la Préhistoire: Hommage à Henri Delporte* [Arts and cultures in prehistory: In honor of Henri Delporte]. Paris: Éditions du CTHS (Comité des travaux historiques et scientifiques).

Clottes, Jean. 2007b. "Du chamanisme à l'Aurignacien?/Schamanismus im Aurignacien?" [Shamanism in the Aurignacian?]. Pp. 435–449 in Floss, Harald, and Nathalie Rouquerol, eds., *Les Chemins de l'art aurignacien en Europe/Das Aurignacien und die Anfänge der Kunst in Europa: Colloque international/Internationale Fachtagung, Aurignac, 16–18 septembre 2005* [The trajectories of Aurignacian art in Europe: International Colloquium, Aurignac, 16–18 September 2005]. Aurignac: Éditions Muséeforum d'Aurignac.

Clottes, Jean. 2007c. "El chamanismo paleolítico: Fundamentos de una hipótesis" [Paleolithic shamanism: Foundations of a hypothesis]. *Veleia* 24/25: 269–284.

Clottes, Jean. 2008. *L'Art des cavernes préhistoriques*. Paris: Phaidon. English edition: *Cave Art* (London: Phaidon, 2008; revised edition published in 2010).

Clottes, Jean. 2009. "Sticking Bones into Cracks in the Upper Palaeolithic." Pp. 195–211 in Renfrew, Colin, and Iain Morley, eds., *Becoming Human: Innovation in Prehistoric Material and Spiritual Culture*. Cambridge, Cambridge University Press.

Clottes, Jean. 2010a. *Les Cavernes de Niaux: Art préhistorique en Ariège-Pyrénées* [The caves of Niaux: Prehistoric art in Ariège-Pyrénées]. Paris: Éditions Errance.

Clottes, Jean. 2010b. "Les mythes" [The myths]. Pp. 237–251 in Otte, Marcel, ed., *Les Aurignaciens* [The Aurignacians]. Paris: Éditions Errance.

Clottes, Jean, and Jean Courtin. 1994. *La Grotte Cosquer: Peintures et gravures de la caverne engloutie* [The Cosquer cave: Paintings and engravings in the submerged cave]. Paris: Éditions du Seuil.

Clottes, Jean, Jean Courtin, and Luc Vanrell. 2005a. *Cosquer redécouvert* [Cosquer rediscovered]. Paris: Éditions du Seuil.

Clottes, Jean, Jean Courtin, and Luc Vanrell. 2005b. "Images préhistoriques et 'méde-
cines' sous la mer" [Prehistoric images and "medicines" beneath the sea]. *INORA:
International Newsletter on Rock Art* 42: 1–8.

Clottes, Jean, and Henri Delporte, eds. 2003. *La Grotte de La Vache (Ariège), Tome 1: Les
Occupations du Magdalénien; Tome 2: L'Art mobilier* [The Grotte de La Vache (Ariège),
Volume 1: The Magdalenian occupations; Volume 2: Portable art]. Paris: Éditions
de la Réunion des Musées nationaux et du Comité des Travaux historiques et sci-
entifiques.

Clottes, Jean, Marilyn Garner, and Gilbert Maury. 1994. "Bisons magdaléniens des
cavernes ariégeoises" [Magdalenian bison in the caves of Ariége]. *Préhistoire arié-
geoise, Bulletin de la société préhistorique Ariège-Pyrénées* 49: 15–49.

Clottes, Jean, and David Lewis-Williams. 1996. *Les Chamanes de la Préhistoire: Transe et
magie dans les grottes ornées*. Paris: Éditions du Seuil. English edition: *The Shamans of
Prehistory: Trance and Magic in the Painted Caves* (New York: Harry N. Abrams, 1998).

Clottes, Jean, and David Lewis-Williams. 1997a. "Les chamanes des cavernes" [Shamans
of the caves]. *Archéologia* 336: 30–41.

Clottes, Jean, and David Lewis-Williams. 1997b. "Transe ou pas transe: Réponse à Ro-
berte Hamayon" [Trance or no trance: Reply to Roberte Hamayon]. *Nouvelles de l'Ar-
chéologie* 69: 45–47.

Clottes, Jean, and David Lewis-Williams. 2000. "Chamanisme et art pariétal paléo-
lithique: Réponse à Yvette Taborin" [Shamanism and Paleolithic rock art: Reply to
Yvette Taborin]. *Archéologia* 338: 6–7.

Clottes, Jean, and David Lewis-Williams. 2001a. *Les Chamanes de la Préhistoire: Texte in-
tégral, polémiques et réponses* [The shamans of prehistory: Complete text, polemics
and responses]. Paris: La Maison des Roches.

Clottes, Jean, and David Lewis-Williams. 2001b. "After *The Shamans of Prehistory*:
Polemics and Responses." Pp. 100–142 in Keyser, James D., George Poetschat, and
Michael W. Taylor, eds., *Talking with the Past: The Ethnography of Rock Art*. Portland:
The Oregon Archaeological Society.

Clottes, Jean, and David Lewis-Williams. 2007. "Les Chamanes de la Préhistoire suivi de
Après Les Chamanes, polémiques et réponses" [*The Shamans of Prehistory* followed
by *After the Shamans: Polemics and Responses*]. Paris: Éditions du Seuil (Collection
Points Histoire).

Clottes, Jean, and David Lewis-Williams. 2009. "Palaeolithic Art and Religion." Pp. 7–45
in Hinnells, John R., ed., *The Penguin Handbook of Ancient Religions*. London: Pen-
guin Reference Library.

Clottes, Jean, François Rouzaud, and Luc Wahl. 1984. "Grotte de Fontanet" [The Fonta-
net cave]. Pp. 433–437 in *L'Art des Cavernes: Atlas des grottes ornées paléolithiques fran-
çaises* [Cave art: Atlas of the Paleolithic painted caves of France]. Paris: Imprimerie
Nationale/Ministère de la Culture.

Clottes, Jean, and Robert Simonnet. 1972. "Le Réseau René Clastres de la caverne de Niaux (Ariège)" [The René Clastres galleries in the Niaux cave (Ariège)]. *Bulletin de la Société préhistorique française* 69: 293–323.

Clottes, Jean, and Robert Simonnet. 1990. "Retour au Réseau Clastres" [Revisiting the Clastres galleries]. *Bulletin de la Société préhistorique Ariège-Pyrénées* 45: 51–139.

Cohen, Claudine. 2003. *La Femme des origines: Images de la femme dans la préhistoire occidentale* [Primordial woman: Images of women in Western prehistory]. Paris, Éditions Belin-Herscher.

Collina-Girard, Jacques. 1998. *Le Feu avant les allumettes* [Fire before matches]. Paris: Éditions de la Maison des sciences de l'homme.

Conard, Nicholas J. 2003. "Palaeolithic Ivory Sculptures from Southwestern Germany and the Origins of Figurative Art." *Nature* 426: 380–382.

Dauvois, Michel, and Xavier Boutillon. 1994. "Caractérisation acoustique des grottes ornées paléolithiques et de leurs lithophones naturels/Acoustical Characterizings of Orned Palaeolithic Caves and Their Natural Lithophones." Pp. 209–251 in *La Pluridisciplinarité en archéologie musicale, IVe Rencontres internationales d'archéologie musicale de l'ICTM (Saint-Germain-en-Laye, octobre 1990)* [Multidisciplinarity in Musical Archeology, 4th International Meetings in Musical Archeology of the International Council for Traditional Music (Saint-Germain-en-Laye, October 1990)]. Paris: Centre français d'archéologie musicale Pro Lyra.

Delporte, Henri. 1984. *Archéologie et réalité: Essai d'approche épistémologique* [Archeology and reality: An attempted epistemological approach]. Paris: Picard.

Delporte, Henri. 1990. *L'Image des animaux dans l'art préhistorique* [Animal images in prehistoric art]. Paris: Picard.

Demoule, Jean-Paul. 1997. "Images préhistoriques, rêves de préhistoriens" [Prehistoric images, dreams of prehistorians]. *Critique* 606: 853–870.

D'Errico, Francesco, and April Nowell. 2000. "A New Look at the Berekhat Ram Figurine: Implications for the Origins of Symbolism. *Cambridge Archaeological Journal* 10: 123–167.

Eliade, Mircea. 1951. *Le Chamanisme et les techniques archaïques de l'extase* [Shamanism and archaic techniques for achieving ecstasy]. Paris: Payot.

Fage, Luc-Henri, and Jean-Michel Chazine. 2009. *Bornéo, la mémoire des grottes (préface par Jean Clottes)* [Borneo: A report on the caves (preface by Jean Clottes)]. Lyon: Fage Éditions.

Faulkner, Charles H. 1988. "A Study of Seven Southern Glyph Caves." *North American Archaeologist* 9: 223–246.

Faulkner, Charles H. 1997. "Four Thousand Years of Native American Cave Art in the Southern Appalachians." *Journal of Cave and Karst Studies* 59: 148–153.

Fénies, Jacques. 1965. *Spéléologie et medicine* [Speleology and medicine]. Paris: Masson (Collection de médecine légale et de toxicology médicale).

François, Damien, and Anton J. Lennartz. 2007. "Les croyances des Indiens d'Amérique du Nord" [Beliefs of North American Indians]. *Religions et Histoire* 12: 78–87.

Garcia, Michel-Alain. 2001, 2010. "Les empreintes et les traces humaines et animals" [Human and animal tracks and traces]. Pp. 34–43 in Clottes, Jean, ed., *La Grotte Chauvet. L'art des origines* [The Chauvet cave: Original art]. Paris: Éditions du Seuil.

Garfinkel, Alan P., Donald R. Austin, David Earle, and Harold Williams. 2009. "Myth, Ritual and Rock Art: Coso Decorated Animal-Humans and the Animal Master." *Rock Art Research* 26: 179–197.

Gould, Stephen Jay. 1998. "The Sharp-Eyed Lynx, Outfoxed by Nature." *Natural History* 98(6): 23–27 and 69–73.

Groenen, Marc. 1994. *Pour une histoire de la Préhistoire. Le Paléolithique* [Toward a history of prehistory: The Paleolithic]. Grenoble: Jérôme Millon.

Guthrie, Russell Dale. 1984. "Ethological Observations from Paleolithic art." Pp. 35–74 in Bandi, Hans-Georg, Walter Huber, Marc-Roland Sauter, and Beat Sitter, eds., *La contribution de la zoologie et de l'éthologie à l'interprétation de l'art des peuples chasseurs préhistoriques: Colloque de Sigriswill, 1979* [The contribution of zoology and ethology to interpretation of the art of prehistoric hunters: Sigriswill Colloquium, 1979]. Fribourg (Switzerland): Éditions Universitaires.

Guthrie, Russell Dale. 2005. *The Nature of Paleolithic Art*. Chicago: University of Chicago Press.

Halifax, Joan. 1982. *Shamanism: The Wounded Healer*. New York: Crossroad.

Halverson, John. 1987. "Art for Art's Sake in the Paleolithic." *Current Anthropology* 28: 63–89.

Hamayon, Roberte. 1990a. *La Chasse à l'âme: Esquisse d'une théorie du chamanisme sibérien* [Hunters to the core: Outline of a theory of Siberian shamanism]. Paris: Société d'Ethnologie, Université Paris X.

Hamayon, Roberte. 1990b. "Le chamanisme sibérien: Réflexion sur un medium" [Siberian shamanism: Reflection on a medium]. *La Recherche* 275: 416–421.

Hamayon, Roberte. 1997. "La 'transe' d'un préhistorien: À propos du livre de Jean Clottes et David Lewis-Williams" [The "trance" of a prehistorian: Commentary on the book by Jean Clottes and David Lewis-Williams]. *Les Nouvelles de l'Archéologie* 67: 65–67.

Hempel, Carl Gustav. 1966. *Philosophy of Natural Science*. Englewood Cliffs: Prentice Hall.

Henshilwood, Christopher, Francesco D'Errico, Royden Yates, Zenobia Jacobs, Chantal Tribolo, Geoff A. T. Duller, Norbert Mercier, Judith C. Sealy, Helene Valladas, Ian Watts, and Ann G. Wintle. 2002. "Emergence of Modern Human Behavior: Middle Stone Age Engravings from South Africa." *Science* 295: 1278–1280.

Henshilwood, Christopher S. 2006. "Modern Humans and Symbolic Behaviour: Evidence from Blombos Cave, South Africa." Pp. 78–83 in Blundell, Geoffrey, ed.,

Origins: The Story of the Emergence of Humans and Humanity in Africa. Cape Town: Double Storey Books.

Heyd, Thomas, and John Clegg, eds. 2005. *Aesthetics and Rock Art* (with an introduction by Jean Clottes). Burlington: Ashgate.

Hill, Carol A., and Paolo Forti, eds. 1997. *Cave Minerals of the World* (with an introduction by Trevor R. Shaw). Huntsville: National Speleological Society.

Hodgson, Derek. 2008. "The Visual Dynamics of Upper Palaeolithic Art." *Cambridge Archaeological Journal* 18: 341–353.

Hume, Lynne. 2004. "Australian Aboriginal Shamanism." Pp. 860–865 in Walter, Mariko Namba, and Eva Jane Neumann Fridman, eds., *Shamanism: An Encyclopedia of World Beliefs, Practices and Culture, Volume 2*. Santa Barbara, CA: ABC-CLIO.

Humphrey, Nicholas. 1998. "Cave Art, Autism, and the Evolution of the Human Mind." *Cambridge Archaeological Journal* 8: 165–191.

Iliès, Sidi Mohamed. 2003. *Contes du desert*. Préface et textes recueillis par Jean Clottes, illustré par Laurent Corvaisier [Tales of the desert. Preface and selected texts by Jean Clottes, illustrated by Laurent Corvaisier]. Paris: Éditions du Seuil.

Jankélévitch, Vladimir. 1994. *Penser la mort?* [Thinking death?]. Paris: Éditions Liana Levi.

Kumar, Giriraj. 1992. "Rock Art of Upper Chambal Valley. Part II: Some Observations." *Purakal* 3: 56–67.

La Barre, Weston. 1972. "Hallucinogens and the Shamanic Origin of Religion." Pp. 261–278 in Furst, Peter T., ed., *Flesh of the Gods: The Ritual Use of Hallucinogens*. London: George Allen & Unwin.

Laming-Emperaire, Annette. 1962. *La Signification de l'art rupestre paléolithique* [The meaning of Paleolithic rock art]. Paris: Picard.

Lartet, Édouard, and Henry Christy. 1864. "Sur des figures d'animaux gravés ou sculptés et autres produits d'art et d'industrie rapportables aux temps primordiaux de la période humaine" [On engraved or sculptured animal figures and other products of art and industry attributable to a primordial stage of the human period]. *Revue archéologique* 9: 233–267.

Lee, Georgia. 1992. *The Rock Art of Easter Island: Symbols of Power, Prayers to the Gods*. Los Angeles: UCLA Institute of Archaeology.

Lee, Richard Borshay. 1979. *The !Kung San: Men, Women and Work in a Foraging Society*. Cambridge: Cambridge University Press.

Le Guillou, Yanik. 2001. "La Vénus du Pont-d'Arc" [The Venus of Pont-d'Arc]. *INORA: International Newsletter on Rock Art* 24: 1–5.

Lemaire, Catherine. 1993. *Rêves éveillés. L'âme sous le scalpel* [Waking dreams: The soul under the scalpel]. Paris: Les Empêcheurs de Penser en Rond.

Lemozi, Amédée. 1929. *La Grotte-Temple du Pech-Merle: Un nouveau sanctuaire préhisto-*

rique, préface de l'abbé Henri Breuil [The Cave-Temple of Pech-Merle: A new prehistoric sanctuary, with a preface by abbé Henri Breuil]. Paris: Picard.

Lenssen-Erz, Tilman. 2008. "L'espace et le discours dans la signification de l'art rupestre—un exemple de Namibie" [Space and discussion of the meaning of rock art—an example from Namibia]. *Préhistoire, Art et Sociétés. Bulletin de la Société Préhistorique Ariège-Pyrénées* 63: 159–169.

Le Quellec, Jean-Loïc. 2009. *Des Martiens au Sahara* [Martians in the Sahara]. Paris: Actes Sud/Errance.

Leroi-Gourhan, André. 1964. *Les Religions de la Préhistoire* [Prehistoric religions]. Paris: Presses Universitaires de France.

Leroi-Gourhan, André. 1965. *Préhistoire de l'art occidental* [Prehistory of Western art]. Paris: Mazenod.

Leroi-Gourhan, André. 1967. "Les mains de Gargas: Essai pour une étude d'ensemble" [The Gargas hands: Attempt at an overall study]. *Bulletin de la Société préhistorique française* 69: 107–122.

Leroi-Gourhan, André. 1974/1975. "Résumé des cours de 1974–1975" [Summary of courses for 1974–1975]. *Annuaire du Collège de France* 75: 387–403.

Leroi-Gourhan, André. 1976/1977. "Résumé des cours de 1976–1977" [Summary of courses for 1976–1977]. *Annuaire du Collège de France* 77: 489–501.

Leroi-Gourhan, André. 1977. "Le préhistorien et le chamane" [The prehistorian and the shaman]. *L'Ethnographie* 74–75, *numéro special: Études chamaniques*: 19–25.

Leroi-Gourhan, André. 1980 "Les débuts de l'art" [The beginnings of art]. Pp. 131–132 in *Les Processus de l'hominisation: L'évolution humaine, les faits, les modalités* [The processes of hominization: Human evolution—facts and modes]. *Colloques internationaux du CNRS* 599.

Leroi-Gourhan, André. 1982. *The Dawn of European Art: An Introduction to Palaeolithic Cave Painting*. Cambridge: Cambridge University Press.

Leroi-Gourhan, André. 1984. "Le réalisme de comportement dans l'art paléolithique de l'Europe de l'Ouest" [Behavioral realism in the Paleolithic art of Western Europe]. Pp. 75–90 in Bandi, Hans-Georg, Walter Huber, Marc-Roland Sauter, and Beat Sitter, eds., *La contribution de la zoologie et de l'éthologie à l'interprétation de l'art des peuples chasseurs préhistoriques: Colloque de Sigriswill, 1979* [The contribution of zoology and ethology to interpretation of the art of prehistoric hunters: Sigriswill Colloquium, 1979]. Fribourg (Switzerland): Éditions Universitaires.

Lewis-Williams, David. 1997. "Prise en compte du relief naturel des surfaces rocheuses dans l'art pariétal sud-africain et paléolithique ouest-européen: Étude culturelle et temporelle croisée de la croyance religieuse" [Taking account of natural relief of rock surfaces in South African and Paleolithic Western European parietal art: Cross-cultural and temporal study of religious belief]. *L'Anthropologie* 101: 220–237.

Lewis-Williams, David. 2000. *L'Art rupestre en Afrique du Sud: Mystérieuses images du*

Drakensberg [Rock art in South Africa: Mysterious images of the Drakensberg]. Paris: Éditions du Seuil.

Lewis-Williams, David. 2002. *The Mind in the Cave: Consciousness and the Origins of Art.* London: Thames & Hudson.

Lewis-Williams, David, and Jean Clottes. 1996. "Upper Palaeolithic Cave Art: French and South African Collaboration." *Cambridge Archaeological Journal* 6: 137–139.

Lewis-Williams, David, and Jean Clottes. 1998a. "Shamanism and Upper Palaeolithic Art: A Response to Bahn." *Rock Art Research* 15: 46–50.

Lewis-Williams, David, and Jean Clottes. 1998b. "The Mind in the Cave — the Cave in the Mind: Altered Consciousness in the Upper Paleolithic." *Anthropology of Consciousness* 9: 12–21.

Lewis-Williams, David, and Thomas A. Dowson. 1988. "The Signs of All Times. Entoptic Phenomena in Upper Palaeolithic Art." *Current Anthropology* 29: 201–245.

Lewis-Williams, David, and Thomas A Dowson. 1990. "Through the Veil: San Rock Paintings and the Rock Face." *South African Archaeological Bulletin* 45: 55–65.

Lewis-Williams, David, and David G. Pearce. 2004. *San Spirituality: Roots, Expressions and Social Consequences.* Cape Town: Double Storey Books.

Lommel, Andreas. 1967a. *Shamanism: The Beginnings of Art.* New York: McGraw-Hill.

Lommel, Andreas. 1967b. *The World of the Early Hunters.* London: Evelyn, Adams & Mackay.

Lommel, Andreas. 1997. *The Unambal: A Tribe in Northwest Australia.* Carnavon Gorge: Takarakka Nowan Kas Publications.

López Belando, Adolfo. 2003. *El Arte en la penumbra: Pictografías y petroglifos en las cavernas del parquet nacional del este República Dominicana/Art in the Shadows: Pictographs and Petroglyphs in the Caves of the National Park of the East Dominican Republic.* Santo Domingo: Amigo del Hogar.

Lorblanchet, Michel. 1988. "De l'art pariétal des chasseurs de rennes à l'art rupestre des chasseurs de kangourous" [From the wall art of reindeer hunters to the rock art of kangaroo hunters]. *L'Anthropologie* 92: 271–316.

Lorblanchet, Michel. 1989. "Art préhistorique et art ethnographique" [Prehistoric art and ethnographic art]. Pp. 60–63 in Mohen, Jean-Pierre, ed., *Le Temps de la Préhistoire* [The prehistoric period]. Dijon: Éditions Archeologia.

Lorblanchet, Michel. 1990. "Étude des pigments de grottes ornées paléolithiques du Quercy" [Study of the pigments in the Paleolithic decorated caves of Quercy]. *Bulletin de la Société des études littéraires, scientifiques et artistiques du Lot* 111: 93–143.

Lorblanchet, Michel. 1992. "Diversity and Relativity in Meaning." *Rock Art Research* 9: 132–133.

Lorblanchet, Michel. 1994. "Le mode d'utilisation des sanctuaires paléolithiques" [Mode of utilization of the Paleolithic sanctuaries]. Pp. 235–251 in Lasheras, José Antonio, ed., *Homenaje al Dr. Joaquín González Echegaray* [Homage to Dr. Joaquín González

Echegaray]. Madrid: Ministerio de Cultura, Museo y Centro de Investigación de Altamira, Monografías 17.

Lorblanchet, Michel. 1999. *La Naissance de l'art: Genèse de l'art préhistorique dans le monde* [The birth of art: Genesis of the prehistoric art of the world]. Paris: Errance.

Lorblanchet, Michel, and Ann Sieveking. 1997. "The Monsters of Pergouset." *Cambridge Archaeological Journal* 7: 37–56.

Macintosh, Neil William George. 1977. "Beswick Creek Cave Two Decades Later: A Reappraisal." Pp. 191–197 in Ucko, Peter John, ed., *Form in Indigenous Art: Schematisation in the Art of Aboriginal Australia and Prehistoric Europe*. Canberra: Australian Institute of Aboriginal Studies; London: Gerald Duckworth.

Malinovski, Bronislaw. 1944. *A Scientific Theory of Culture and Other Essays*. Chapel Hill: University of North Carolina Press.

May, Sally K., and Inés Domingo Sanz. 2010. "Making Sense of Scenes." *Rock Art Research* 27: 35–42.

Méroc, Louis, and Jean Mazet. 1956. *Cougnac: Grotte Peinte* [The painted cave of Cougnac]. Stuttgart: W. Kohlhammer Verlag.

Ngarjno, Ungudman, Banggal and Nyawarra. 2000. *Gwion Gwion: Secret and Sacred Pathways of the Ngarinyin Aboriginal People of Australia*. Cologne: Könemann Verlag.

Nielsen, Konrad, and Asbjørn Nesheim. 1956. *Lapp Dictionary, Volume 4: Systematic Part*. Oslo: Instituttet for Sammenlignende Kulturforskning.

Otte, Marcel. 2001. *Les Origines de la pensée: Archéologie de la conscience* [Origins of thought: The archeology of consciousness]. Sprimont: Pierre Mardaga.

Pales, Léon. 1976. *Les Empreintes de pieds humains dans les cavernes: Les empreintes du Réseau Nord de la caverne de Niaux (Ariège). Collection des Archives de l'Institut de paléontologie humaine 36* [Human footprints in caves: Prints in the Réseau Nord of the Niaux cave (Ariège). Collection of the Archives of the Institut de Paléontologie Humaine 36]. Paris: Masson.

Péquart, Marthe, and Saint-Just Péquart. 1963. "Grotte du Mas d'Azil (Ariège): Une nouvelle galerie magdalénienne" [The cave of Mas d'Azil (Ariège): A new Magdalenian gallery]. *Annales de Paléontologie* 49: 257–351.

Perlès, Catherine. 1977. *Préhistoire du feu* [The prehistory of fire]. Paris: Masson.

Perlès, Catherine. 1992. "André Leroi-Gourhan et le comparatisme" [André Leroi-Gourhan and comparatism]. *Les Nouvelles de l'Archéologie* 48/49: 46–47.

Perrin, Michel. 1995. *Le Chamanisme* [Shamanism]. Paris: Presses Universitaires de France.

Pradhan, Sadasiba. 2001. *Rock Art in Orissa*. New Delhi: Aryan Books International.

Pradhan, Sadasiba. 2004. "Ethnographic Parallels between Rock Art and Tribal Art in Orissa." P. 39 in *The RASI 2004 International Rock Art Congress, Programme and Congress Handbook*.

Prous, André. 1994. "L'art rupestre du Brésil" [Rock art of Brazil]. *Préhistoire ariégeoise, Bulletin de la Société préhistorique Ariège-Pyrénées* 44: 77–144.

Raphael, Max. 1945. *Prehistoric Cave Paintings*. New York: Pantheon Books, The Bollingen Series IV.

Reinach, Salomon. 1903. "L'Art et la Magie à propos des peintures et des gravures de l'Âge du Renne" [Art and magic in connection with the paintings and engravings of the reindeer age]. *L'Anthropologie* 14: 257–266.

Reznikoff, Iégor. 1987. "Sur la dimension sonore des grottes à peintures du Paléolithique" [On the acoustic dimension of painted caves of the Paleolithic]. *Comptes rendus de l'Académie des sciences, Paris* 304, series II/3: 153–156; and 305, series II: 307–310.

Reznikoff, Iégor, and Michel Dauvois. 1988. "La dimension sonore des grottes ornées" [The acoustic dimension of decorated caves]. *Bulletin de la Société préhistorique française* 85: 238–246.

Robert, Romain. 1953. "Le 'Faon à l'Oiseau.' Tête de propulseur sculpté du Magdalénien de Bédeilhac" [The "Fawn with the Bird": Sculpted handle of a Magdalenian spear-thrower at Bédeilhac]. *Préhistoire ariégeoise, Bulletin de la Société préhistorique Ariège-Pyrénées* 8: 11–18.

Robert-Lamblin, Joëlle. 1996. "Les dernières manifestations du chamanisme au Groenland oriental" [The last manifestations of shamanism in western Greenland]. *Boréales, Revue du Centre de recherches inter-nordique* 65–69: 115–130.

Rosman, Abraham, and Paula Ruebel. 1990. "Structural Patterning in Kwakiutl Art and Ritual." *Man* 25: 620–639.

Rozwadowski, Andrzej. 2004. *Symbols through Time: Interpreting the Rock Art of Central Asia*. Poznan: Institute of Eastern Studies, Adam Mickiewicz University.

Sahly, Ali. 1966. *Les Mains mutilées dans l'art préhistorique* [Mutilated hands in prehistoric art]. Toulouse: Private printing.

Sauvet, Georges, and Gilles Tosello. 1998. "Le mythe paléolithique de la caverne" [The Paleolithic cave myth]. Pp. 55–90 in Sacco, François, and Georges Sauvet, eds., *Le Propre de l'homme: Psychanalyse et préhistoire* [Uniquely human: Psychoanalysis and prehistory]. Lausanne: Delachaux & Niestlé.

Sauvet, Georges, and André Wlodarczyk. 2008. "Towards a Formal Grammar of the European Palaeolithic Cave Art." *Rock Art Research* 25: 165–172.

Sharpe, Kevin, and Leslie Van Gelder. 2004. "Children and Paleolithic 'Art': Indications from Rouffignac Cave, France." *International Newsletter on Rock Art* 38: 9–17.

Simonnet, Georges, Louise Simonnet, and Robert Simonnet. 1991. "Le Propulseur au faon de Labastide (Hautes-Pyrénées)" [The spear-thrower with the fawn from Labastide (Hautes-Pyrénées)]. *Préhistoire ariégeoise, Bulletin de la Société préhistorique Ariège-Pyrénées* 46: 133–143.

Simonnet, Robert. 1996. "Les techniques de representation dans la grotte ornée de Labastide (Hautes-Pyrénées)" [Techniques of representation in the decorated cave of Labastide (Hautes-Pyrénées)]. Pp. 341–352 in Delporte, Henri, and Jean Clottes, eds., *Pyrénées préhistoriques: Arts et Sociétés, Actes du 118e Congrès national des Sociétés historiques et scientifiques, octobre 1993* [Prehistory of the Pyrenees: Arts and Societies, Proceedings of the 118th National Congress of the Historical and Scientific Societies, October 1993]. Paris: Éditions du CTHS (Comité des travaux historiques et scientifiques).

Smith, Claire. 1991. "Female Artists: The Unrecognized Factor in Sacred Rock Art Production." Pp. 45–52 in Bahn, Paul G., and Andree Rosenfeld, eds., *Rock Art and Prehistory*. Oxford: Oxbow Books, Oxbow Monograph 10.

Smith, Noel W. 1992. *An Analysis of Ice Age Art: Its Psychology and Belief System*. New York: Peter Lang.

Stone, Andrea J. 1995. *Images from the Under World: Naj Tunij and the Tradition of Maya Cave Painting*. Austin: University of Texas Press.

Stone, Andrea J. 1997. "Precolumbian Cave Utilization in the Maya Area." Pp. 201–206 in Bonsall, Clive, and Christopher Tolan-Smith, eds., *The Human Use of Caves*. Oxford: BAR [British Archaeological Reports] International Series 667.

Testart, Alain. 1986. *Essai sur les fondements de la division sexuelle du travail chez les chasseurs-cueilleurs* [Essay on the foundations of sexual division of labor in hunters-and-gatherers]. Paris: Éditions de l'EHESS, Cahiers de l'Homme, nouvelle série 25.

Testart, Alain. 1991. *Des Mythes et des croyances: Esquisse d'une théorie générale* [Myths and beliefs. Outline for a general theory]. Paris: Éditions de la Maison des sciences de l'homme.

Testart, Alain. 1993. *Des Dons et des Dieux: Anthropologie religieuse et sociologie comparative* [Gifts and gods: The anthropology of religion and comparative sociology]. Paris: Armand Colin.

Texier, Pierre-Jean, Guillaume Porraz, John Parkington, Jean-Philippe Rigaud, Cedric Poggenpoel, Christopher Miller, Chantal Tribolo, Caroline Cartwright, Aude Coudenneau, Richard Klein, Teresa Steele, and Christine Verna. 2010. "A Howiesons Poort Tradition of Engraving Ostrich Eggshell Containers Dated to 60,000 Years Ago at Diepkloof Rock Shelter, South Africa." *Proceedings of the National Academy of Sciences, USA* 107: 6180–6185.

Treffert, Darold A. 2009. "Savant-Syndrome: An Extraordinary Condition. A Synopsis: Past, Present, Future." *Philosophical Transactions of the Royal Society of London B* 364: 1351–1357.

Triolet, Jérôme, and Laurent Triolet. 2002. *Souterrains et croyances: Mythologie, folklore, cultes, sorcellerie, rites initiatiques* [The underground realm and beliefs: Mythology, folklore, cults, sorcery and rites of initiation]. Rennes: Éditions Ouest-France.

Ucko, Peter J., and Andree Rosenfeld. 1967. *Palaeolithic Cave Art*. New York: McGraw-Hill.

Utrilla Miranda, Pilar. 1994. "Campamentos-base, cazaderos y santuarios. Algunos ejemplos del paleolítico peninsular" [Base-camps, hunting grounds and sanctuaries: Some examples from the peninsular Paleolitihic]. Pp. 97–113 in Lasheras, José Antonio, ed., *Homenaje al Dr. Joaquín González Echegaray* [Homage to Dr. Joaquín González Echegaray]. Madrid: Ministerio de Cultura, Museo y Centro de Investigación de Altamira, Monografías 17.

Utrilla Miranda, Pilar, and Manuel Martínez Bea. 2008. "Sanctuaires rupestres comme marqueurs d'identité territoriale: Sites d'agrégation et animaux 'sacrés'" [Rock sanctuaries as markers of territorial identity: Meeting sites and "sacred" animals]. *Préhistoire, Art et Sociétés, Bulletin de la Société préhistorique Ariège-Pyrénées*, 63: 109–133.

Valde-Nowak, Pawel. 2003. "Oblazowa Cave: Nouvel éclairage pour les mains de Gargas?" [Oblazowa cave: New light on the Gargas hands?] *INORA: International Newsletter on Rock Art* 3: 7–10.

Vallois, Henri Victor 1928. "Étude des empreintes de pieds humains du Tuc d'Audoubert, de Cabrerets et de Ganties" [Study of the human footprints of Tuc d'Audoubert, Cabrerets and Ganties]. *Congrès international d'anthropologie et d'archéologie préhistoriques, Amsterdam* 3: 328–335.

Vazeilles, Danièle. 1991. *Les Chamanes, maîtres de l'univers* [Shamans: Masters of the universe]. Paris: Éditions du Cerf.

Vialou, Denis. 1986. *L'Art des grottes en Ariège magdalénienne* [Magdalenian cave art in Ariège]. Paris: Éditions du CNRS, 22e Supplément à Gallia Préhistoire.

Victor, Paul-Émile, and Joëlle Robert-Lamblin. 1993. *La Civilisation du phoque: Légendes, rites et croyances des Eskimo d'Ammassalik* [The seal civilization: Legends, rites and beliefs of the Ammassalik Eskimos]. Bayonne: Éditions Raymond Chabaud.

Villaverde Bonilla, Valentín. 1994. *Arte paleolítico de la Cova del Parpalló: Estudio de la colección de plaquetas y cantos grabados y pintados* [Paleolithic art of the Parpalló cave: Study of the collection of engraved and painted flat stones and pebbles]. Valencia: Diputacióde València, Servei d'Investigació Prehistòrica.

Vitebsky, Piers. 1995. *Les Chamanes* [Shamans]. Paris: Albin Michel.

Vitebsky, Piers. 1997. "What Is a Shaman?" *Natural History* 106/3: 34–35.

Waller, Steven J. 1993. "Sound Reflection as an Explanation for the Content and Context of Rock Art." *Rock Art Research* 10: 91–101.

Wallis, Robert J. 2004. "Art and Shamanism." Pp. 21–30 in Walter, Mariko Namba, and Eva Jane Neumann Fridman, eds., *Shamanism: An Encyclopedia of World Beliefs, Practices and Culture, Volume 1*. Santa Barbara: ABC-CLIO.

Walter, Mariko Namba, and Eva Jane Neumann Fridman, eds. 2004. *Shamanism: An Encyclopedia of World Beliefs, Practices and Culture*, 2 volumes. Santa Barbara: ABC-CLIO.

White, Randall. 2006. "Looking for Biological Meaning in Cave Art, a Review of D. Guthrie's *The Nature of Paleolithic Art*." *American Scientist* 94: 371–372.

Whitley, David S. 1996. *A Guide to Rock Art Sites: Southern California and Southern Nevada*. Missoula: Mountain Press.

Whitley, David S. 2000. *Art of the Shaman*. Salt Lake City: University of Utah Press.

Wylie, Alison. 1989. "Archaeological Cables and Tacking: The Implications of Practice for Bernstein's 'Options beyond Objectivism and Relativism.'" *Philosophy of the Social Sciences* 19: 1–18.

Young, M. Jane. 1992. *Signs from the Ancestors, Zuni Cultural Symbolism and Perceptions of Rock Art*. Albuquerque: University of New Mexico Press.

Zilhão, João, Diego E. Angelucci, Ernestina Badal-García, Francesco D'Errico, Floréal Daniel, Laure Dayet, Katerina Douka, Thomas F. G. Higham, María José Martínez-Sánchez, Ricardo Montes-Bernárdez, Sonia Murcia-Mascarós, Carmen Pérez-Sirvent, Clodoaldo Roldán-García, Marian Vanhaeren, Valentín Villaverde Bonilla, Rachel Wood, and Josefina Zapata. 2010. "Symbolic Use of Marine Shells and Mineral Pigments by Iberian Neandertals." *Proceedings of the National Academy of Sciences, USA* 107: 1023–1028.

Index

Page numbers in *italics* refer to illustrations.